Nikon® D780™

for dummies®

A Wiley Brand

Nikon® D780™

by Doug Sahlin

A Wiley Brand

Nikon® D780™ For Dummies®

Published by: **John Wiley & Sons, Inc.**, 111 River Street, Hoboken, NJ 07030-5774, www.wiley.com

Copyright © 2020 by John Wiley & Sons, Inc., Hoboken, New Jersey

Published simultaneously in Canada

For general information on our other products and services, please contact our Customer Care Department within the U.S. at 877-762-2974, outside the U.S. at 317-572-3993, or fax 317-572-4002. For technical support, please visit https://hub.wiley.com/community/support/dummies.

Wiley publishes in a variety of print and electronic formats and by print-on-demand. Some material included with standard print versions of this book may not be included in e-books or in print-on-demand. If this book refers to media such as a CD or DVD that is not included in the version you purchased, you may download this material at http://booksupport.wiley.com. For more information about Wiley products, visit www.wiley.com.

Library of Congress Control Number: 2020939544

ISBN 978-1-119-71637-2 (pbk); ISBN 978-1-119-71642-6 (ebk); ISBN 978-1-119-71643-3 (ebk)

10 9 8 7 6 5 4 3 2 1

Contents at a Glance

Contents at a Glance

Table of Contents

Introduction

Your Nikon D780 is the latest and greatest digital camera on the market, with a stunning 24.5-megapixel capture, live view, high-definition video, and much more. But all this technology can be a bit daunting, especially if this is your first real digital single-lens reflex (DSLR) camera or if you've upgraded from an earlier Nikon model. When you unboxed your Nikon D780, you graduated to the big leagues. All you have to do is master the power you hold in your hands!

I've been using DSLR cameras since 2000. In fact, my first digital camera was a Nikon. But my earliest forays into photography were with film cameras, cameras that didn't give you instant gratification by showing you the resulting image on an LCD monitor. I learned the hard way (and wasted a lot of film), but I loved photography, so I persevered and created images whenever I had the time. I've photographed weddings and sporting events for hire, and I've written several books about digital photography. In this book, I share my experience and knowledge with you. I don't get too technical in this book, even though your camera is very technical. I also do my best to keep it lively. So, if you want to master your Nikon D780, you have the right book in your hands.

About This Book

If you find the buttons and menus on your shiny new D780 a tad intimidating, this book is for you. Here, I take you from novice point-and-shoot photographer to one who can utilize all the bells and whistles your camera offers. You'll find information about the camera menus and every button on your camera, as well as when to use them, and what settings to use for specific picture-taking situations.

This book is a reference, which means you don't have to commit it to memory or read it from beginning to end. Instead, you can return to it again and again, using the Table of Contents and Index to find the information you need.

Throughout the book, you'll see sidebars (text in gray boxes), as well as Technical Stuff icons. All this text is interesting, but if you're short on time or just need to know the basics, you can safely skip these pieces without missing anything critical.

Within this book, you may note that some web addresses break across two lines of text. If you're reading this book in print and want to visit one of these web pages, simply key in the web address exactly as it's noted in the text, pretending as though the line break doesn't exist. If you're reading this as an e-book, you've got it easy — just click the web address to be taken directly to the web page.

Foolish Assumptions

As I wrote this book, I made some assumptions about you, the reader:

>> **You own, or have on order, a Nikon D780.** If you own one of those cute little point-and-shoot Nikon cameras, or shoot images with your smartphone, good for you, but this book won't help you with those cameras.

>> **You have a computer on which to download your images and preferably a program with which to edit your images.** This program may be something like Adobe Photoshop, Adobe Photoshop Elements, Adobe Lightroom, the Photos application that comes with macOS, or Nikon's Capture NX-D, which is available for Windows and Mac.

>> **A basic knowledge of photography is also helpful.** If you're totally new to photography and want more information about things like aperture, shutter speed, and ISO, and how they combine to make a properly exposed image, check out *Digital SLR Photography All-in-One For Dummies,* 3rd Edition, by Robert Correll (Wiley).

Icons Used in This Book

Every *For Dummies* book has icons in the margin that draw your attention to important bits of information, and this book is no different. Here's what the various icons mean:

TIP

Whenever you see the Tip icon, you're sure to find information designed to save you time and make your life easier (well, at least your life with your Nikon D780 — I can't promise anything beyond that).

WARNING

The Warning icon warns you about something you should not do — something your fearless author has likely already done and wants to warn you off from. Think of these as headache prevention.

REMEMBER

The Remember icon is the equivalent of a virtual piece of string tied around your finger. This is information you want to commit to memory.

TECHNICAL STUFF

The Technical Stuff icon is for the geeks in the group who like to know all manner of technical stuff. If that's you, great! If not, you can skip anything marked with this icon without missing anything essential to your understanding of the topic at hand.

Beyond This Book

In addition to what you're reading right now, this product comes with a free access-anywhere Cheat Sheet that includes the Nikon D780 shooting modes and metering modes, a post-shoot checklist, and more. To get this Cheat Sheet, go to www.dummies.com and type **Nikon D780 For Dummies Cheat Sheet** in the Search box.

Where to Go from Here

If you've had a chance to dip your toe into the shallow end of the Nikon D780 pool, you probably know the camera pretty well, so feel free to skip the first four chapters of the book, and pick and choose which sections contain the information you need to become even better acquainted with your camera.

If you bought this book before getting your camera, or your friendly retailer suggested you buy a copy to get up to speed quickly, I've got you covered. In Chapters 1 through 4, I familiarize you with the basic things you need to know to create great pictures in a short period of time. In Chapters 5 and 6, I show you how to specify image size and image quality and get down to brass tacks with the tilting monitor. No matter where you start, feel free to create your own buffet of information from the remaining chapters in the book. When you're just getting started, consider keeping a copy of the book in your camera bag for ready reference.

Finally, when you go on a photo shoot with your D780, take your time. If you rush a photo shoot, you miss the point of photography, which in my opinion is to observe, imagine, and create.

Beyond This Book

In addition to what you're reading right now, this product comes with a free, access-anywhere Cheat Sheet that includes the Nikon D780 shortcut makes and metering modes a peek about clearly, and more. To get this Cheat Sheet, go to www.dummies.com and type Nikon D780 For Dummies Cheat Sheet in the Search box.

Where to Go from Here

If you've had a chance to dip your toe into the shallow end of the Nikon D780 pool, you probably know the camera pretty well, so feel free to skip the first four chapters of the book, and pick and choose which sections contain the information you need to become even better acquainted with your camera.

If you bought this book before getting your camera, or your literally totally suggested, you buy a copy to get up to speed quickly, I've got you covered. In Chapters 1 through 4, I familiarize you with the basic things you need to know to create great pictures in a short period of time. In Chapters 5 and 6, I show you how to specify image size and image quality and get down to brass tacks with the tilting monitor. No matter where you start, feel free to flip to the main buffet of information from the remaining chapters in the book. When you're just getting started, consider keeping a copy of the book in your camera bag for ready reference.

Finally, when you go on a photo shoot with your D780, take your time. If you rush a photo shoot, you miss the point of photography, which in my opinion is to observe, imagine, and create.

1

Getting Started with the Nikon D780

Chapter **1**

Exploring the Nikon D780's Controls

The Nikon D780, which evolved from the Nikon D750 that was introduced in late 2014, is a full-frame camera that captures stunning 24.5-megapixel images. It has all the latest bells and whistles Nikon has to offer on a full-frame digital single-lens reflex (DSLR) camera. It's a technological marvel that enables you to take great pictures and capture high-definition (HD) video. The camera has a new processor and an advanced, highly customizable 51-point auto-focus system that gives you the ability to capture great images in low light and at a blindingly fast speed of up to 12 frames per second, which is ideal for action photography. You can also create high dynamic range (HDR) images and use the interval timer to create time-lapse movies. This camera features a viewfinder that shows you 100 percent of what the lens captures at a magnification of 0.70x — what you see is what you get. The camera also features a virtual horizon, which enables you to capture images that are perfectly level.

The learning curve with all these bells and whistles may seem a little steep, but don't worry — I'm an experienced professional photographer, and I take pride in understanding how a camera works and how to get the most from any camera. In this chapter, I introduce you to the Nikon D780's controls and help you get the lay of the land, so to speak.

Exploring the Top of Your Camera

The top of the camera is where you find the controls you use most when taking pictures. This is where you change settings like ISO (how sensitive the sensor is to light) and shutter speed, choose a shooting mode, and press the shutter button to take a picture.

TECHNICAL STUFF

ISO stands for International Organization for Standardization, but all you really need to know is that, on your camera, it controls how sensitive the camera's sensor is to light.

You can do lots of other things from the top of the camera, which, in my humble opinion, is the most important real estate on the camera, with the possible exception of the lens. I suggest you get to know the controls on the top of your camera intimately, like the back of your hand. Many photographers, including me, make it a point to memorize where the controls are and access them without taking an eye off the viewfinder.

Here's what you find on the top of the camera (see Figure 1-1):

» **Release mode dial lock release:** Press the button to unlock the release mode dial.

» **Release mode dial:** Rotate this dial to choose whether pressing the shutter button captures a single image or a sequence or images. (Turn to Chapter 9 for more on the shutter release modes.)

» **Mode dial lock release:** Pushing this button enables you to change from one shooting mode to another. When in the upright and locked position, it's not possible to accidentally change shooting modes in the heat of battle.

» **Mode dial:** You use this dial to specify which shooting mode the camera uses to take the picture. (For more on how to use this dial to choose specific shooting modes, turn to Chapter 9; for more on how to choose optimal settings for specific picture-taking situations, turn to Chapter 13.)

» **Accessory shoe:** Slide a flash unit that's compatible with the Nikon D780 into this slot (also sometimes known as a hot shoe). The contacts in the accessory shoe communicate between the camera and the flash unit. (For more on flash photography, turn to Chapter 11.)

» **Sub-command dial:** This dial is used in conjunction with menu commands and other buttons to specify settings.

» **Power switch:** Turn this switch one notch to power the camera on, and turn it a second notch to turn on the LCD illuminator.

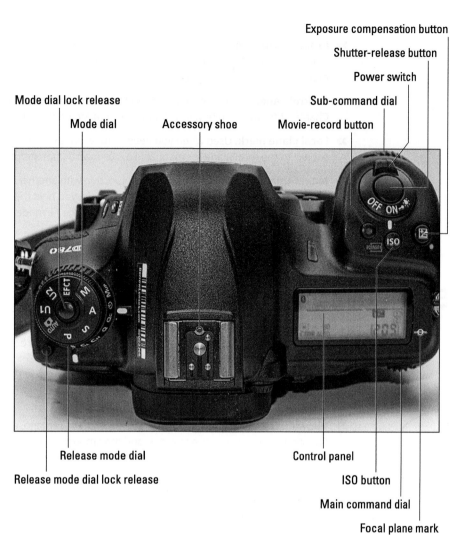

Mode dial lock release

Mode dial Accessory shoe

Exposure compensation button

Shutter-release button

Power switch

Sub-command dial

Movie-record button

Release mode dial

Release mode dial lock release

Control panel

ISO button

Main command dial

Focal plane mark

FIGURE 1-1:
The top of the
Nikon D780.

>> **Shutter-release button:** This button pre-focuses the camera and takes a picture. (Turn to Chapter 2 for more information.)

>> **Movie-record button:** Press this button to start recording video. (For more on how to use this button with other features to capture videos, turn to Chapter 8.)

>> **ISO button:** Use this button in conjunction with the main command dial to choose the ISO sensitivity of the camera's sensor. (For more on setting the ISO, turn to Chapter 10.)

>> **Exposure compensation button:** Use the button in conjunction with the main command dial to increase or decrease the exposure. (See Chapter 9 for more information on using this feature.)

>> **Control panel:** This panel shows you all the current settings. (Turn to Chapter 2 for more on how to read the information on the control panel.)

>> **Focal plane mark:** Used when you need to measure exact distance from the subject to the focal plane for manual focus or macro photography.

>> **Main command dial:** Use this dial in conjunction with another button or menu command to change a setting. For example, you hold the AF-mode button and use the main command dial to specify the AF mode used to capture images.

Exploring the Back of Your Camera

The back of the camera is where you find controls to capture images or movies using live view, access the camera menu, and much more.

Here's what you find on the back of your Nikon D780 (see Figure 1-2):

>> **Viewfinder eyepiece:** Look through the viewfinder to compose your pictures. Shooting information, battery status, and the amount of shots that can be stored on the memory card are displayed in the viewfinder. The eyepiece cushions your eye when you press it against the viewfinder and creates a seal that prevents ambient light from having an adverse effect on the exposure.

>> **Diopter adjustment control:** This control fine-tunes the viewfinder to your eyesight. (Turn to Chapter 2 for more on how to use this control.)

>> **Live view selector:** This control is a switch that enables you to capture images in live view mode or to shoot movies. (I explain how to use this switch in detail in Chapters 7 and 8.)

>> **Live view button:** Press this button to lock the mirror; the view through the lens is displayed on the tilting monitor. Push this button to shoot images or movies in live view mode (see Chapter 6).

>> **AF-ON button:** This button can be used for focus in autofocus mode. You can also choose the role assigned to this button by creating a custom setting (see Chapter 14).

>> **AE-L/AF-L button:** This button enables you to lock exposure and focus to a specific part of the frame (see Chapter 9).

- **Multi selector:** You use the multi selector for a myriad of tasks, such as changing the autofocus point, selecting an option when using the *i* menu instead of the camera menu, switching from one camera menu to the next, or selecting a menu item. The multi selector has four arrows (up, down, right, and left) that you use to navigate to and select options, menu commands, and settings. In the middle of the dial is an OK button, which you use to commit a setting or option. (I show you how to use this dial throughout this book as it relates to a specific task.)

- **OK button:** Use this button to select a highlighted option. This button can also be assigned to perform a specific task in viewfinder or live view photography (see Chapter 14).

- **Focus selector lock:** Use this button to lock focus to a specific autofocus point. This feature comes in handy when you're focusing on an off-center subject or locking focus to a specific point in the frame.

- **i button:** Press this button to access the *i* menu. (I show you how to use the *i* menu throughout this book in conjunction with various tasks.)

- **Speaker:** This is where camera sounds and movie sounds are played.

- **Memory card access lamp:** Flashes when the camera is accessing the memory card.

- **Tilting monitor:** This is where you view menu items, review images, and create images and movies in live view mode. (Turn to Chapter 2 for more on the tilting monitor.)

- **Info button:** Use this button to review shooting information.

- **Zoom out/metering button:** Use this button to change metering modes (see Chapter 9). This button is also used to zoom out while reviewing images.

- **Zoom in/QUAL button:** Use this button to specify image quality (see Chapter 5). This button is also used to zoom in while reviewing images.

- **Help/protect/WB button:** This button is multifunctional. You can use it to view help information on the currently selected item (when available), protect images when reviewing them, or set the white balance.

- **MENU button:** Press this button to display the last-used camera menu on the tilting monitor. (Turn to Chapter 4 for more on the camera menu.)

- **Charge lamp:** Illuminates when you connect an external charger to the camera.

- **Play button:** Press this button to review images and play movies (see Chapter 6).

- **Delete button:** This button deletes an image (see Chapter 4).

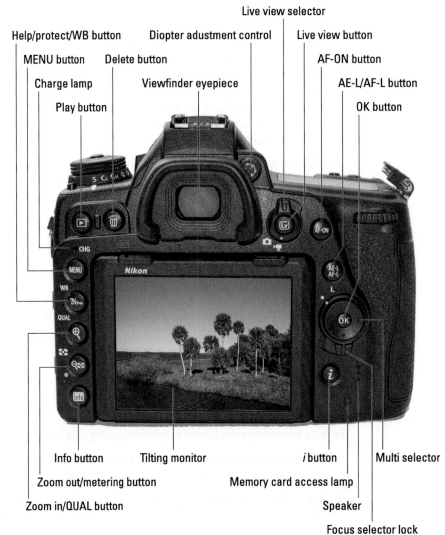

Live view selector

Help/protect/WB button Diopter adustment control Live view button

MENU button Delete button AF-ON button

Charge lamp Viewfinder eyepiece AE-L/AF-L button

Play button OK button

Info button Tilting monitor *i* button Multi selector

Zoom out/metering button Memory card access lamp

FIGURE 1-2: Zoom in/QUAL button Speaker
The back of the
Nikon D780. Focus selector lock

Exploring the Front of Your Camera

On front of your camera, you'll find a couple of buttons that you use every day and some that access features you rarely use. The following features are on the front of your camera (see Figure 1-3):

>> **Self-timer lamp:** This light flashes when the self-timer is used. It flashes faster when it's time to smile and say, "Cheese."

>> **Pv button:** Press this button to preview the *depth of field* (the amount of the image in front of and behind your subject that's in focus) at the current f-stop.

>> **Fn button:** Press this button to quickly access selected settings. The default role for this button is to choose image area (see Chapter 5). Pressing this button is not for the ambidextrously challenged — you have to hold the button with one hand and rotate either the main command dial and/or the sub-command dial. You can assign a different role to the button by creating a custom setting (see Chapter 14).

>> **Stereo microphone:** Records audio when recording movies. Because the Nikon D780 is a state-of-the-art camera, it records in stereo.

>> **Flash mode/flash compensation button:** Use this button to choose the flash mode and to enable flash compensation. (I discuss flash, an illuminating subject, in Chapter 11.)

>> **BKT button:** Use this button to specify the bracketing increment and number of shots when bracketing exposure. You can also change the role of this button by creating a custom setting (see Chapter 14).

>> **Lens mounting mark:** Use this to align a lens when mounting it to your camera. (For more information, see Chapter 3.)

>> **Lens release button:** Press this button when releasing a lens from the camera (see Chapter 3).

>> **AF-mode button:** Use this button to specify the desired autofocus (AF) mode. (For more information on autofocus modes, turn to Chapter 10.)

>> **Focus-mode selector:** Use this switch to specify autofocus or manual focus. (For more information on focusing your camera, see Chapter 4.)

>> **Body cap (not shown):** Use the body cap to protect the interior of the camera when a lens isn't attached.

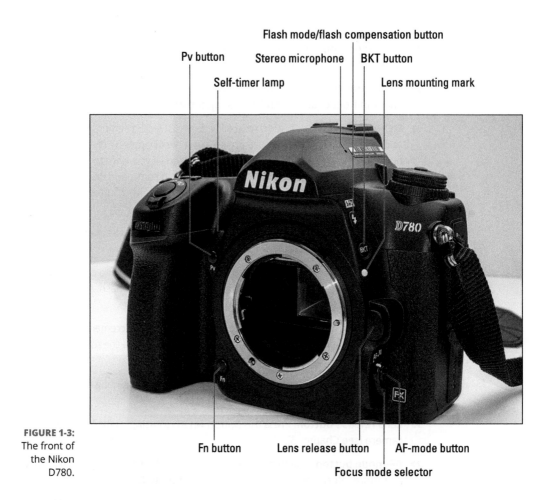

Flash mode/flash compensation button

Pv button　　Stereo microphone　BKT button

Self-timer lamp　　　　　Lens mounting mark

Fn button　　　Lens release button　　AF-mode button

Focus mode selector

FIGURE 1-3:
The front of
the Nikon
D780.

Exploring the Bottom of Your Camera

Here's what you find on the bottom of the Nikon D780:

>> **Battery-chamber cover:** Protects your battery from the elements.

>> **Battery-chamber cover latch:** Press this latch to one side to open the cover
and access your battery.

>> **Tripod socket:** Thread a tripod into this socket. Tripods come in handy when
you want to steady the camera when shooting at slow shutter speeds or when
you're taking a family photo and you don't want to be missing from the frame.

IN THIS CHAPTER

» **Changing the default settings that matter most**

» **Taking a gander at the tilting monitor**

» **Getting to know the control panel**

» **Working with the viewfinder**

» **Taking a look at the _i_ menu**

» **Seeing what happens when you press the Info button**

Chapter **2**

Setting Up the Nikon D780

When you unbox your Nikon D780, it's like stepping into a brand-new car. Everything is all bright and shiny. You nestle into the driver's seat and take it all in. You know how to drive, but this car is different from your old one. It's the same with your new camera. You probably know how to take pictures, but the viewfinder and the tilting monitor are different. And maybe your last camera didn't have a control panel on top of the camera. Your Nikon D780 does. It's a whole new world!

Even if you're a seasoned Nikon user, there's something for you in this chapter. Here, I show you how to set the date and time, use the tilting monitor, get familiar with the viewfinder and _i_ menu, and more.

Customizing the Default Settings

Your camera ships with some default settings you can modify to suit your taste. In this section, I show you how.

Setting the date and time

Chances are, your camera won't be set up with the correct date and time when you get it, so one of the first things you'll want to do is get those two items set correctly. To change the date and time, follow these steps:

1. **Rotate the power switch to the ON position.**

 Your Nikon D780 powers on.

2. **Press the MENU button on the back of your camera.**

 You're presented with many choices. Breathe.

3. **Press the down arrow on the multi selector to navigate to the setup menu (it looks like a wrench), and then press the left arrow on the multi selector to select the icon.**

 The monitor refreshes, and you're presented with lots of setup options.

4. **Press the right arrow on the multi selector to place the cursor inside the menus, and then press the down arrow to select Time Zone and Date (see Figure 2-1).**

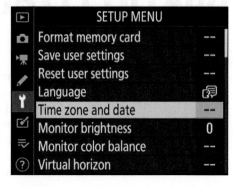

5. **Press the right arrow on the multi selector.**

 The monitor refreshes and displays the time zone and date options.

6. **Press the down arrow on the multi selector to select the Time Zone option (see Figure 2-2).**

 FIGURE 2-1:
 Navigating to Time Zone and Date.

7. **Press the left arrow or right arrow on the multi selector to select your time zone (see Figure 2-3), and then press OK.**

 The camera is set to your time zone and the monitor refreshes to show the time zone and date options.

8. Press the down arrow on the multi selector to select Date and Time, and then press OK.

The monitor refreshes and displays the date and time controls (see Figure 2-4).

9. Press the up arrow or down arrow on the multi selector to select the current year, and then press OK.

The monitor refreshes, and the month is highlighted.

10. Press the up arrow or down arrow on the multi selector to select the current month, and then press OK.

The monitor refreshes to highlight the current day.

11. Press the up arrow or down arrow on the multi selector to select the day and current time, and then press OK.

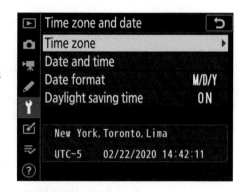

FIGURE 2-2:
Navigating to Time Zone.

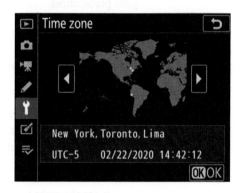

FIGURE 2-3:
Selecting the time zone.

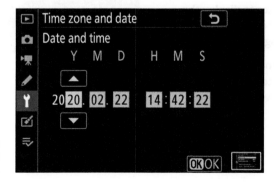

⚠

WARNING

The camera uses a 24-hour clock, so if you're not familiar with the 24-hour clock, you'll have to do the math. For example, 1:00 p.m. is 1300 hours, so enter 13 for the H setting.

The current date and time are set and will be recorded as metadata on every photograph you create.

FIGURE 2-4:
Setting the date and time.

There are also options to change the date format to suit your preference, and enable daylight saving time if you have to reset your clocks in spring and fall. You set these options with the multi selector and the OK button in the same manner as you set the time zone, date, and time.

TIP

If your camera wasn't set up for your native language, navigate to Language in the setup menu, and then choose your desired language.

Setting the monitor off delay

By default, the tilting monitor powers off after you haven't used it for a designated period of time. This feature conserves the life of your camera battery. If you want, you can change the amount of time before the monitor powers off to suit your preferences.

To set the monitor off delay, follow these steps:

1. **Press the MENU button on the back of your camera.**

The monitor refreshes, and you have a plethora of menu choices.

2. **Press the down arrow on the multi selector to navigate to the Custom Settings menu (it looks like a pencil), and then press the left arrow on the multi selector to select the icon.**

The monitor refreshes, and you're presented with lots of custom options.

3. **Press the right arrow on the multi selector to display the custom options, and then press the down arrow on the multi selector to select c4: Monitor Off Delay (see Figure 2-5).**

4. **Press the right arrow on the multi selector to display the monitor off delay options, shown in Figure 2-6.**

5. **Press the down arrow on the multi selector to navigate to the option you want to change.**

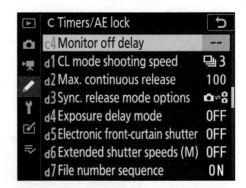

FIGURE 2-5:
Navigate to this option to set the monitor off delay.

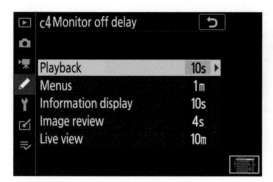

FIGURE 2-6:
The monitor
off delay
options.

You can change the following options:

- *Playback:* This option determines how long the monitor is on after a movie stops playing. The default is 10 seconds, but you can choose for the monitor to automatically shut off after anywhere from 4 seconds to 10 minutes of inactivity.

- *Menus:* This option determines how long the monitor is on when displaying a menu option. The default is 1 minute, but you can choose for the monitor to automatically shut off after anywhere from 4 seconds to 10 minutes of inactivity.

- *Information Display:* This option determines how long the monitor is on when displaying information. The default is 10 seconds, but you can choose for the monitor to automatically shut off after anywhere from 4 seconds to 10 minutes of inactivity.

- *Image Review:* This option determines how long the monitor is on when you're reviewing an image. The default is 4 seconds, but you can choose for the monitor to automatically shut off after anywhere from 2 seconds to 10 minutes of inactivity.

- *Live View:* This option determines how long the monitor is on when you're shooting images or recording movies in live view mode. The default is 10 minutes, but you can choose for the monitor to automatically shut off after anywhere from 5 minutes to no limit. The latter option means live view will be active until you press the live view button again, you turn the camera off, or the battery runs out of juice.

The following steps show you how to change the Image Review option. Changing the other options works the same.

6. **Press the down arrow on the multi selector to select the Image Review option (see Figure 2-7).**

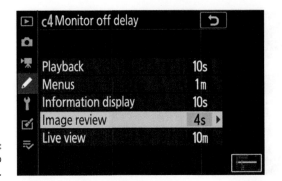

FIGURE 2-7:
Navigating to
Image Review.

7. **Press the right arrow on the multi selector.**

The Image Review monitor off delay options appear (see Figure 2-8).

8. **Press the down arrow on the multi selector to select the desired option, and then press OK.**

The monitor off delay option is now modified to suit your preference.

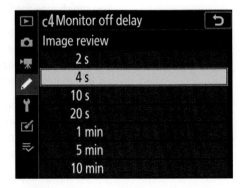

FIGURE 2-8:
Setting the Image Review monitor off delay.

If you've got two or three extra batteries in your camera bag, you can increase monitor off delay as needed, but if you're shooting with one battery and/or shooting in a cold climate, I recommend that you choose the shortest duration possible for tasks you frequently perform using the tilting monitor.

Working with the Tilting Monitor

The tilting monitor is used for a myriad of functions, including live view photography and movie making. The monitor (see Figure 2-9) is smack dab in the middle of the back of the camera. It allows you to access menu commands, review images, choose images for deletion, and more. In addition, when you press the live view button, the mirror locks and the monitor shows you exactly what the camera sensor captures. The view you get is crystal clear in live and living color. After pressing the live view button, you can create images (see Chapter 7) or record movies (see Chapter 8) using the tilting monitor.

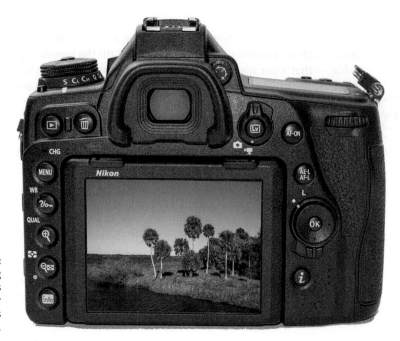

FIGURE 2-9:
The tilting
monitor lets
you see your
lovely images
better.

TIP

The tilting monitor is a sensitive piece of equipment that can be damaged. Consider purchasing a tempered-glass screen protector for your camera. I put one on every camera I own.

TIP

Carry a couple of LCD screen cleaner wipes and a microfiber cloth in your camera bag. These come in handy when your fingerprints, sweat, or sunscreen obscure the surface of the LCD display.

You can use touch control to perform certain tasks on your monitor. For example, you can choose menu options using touch control, focus the camera using touch control, and release the shutter using touch control. For more information on touch control, see Chapter 6.

Tilting the monitor comes in handy when you're taking pictures or recording movies in live view. This feature enables you to shoot from a vantage point not possible when shooting through the viewfinder or with a monitor that doesn't tilt.

To tilt the monitor, grasp it by the top or bottom and gently rotate the monitor to the desired position. For example, you can tilt the monitor and then lower the camera to shoot from a snail's-eye view. You can also tilt the monitor and hold it over your head for a bird's-eye view. Use touch control when creating images with

the monitor tilted, and you don't have to be a contortionist to reach the shutter-release button. However, you won't be able to tilt the monitor far enough to take a selfie — that's not what the monitor was designed for. If you're into selfies, never leave home without your smartphone. Figure 2-10 shows the monitor when tilted.

Here are some precautions to take with your tilting monitor:

>> After you finish taking pictures or creating movies with the monitor tilted, return it to the upright position.

>> Don't force the monitor. It's a sensitive piece of equipment and you may damage it if you try to tilt the monitor beyond its limits.

>> Don't touch the area behind the monitor. Doing so may damage the monitor.

>> Don't allow liquid to contact the area behind the monitor.

>> Don't tilt the monitor when shooting in heavy fog or mist. The moisture may come in contact with the area behind the monitor and cause it to malfunction.

>> Don't carry the camera by the monitor.

>> When shooting with a tripod, make sure the monitor doesn't contact the tripod when you tilt it.

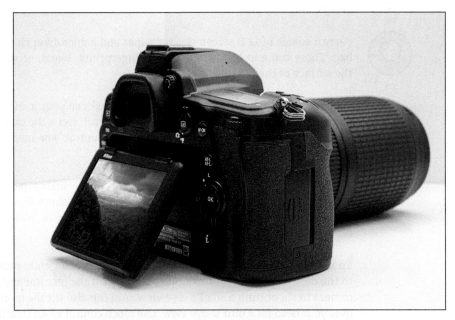

FIGURE 2-10:
Tilting the monitor to shoot from a different vantage point.

Using the Control Panel

Another important piece of real estate on your camera is the control panel, which, as you're looking at the back of the camera, resides on top of the camera to the right of the viewfinder. The control panel gives you lots of useful information while you're shooting or recording movies, such as the shutter speed, aperture, ISO, metering mode, number of exposures remaining, and more.

TIP

When you're shooting at night or in dim conditions, rotate the power switch to the white icon that looks like a light bulb to turn on the LCD illuminator.

The amount of information displayed in the control panel (see Figure 2-11) changes depending on the options you choose. The control panel gives you quick and easy access to camera settings and other useful information. Here's a road map for the information you'll find on the control panel when shooting:

>> **Shutter speed:** Displays the shutter speed that will be used to create the image.

>> **Aperture:** Displays the aperture that will be used to create the image.

>> **Memory card icon (Slot 1):** This icon is displayed when a memory card is inserted in Slot 1.

>> **Memory card icon (Slot 2):** This icon is displayed when a memory card is inserted in Slot 2.

>> **Number of exposures remaining:** This icon displays the number of exposures that can be added to the card using the current settings. The number is followed by *k* when the amount of remaining exposures is more than 1,000. For example, 7.1k means approximately 7,100 exposures can be added to the card.

>> **ISO sensitivity:** This icon displays the currently selected ISO, or ISO sensitivity. (I show you how to set the ISO sensitivity in Chapter 10.)

>> **Auto ISO sensitivity:** This icon is displayed when shooting in auto ISO mode.

>> **Battery indicator:** This icon shows the amount of charge left in the battery. When it's red, it's time to change the battery.

>> **Metering:** This icon shows the currently selected light metering mode. (I show you how to set the metering mode in Chapter 9.)

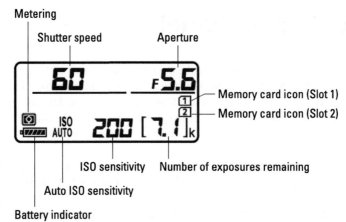

Metering

Shutter speed

Aperture

Memory card icon (Slot 1)

Memory card icon (Slot 2)

ISO sensitivity

Number of exposures remaining

Auto ISO sensitivity

Battery indicator

FIGURE 2-11:
The control panel gives you easy access to shooting information.

Other icons may appear in the control panel, depending on which options you're using and which mode you're shooting in or whether you're filming (see Figure 2-12):

>> **Bluetooth connection indicator:** This icon appears when the camera is connected to a device via Bluetooth.

>> **Wi-Fi connection indicator:** This icon appears when your camera is connected to a local network via Wi-Fi.

>> **Color temperature:** This icon (an upper case *K*) appears when you specify the color temperature used for white balance.

>> **Multiple exposure indicator:** This icon appears when you're creating a multiple exposure.

>> **Flash compensation indicator:** This icon appears when you're controlling the output of a supported flash that is connected to the accessory shoe (see Chapter 11).

>> **Exposure compensation indicator:** This icon appears when you're using exposure compensation (see Chapter 9).

>> **Clock indicator:** This icon appears when the camera clock has been reset. This happens when the camera battery has not been inserted in the battery slot for an extended period of time, which causes the clock battery (which is independent of the camera battery) to discharge. When this icon appears, you'll have to reset the camera clock (see "Setting the date and time," earlier in this chapter) if the camera clock is incorrect.

>> **Bracketing indicator:** This icon appears when you're bracketing exposure.

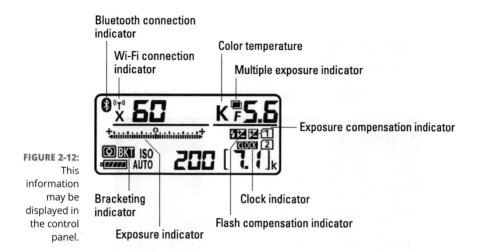

FIGURE 2-12: This information may be displayed in the control panel.

Labels around the figure:
- Bluetooth connection indicator
- Wi-Fi connection indicator
- Color temperature
- Multiple exposure indicator
- Exposure compensation indicator
- Bracketing indicator
- Exposure indicator
- Flash compensation indicator
- Clock indicator

>> **Exposure indicator:** This icon appears when you're manually setting exposure (see Chapter 9), using exposure compensation (see Chapter 9), using exposure bracketing (see Chapter 9) or flash bracketing (see Chapter 11), using white balance bracketing (see Chapter 10), or using Active D-Lighting (ADL) bracketing (see Chapter 12).

Using the Viewfinder

The viewfinder, or *information central* as I like to call it, is another place you find a plethora of information. In the viewfinder, you see the image as it will be captured by your camera plus information about camera settings, battery life, and so on. Your Nikon D780 has a viewfinder that enables you to see 100 percent of what you'll capture. Use the viewfinder to compose your picture and view camera settings while you change them.

Decoding what you see in the viewfinder

Figure 2-13 shows all the possible icons that can be displayed while taking a picture, as well as all the autofocus points — you never see this much information displayed while taking a picture. When you peer into the viewfinder, you find the current shooting settings, icons for battery status, shots remaining, and much more. By default, all the icons shown in Figure 2-13 are not visible until you use a menu command to display or hide information in the viewfinder.

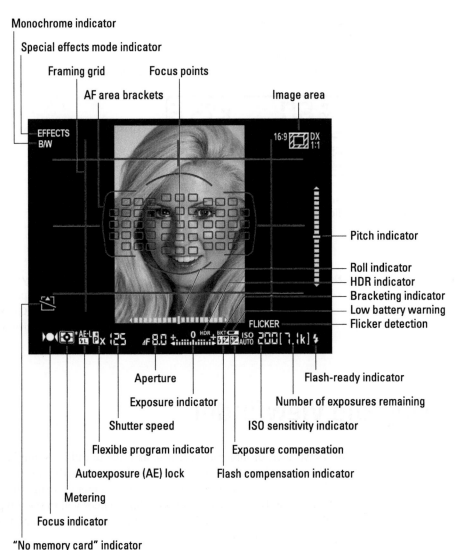

Monochrome indicator

Special effects mode indicator

Framing grid Focus points

AF area brackets Image area

EFFECTS
B/W

16:9 DX
1:1

Pitch indicator

Roll indicator

HDR indicator

Bracketing indicator

Low battery warning

FLICKER Flicker detection

Aperture

Exposure indicator

Shutter speed

Flexible program indicator

Autoexposure (AE) lock

Metering

Focus indicator

"No memory card" indicator

Flash-ready indicator

Number of exposures remaining

ISO sensitivity indicator

Exposure compensation

Flash compensation indicator

FIGURE 2-13:
The viewfinder
displays lots
of useful
information.

Here's the information that may be displayed in your viewfinder:

>> **Framing grid:** Displays a grid you use as a guide when composing your images. You enable the framing grid as a custom setting (see Chapter 14).

>> **Focus points:** Displays the focus points that will be used to focus on the subject. Figure 2-13 shows all 51 autofocus points and the autofocus frame.

>> **Image area:** This icon shows the currently selected image area option.

>> **Pitch indicator:** Functions as a pitch indicator when you turn the camera 90 degrees to shoot in "tall" (portrait) orientation. Pitching is tilting the camera up and down.

>> **Roll indicator:** Functions as a roll indicator when you turn the camera 90 degrees to shoot in "tall" (portrait) orientation. Rolling is tilting the camera left and right.

>> **Flicker detection:** This icon is displayed when you enable flicker reduction (see Chapter 11).

>> **"No memory card" indicator:** This icon appears when you don't have a memory card inserted in the camera.

>> **AF area brackets:** This icon displays the area in which the autofocus points appear and in which the points used to achieve focus are displayed.

>> **Monochrome indicator:** This icon appears when you shoot using one of the monochrome modes.

>> **Special effects mode indicator:** This icon appears when you shoot in special effects mode.

>> **Focus indicator:** When your subject is in focus, a white dot appears. If the camera is hunting for focus, you see a flashing left arrow and a flashing right arrow. If the focus point is in front of the subject, a steady right arrow appears. If the focus point is behind the subject, a steady left arrow appears.

>> **Metering:** This icon shows the currently selected metering mode.

>> **Autoexposure (AE) lock:** This icon appears when you use the AE-L button to lock exposure to a specific part of the frame.

>> **Flexible program indicator:** This icon appears when you shoot in programmed auto (P) mode and you use the main command dial to modify the shutter speed and aperture without altering the exposure value chosen by the camera.

>> **Shutter speed:** Displays the shutter speed that will be used to take the next picture. You can also use this information to manually set the shutter speed when shooting in shutter-priority auto (S) mode or manual (M) mode (see Chapter 9).

>> **Aperture:** Displays the f-stop that will be used to take the next picture. You can use this information to manually set the aperture when shooting in aperture-priority auto (c) mode or manual (M) mode (see Chapter 9).

>> **HDR indicator:** This icon appears when you shoot high dynamic range (HDR) images (see Chapter 12).

>> **Bracketing indicator:** This icon appears when you use exposure/flash bracketing, white balance bracketing, or ADL bracketing.

>> **Low battery warning:** This icon shows you the amount of charge left in your battery.

>> **ISO sensitivity indicator:** Displays the ISO currently being used or AUTO, which indicates you're shooting in auto ISO mode.

>> **Number of exposures remaining:** Displays the number of exposures that can be added to the card using the current settings. The number is followed by *k* when the amount of remaining exposures is more than 1,000. For example, 7.1k means approximately 7,100 exposures can be added to the card.

>> **Flash-ready indicator:** This icon indicates that the flash has recycled to full power and is ready for use (see Chapter 12).

>> **Exposure indicator:** This icon appears when you're manually setting exposure (see Chapter 9), using exposure compensation (see Chapter 9), using exposure bracketing (see Chapter 9) or flash bracketing (see Chapter 11), using white balance bracketing (see Chapter 10), or using Active D-Lighting (ADL) bracketing (see Chapter 12).

>> **Flash compensation indicator:** This icon appears when you're controlling the output of a supported flash that is connected to the accessory shoe (see Chapter 11).

>> **Exposure compensation:** This icon appears when you use exposure compensation (see Chapter 9).

Adjusting viewfinder clarity

If you wear glasses, or if your vision isn't perfect, you can adjust the viewfinder clarity, which makes it easier to compose your images and focus manually. After all, if what you see in the viewfinder isn't what you get, you won't be a happy camper.

To adjust viewfinder clarity, follow these steps:

1. **Attach a lens to the camera.**

2. **Look into the viewfinder and rotate the diopter adjustment control (see Figure 2-14) left or right until the autofocus points and shooting information look sharp and clear.**

Diopter adjustment control

FIGURE 2-14:
A clear
viewfinder. All
the better to
see you with,
my dear.

Introducing the *i* Menu

The *i* menu is an extremely useful tool. It gives you access to many features, enabling you to change settings to frequently used settings on the fly. There is a playback *i* menu, a still photography *i* menu, and a movie *i* menu. To access the *i* menu, press the *i* button on the back of your camera.

Figure 2-15 shows the still photography *i* menu. Note that an icon is selected (in this case, metering). When an icon is selected on an *i* menu, the settings can be changed. I discuss each *i* menu in detail in upcoming sections of the book.

FIGURE 2-15:
The still photography *i* menu.

Pressing the Info Button

The Info button is at the lower-left side of the back of the camera. When you press the Info button, information is displayed on the tilting monitor.

When you use the viewfinder to compose your images, pressing the Info button displays information such as shutter speed, aperture, number of exposures remaining, and battery life.

When you create images using live view, pressing the Info button displays shoot-ing information. Press the button again for a simplified display. Press it once more to show a histogram (if enabled in custom settings). Press it once more to view a virtual horizon.

When you create movies using live view, pressing the Info button will yield the same results as when creating images using live view.

IN THIS CHAPTER

» Making your lenses work for you

» Using memory cards

» Going the extra mile with your camera's battery

» Being good to your camera's sensor

» Getting accessories for your camera

» Cleaning your camera's body

Chapter **3**

Working with Nikon D780 Peripherals

P hotography is addictive! When you've got a great camera, you shoot lots of pictures, and you have choices. If you bought the Nikon D780 kit, you have a wonderful zoom lens with a wide focal range, enabling you to shoot everything from vast landscapes to portraits. But your photography fun doesn't have to stop there. You can buy more lenses and other goodies as the need arises or the whim strikes.

This chapter is all about working with lenses, memory cards, the battery, and the sensor, not to mention tricking out your camera with accessories galore. I end the chapter by showing you how to keep your camera clean.

Working with Lenses

The beauty of photographing with a digital single-lens reflex (DSLR) camera is that you can change lenses to suit your creative need.

REMEMBER

When you purchase lenses for your camera, make sure they're for the Nikon F mount. If you're graduating from a Nikon camera that uses Dx lenses, you can use those lenses on your D780, too.

TECHNICAL STUFF

Dx lenses are for cameras with a sensor smaller than a 35mm film negative. The D780 camera sensor is full frame, the same size as a 35mm film negative. When you use a Dx lens on a full-frame camera, the lens doesn't capture the full frame — it captures only a portion of it, which is the equivalent of zooming in.

If this is your first DSLR, read this section. Here I show you how to attach and remove lenses. I also explain the benefits of vibration reduction lenses and zoom lenses and show you how to use a lens hood. If you already know this stuff, you can skip this section and move onto something more interesting, like using a macro lens to photograph dust bunnies.

Attaching a lens

The beauty of a DSLR is that you can attach lenses with different focal lengths to achieve different effects. Your Nikon D780 accepts a wide range of lens, from super-wide-angle lenses to long telephoto lenses that let you fill the frame with objects that are far away.

To attach a lens to your camera, follow these steps:

1. **With the front of the camera facing you, twist the body cap to remove it.**

 If your camera already has a lens on it, you'll instead have to remove the lens currently on the camera by following the steps in the next section.

2. **Remove the rear cap from the lens you want to attach to the camera.**

3. **Align the white dot on the lens with the lens mounting mark on the camera body (see Figure 3-1) and gently insert the lens into the body.**

4. **Turn the lens counterclockwise until it locks into place.**

WARNING

Don't force the lens to twist. If it doesn't lock into place with a gentle twist, you may not have aligned it properly.

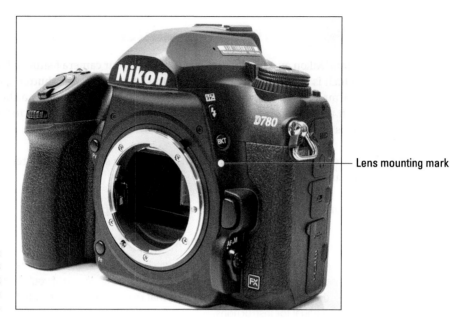

Lens mounting mark

FIGURE 3-1:
The lens
mounting mark
on the camera
body.

Removing a lens

Removing a lens and attaching another lens can be a bit of a juggling act. To remove a lens from your camera, follow these steps:

1. **Press the lens release button.**

The lens is unlocked from the camera.

2. **With the front of the camera pointed toward you, twist the lens clockwise about a quarter of a turn and then gently pull the lens out of the body.**

WARNING

To minimize the chance of dust getting on your sensor, always turn off the camera when changing lenses. If you leave the power on, the sensor has a slight charge that can attract dust floating in the air. For this same reason, don't change lenses in a dusty environment; if you do, dust may blow into your camera. I also find it's a good idea to point the camera body down when changing lenses. Dust on the sensor shows up as little black specks on your images, which isn't the look you're going for.

WARNING

Never store the camera without a lens or the body cap attached. If you do, pollutants may accidentally get into the camera, harming the delicate mechanical parts and possibly damaging the sensor.

Using a vibration reduction lens

Many Nikon and third-party lenses that fit your camera feature *vibration reduction*, which is a feature that enables you to shoot at a slower shutter speed than you'd normally be able to use and still get a crisp image. How slow a shutter speed you can use when employing vibration reduction depends on the focal length of the lens and how steady you are when handling the camera.

REMEMBER

When using a longer focal length, you need to shoot with a faster shutter speed to ensure a blur-free image.

To enable vibration reduction, follow these steps:

1. **Locate the VR switch on the side of your lens.**

 On Nikon lenses, you'll find the switch on the left side of the lens when the camera is pointed toward your subject (see Figure 3-2). If you're using a third-party lens, look for a switch that reads VR or IS, or refer to the lens manual for instructions.

VR switch

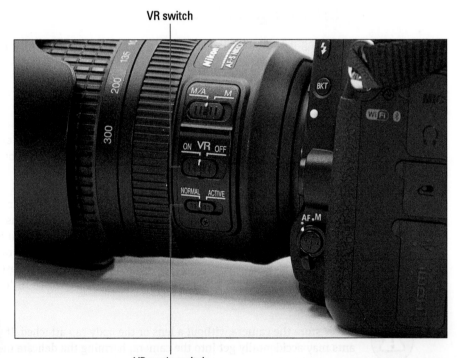

FIGURE 3-2:
The VR switch on a Nikon lens.

VR mode switch

2. **Push the VR switch to ON to enable vibration reduction.**

TIP

Vibration reduction uses the camera battery to compensate for operator movement. So, it's a good idea to turn off this feature when you need to conserve battery power and don't need vibration reduction.

Some lenses have two vibration reduction switches: one that stabilizes the lens in a horizontal and vertical plane, and another that stabilizes the lens when you pan to follow a moving object. Refer to your lens's instruction manual for more information.

3. **Use the VR mode switch to choose Normal or Active.**

You should leave it on Normal for most photography. Switch it to Active if you're shooting from a moving vehicle.

TIP

Always take a couple of pictures to determine if you need Normal or Active VR mode and if the shutter speed you're shooting at is fast enough to capture a sharp image. If your test images are blurry, try switching from Normal to Active and shoot a few more images. If they're still blurry, switch to a larger aperture (smaller f-stop number) or increase the ISO to be able to use a faster shutter speed.

WARNING

When using a tripod to stabilize the camera, disable vibration reduction; otherwise, the feature may actually *induce* image blur because it'll try to compensate for nonexistent camera motion.

Using a zoom lens

The kit lens that comes with the Nikon D780 has a focal length range from 24mm (wide angle) to 120mm (telephoto). You can purchase additional Nikon or third-party zoom lenses from your favorite camera supplier. Zoom lenses come in two varieties: the kind that you twist to zoom in or out, and the kind that you push or pull to zoom out or in.

To use a zoom lens with a barrel that twists to change focal length, follow these steps:

1. **Grasp the lens barrel with your fingers.**

2. **Twist the barrel to zoom in or out.**

To use a push/pull zoom lens, follow these steps:

1. **Grasp the lens barrel with your fingers.**

2. **Push the barrel away from the camera to zoom out and pull the barrel toward the camera to zoom in.**

Using a lens hood

Unless you're pointing the camera directly at a strong light source, a lens hood prevents unwanted light from shining on the lens and causing lens flare. Most lens hoods have a mark that you align with a mark on the end of the lens. Align the two marks and then, with the camera lens pointing away from you, rotate the lens hood counterclockwise until it locks into place. To remove a lens hood, rotate it clockwise. To store the lens and the lens hood in a camera case or camera bag, attach the lens hood in reverse.

Working with Memory Cards

Your camera has slots for two SD memory cards to store the pictures you take. (*SD* stands for *secure digital,* but nobody ever refers to them that way.) A *memory card* is a mechanical device similar to a hard drive. You insert a new memory card when you begin shooting and remove the card when it's full.

With two cards, you have many possibilities. For example, you can capture images in the NEF (RAW) format on one card, and the same images in the JPEG format on the other card (see Chapter 9). This option is handy if you shoot images that needed to be posted online quickly, but then processed to perfection at a later date.

To insert a memory card, follow these steps:

1. **Open the memory card slot cover on the right side of the camera as you look at it from the back.**

 To open the memory card slot cover, slide it away from the camera until it stops, and then rotate it away from the camera.

 Note there are two memory card slots.

2. **Insert the card in the desired slot.**

 As shown in Figure 3-3, the card label is facing you.

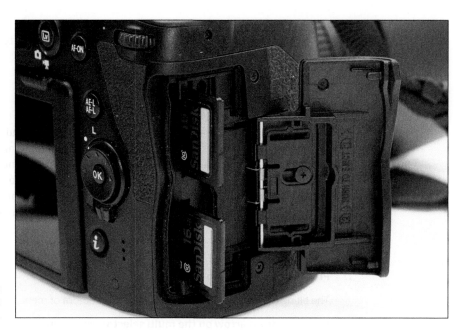

FIGURE 3-3:
Inserting a
memory card.

3. **Gently push the card into the slot.**

 Never force a memory card; forcing it may damage the pins in the camera and the card. The card should slide easily into the camera when aligned properly.

4. **If desired, insert a second card into the other slot.**

 Double your pleasure, double your fun.

5. **Close the memory card slot cover.**

 You're ready to shoot up a storm!

TIP

You may be tempted to pick up a couple of 128GB memory cards, thinking you can store a gazillion images on one card and not worry about running out of room. But memory cards are mechanical devices that are subject to failure — and they typically fail when you least expect it. If a large card fails, you may lose lots of images. I carry a couple 32GB memory cards in my camera bag. Although I hate to lose any images, I'd rather lose 32GB worth of images than 128GB worth. I recommend that you purchase smaller memory cards.

TIP

If your computer can't read a card, you may be able to recover the images with a data recovery program, which you can search for online. Many companies let you download a trial version of their data recovery program. It will let you recover and view images, but not save them. If the application enables you to view images after recovery, purchase the full version and you'll be able to download your precious

images to your computer. Unless a corrupt card is under warranty, throw it away after the data recovery application performs its magic.

Formatting a memory card

Remember back in the Jurassic era of photography when you had to remove film from a camera and send it off to be processed? I do. I know that dates me. But with a digital camera, after you download images to your computer and back them up, you format the card so you can use it again. A good idea is to format your cards before using them again, even if you didn't fill them. This simple step ensures that you'll have an empty card to work with and won't download duplicate images.

To format a memory card, follow these steps:

1. **Press the MENU button on the back of your camera.**

 The tilting monitor refreshes and you've got a plethora of menu choices.

2. **Press the down arrow on the multi selector, and navigate to the Setup icon that looks like a wrench.**

3. **Press the left arrow on the multi selector to highlight the Setup icon and then press the right arrow on the multi selector.**

 The tilting monitor refreshes and you're presented with setup options.

4. **Press the down arrow on the multi selector to highlight the Format Memory Card option (see Figure 3-4).**

5. **Press the right arrow on the multi selector to view the Format Memory Card options (see Figure 3-5).**

 Your options are to format the card in Slot 1 or Slot 2.

SETUP MENU	
Format memory card	---
Save user settings	--
Reset user settings	--
Language	
Time zone and date	--
Monitor brightness	0
Monitor color balance	--
Virtual horizon	--

FIGURE 3-4:
Formatting your memory card.

6. **Press the down arrow on the multi selector to select the slot that contains the card you want to format and then press the right arrow on the multi selector.**

 The tilting monitor refreshes, and a warning appears telling you all images on the card will be deleted. The default option is No (see Figure 3-6).

7. **Press the up arrow on the multi selector to highlight Yes and then press the OK button.**

An hourglass icon appears. When it disappears, your card is formatted and you're returned to the previous menu. You can now format the card in the other slot.

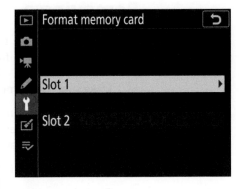

FIGURE 3-5:
Slot 1 or Slot 2. Decisions. . . .

TIP

To quickly format a card, simultaneously press the delete button (which has FORMAT written in red below it) and the ISO button (which has FORMAT written in red beside it) and hold until *For* appears in the control panel. Slot 1 is selected by default. Press the delete and metering buttons again, and the card is formatted. To format the card in Slot 2, press the delete and metering buttons again until *For* appears on the control panel, then use the main command dial to select Slot 2 and press the delete and metering buttons again to format the card in Slot 2.

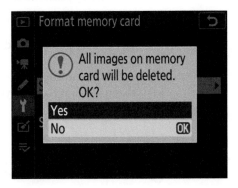

FIGURE 3-6:
To format or not to format, that is the question.

WARNING

SD cards are relatively fragile. Handle them with care and always store them in your camera or the little plastic doohickey that the card manufacturer supplied with the card. Never touch the card contacts with your fingers. Always grip the plastic part of the card when you handle it.

WARNING

Some image-editing applications may prompt you to format the memory card after downloading the images to your computer. Don't do it. Your Nikon D780 is the best way to format memory cards for photography.

Removing a memory card

When a memory card is full, remove it from the camera and insert a new one. To remove a memory card, follow these steps:

1. **Make sure the memory card access lamp is off.**

If the lamp is still illuminated, the camera is writing data to the card. If you power off your camera and remove the card before the lamp is off, you'll lose the data and you may corrupt the card.

2. **Turn the power switch to OFF.**

3. **Open the memory card slot cover by sliding it away from the camera until it stops, and then rotating it away from the camera.**

4. **Gently push the card.**

The card pops out of the slot.

5. **Gently pull the card out from the slot.**

You're now ready to insert a new card, format it, and start shooting, or download the images on the card you removed to your computer and then reinsert and format that card.

Taking Care of Your Camera Battery

The EN-EL15b battery in your Nikon D780 is a rechargeable lithium-ion battery that is engineered for a long life and, according to Nikon, enables you to capture more than 3,000 images when you shoot in JPEG format and use the camera in warm weather. The number of shots you can capture will be fewer if you record movies, shoot in live view, shoot in NEF (RAW) mode, or shoot in cold weather.

TIP

Here are some recommendations for getting the best performance from your camera battery:

>> **Remove the battery from the camera after you've finished shooting for the day.** The battery loses a bit of its charge if you store it in the camera.

>> **In cold conditions, place the spare battery in your coat pocket instead of in a camera bag.** This keeps it warm (because it's next to your body) and extends the life of the battery charge.

>> **Replace the battery immediately when you see the low battery warning.**
If you deplete the battery power completely when your camera is writing data
to the memory card, the card may be corrupted.

>> **Never remove the battery when the memory card access lamp is
blinking.** This indicates your camera is writing data to the card. Removing
the battery prematurely can damage the memory card and cause loss
of data.

>> **Beware of third-party batteries that fit your Nikon D780.** They may not be
compatible with your camera's battery information system, which means you
won't know how much charge remains in the battery. If the battery runs out of
charge while the camera is writing data to the memory card, you may damage
the memory card, the battery, or both. Batteries that don't work with your
camera typically come with their own charging units. Using a third-party
battery may also void your camera warranty.

When you notice the battery status icon is red, it's time to charge the battery. You
can recharge EN-EL15b batteries with the MH-25a battery charger supplied with
your camera. To recharge your camera battery, follow these steps:

1. Insert the battery into the
charger (see Figure 3-7).

2. Plug the battery charger into a
wall outlet.

If you live in North America, your
charger works in a 110-volt outlet.
If you travel overseas with your
camera, make sure you bring a
converter. If you insert the charger
into an outlet with the wrong
voltage, you'll ruin it.

After you plug the charger into the
wall outlet, an orange light on the
charger begins blinking. Unless
you have a spare battery for your
camera, grab a bite to eat, pet your
cat, or edit images. Recharging a
fully depleted battery takes about
2 hours and 35 minutes.

FIGURE 3-7:
Charging the battery.

3. **Continue charging the battery until the light stops blinking.**

 The battery has a 100 percent charge.

4. **Put the battery in the camera, or place the protective cover on it if you won't be using it for a while.**

Cleaning the Sensor

When you power on your Nikon D780, the sensor is automatically cleaned. The camera accomplishes this by vibrating the sensor to dislodge any dust particles. This works well, but sometimes stubborn particles of dust don't fall off the sensor with the automatic cleaning. You can, however, manually clean your sensor as outlined in the next section.

Cleaning your sensor on command

If you notice black specks in areas of your image that are one solid color, such as the sky, you have dust on your sensor. Your camera automatically cleans the sensor, but sometimes that's not enough. If you consistently see dust spots in the same area on several images, you'll be happy to know there's a menu command you can use to clean your sensor, whenever you feel the need, by following these steps:

1. **Press the MENU button.**

2. **Press the down arrow on the multi selector to navigate to the Setup icon, which looks like a wrench, and then press the left arrow on the multi selector.**

 The Setup icon is highlighted.

3. **Press the down arrow on the multi selector to highlight Clean Image Sensor (see Figure 3-8) and then press the right arrow on the multi selector.**

 The Clean Image Sensor options are displayed. Clean Now is selected by default (see Figure 3-9).

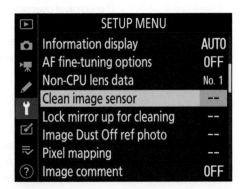

FIGURE 3-8:
From this menu, you get a squeaky clean sensor.

4. **Press the OK button.**

An hourglass icon appears while the sensor is being cleaned.

TIP

After the sensor has been cleaned, manually set the focus to the closest distance at which the lens will focus, and take a picture of the clear blue sky. Open the image in your image-editing program and zoom in to 100 percent magnification. Sensor dust shows as dark spots. If you have stubborn specks of sensor dust on your camera, you may have to clean the image sensor a couple of times to get it clean. If the dust is still there, you can manually clean the sensor (as outlined in the next section).

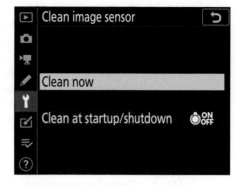

FIGURE 3-9:
Selecting this menu option cleans your sensor now.

Cleaning your sensor manually

Your camera has a self-cleaning sensor, and you can run a cleaning cycle whenever you want. However, a stubborn piece of dust may need to be removed manually.

To determine whether you have dust on your sensor, follow these steps:

1. **Switch to aperture-priority auto (A) mode and choose your smallest aperture (that's the largest f-stop number, like f/16 or f/22).**

For further information on using aperture-priority auto (A) mode and manually setting your aperture, see Chapter 9.

2. **Switch the lens to manual focus and set the focus to its nearest point.**

You want the sky to be out of focus. That way the dust specks will show up as black dots.

3. **Take a picture of a clear blue sky, download the picture to your computer, and review it in your image-editing program at 100 percent magnification.**

If you see black specks in the image, you have dust on your sensor.

The best way to clean dust off your sensor is to blow it off with a powerful bulb blower like the Giotto Rocket Air Blaster, shown in Figure 3-10. A good blower is made of natural rubber and features a small opening at the tip that enables you to direct a strong current of air with pinpoint accuracy.

WARNING

Never clean the sensor outdoors. Clean the sensor in a relatively dust-free environment, like your house or car.

To clean the sensor manually, follow these steps:

1. **Take the lens off the camera.**

2. **Press the MENU button.**

 The camera menu is displayed on the tilting monitor.

3. **Press the down arrow on the multi selector and navigate to the Setup icon, which looks like a wrench, and then press the left arrow on the multi selector to highlight the icon.**

4. **Press the right arrow on the multi selector to view the setup commands, and then press the down arrow on the multi selector to highlight Lock Mirror Up for Cleaning (see Figure 3-11).**

5. **Press the right arrow on the multi selector.**

 The Start command is displayed (see Figure 3-12).

6. **Press the OK button.**

 The camera mirror locks in the up position.

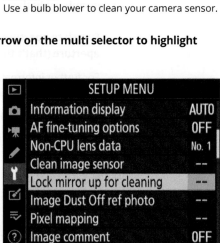

FIGURE 3-10:
Use a bulb blower to clean your camera sensor.

SETUP MENU

Information display	AUTO
AF fine-tuning options	OFF
Non-CPU lens data	No. 1
Clean image sensor	--
Lock mirror up for cleaning	--
Image Dust Off ref photo	--
Pixel mapping	--
Image comment	OFF

FIGURE 3-11:
This command locks the mirror up for sensor cleaning.

7. **Point the camera at the floor and place the air blower inside the sensor chamber, being careful not to touch the sensor.**

When you point the camera at the ground, any dust you dislodge off the sensor falls to the ground. Gravity works.

WARNING

Be careful not to touch the sensor with the blower. I use a black Sharpie to make a spot 1 inch away from the tip of the blower. As long as I can see the spot I've marked, I know the blower won't touch the sensor.

	Lock mirror up for cleaning
	Start
	When the **OK** button is pressed, the mirror lifts and the shutter opens. To lower the mirror, turn the camera off.

FIGURE 3-12:
Lock me up and clean me.

8. **Squeeze the bulb repeatedly.**

When you squeeze the bulb, move the blower around so the blast of air hits all areas of the sensor. This increases your chances of getting rid of all the dust.

9. **When you've finished blowing dust off the sensor, set down the blower and then power off the camera.**

When you flip the power switch to OFF, the mirror closes. Make sure you put a lens on the camera or a body cap on the camera immediately. After thoroughly cleaning the sensor, you don't want dust getting back in the chamber.

WARNING

Never touch the sensor with the blower. And never use a blower with a CO_2 cartridge. CO_2 cartridges contain propellants that can foul your sensor.

Modifying sensor cleaning

When you start the camera, the sensor vibrates to shake any dust off the sensor. You can modify when sensor cleaning occurs or disable sensor cleaning altogether. Whatever you do, don't turn off the automatic sensor cleaning — it's important to keeping your sensor clean, and there's really no reason to turn it off.

To modify sensor cleaning, follow these steps:

1. **Press the MENU button.**

2. **Press the down arrow on the multi selector to navigate to the Setup icon, which looks like a wrench, and then press the left arrow on the multi selector.**

The Setup icon is highlighted.

3. Press the right arrow on the multi selector to view the setup commands.

4. Press the down arrow on the multi selector to highlight Clean Image Sensor (refer to Figure 3-8) and then press the right arrow on the multi selector.

The sensor cleaning options are displayed. Clean Now is selected by default (refer to Figure 3-9).

5. Press the down arrow on the multi selector to highlight Clean at Startup/Shutdown (see Figure 3-13), and then press the right arrow on the multi selector.

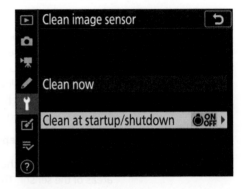

The Clean at Startup/Shutdown options are displayed (see Figure 3-14).

6. Press the down arrow or up arrow on the multi selector to select one of the following options:

FIGURE 3-13:
Choosing a sensor cleaning option.

- *Clean at Startup:* The sensor vibrates to remove dust at startup.

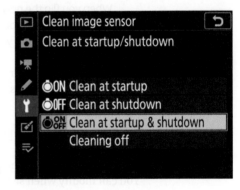

- *Clean at Shutdown:* The camera shakes dust off the sensor when you power off the camera.

- *Clean at Startup & Shutdown:* The camera vibrates the sensor when you power on the camera and again when you power off the camera. This option uses more battery power but ensures a squeaky clean

FIGURE 3-14:
Choosing when the sensor is cleaned.

sensor, especially if you've changed lenses frequently during a photo shoot.

- *Cleaning off:* Automatic sensor cleaning is disabled. Don't choose this option. Just don't.

7. Press the OK button.

The sensor cleaning option you've chosen is in effect.

The sensor chamber of your camera is lubricated. Sometimes lubricant can get on the sensor and cause a spot to appear on your images. If conventional methods of cleaning the sensor don't work, send the camera to Nikon for sensor cleaning, or to a local camera shop that offers this service. If you're brave, you can try cleaning the sensor yourself (see the nearby sidebar), but do this at your own risk: If you muck up your sensor, you'll face a huge repair bill — way more than the cost of paying a professional to clean the sensor for you.

Keeping your sensor clean

The best way to *keep* your sensor clean is to never change a lens. However, this defeats the purpose of a DSLR. If you're meticulous about changing lenses, and you follow a bit of sage advice, you can keep your sensor as squeaky-clean as possible.

I first learned about sensor dust when I had my first DSLR. I was on a business trip/vacation to California. When I was reviewing some images I had shot of the Golden Gate Bridge, I noticed some horrible dust specks on the images. You guessed it: dust on the sensor, lots of dust.

TIP

Since those early days, I've learned that doing the following minimizes the chances of dust adhering to the sensor:

>> **Power off the camera before changing lenses.** If you leave the power on, the sensor maintains a charge that can attract dust.

>> **Never change lenses in a dusty environment.** If you're photographing in a dry, dusty environment, find a sheltered area in which to change lenses. When all else fails, the inside of your car is a better place to change lenses than a dry, dusty area.

>> **Never change lenses when it's windy.** In windy conditions, find a sheltered environment in which to change lenses.

>> **Point the camera down when changing lenses.** This minimizes the chances of dust blowing into the sensor.

>> **Have the other lens ready.** When I change lenses, it's a juggling act. I keep the lens I'm going to put on the camera in one hand with the rear cap off. I point the camera at the ground and grasp the lens I'm going to remove with one hand, and press the lens release button with a finger from the other hand. Then I quickly remove one lens and replace it with the other. With practice, you can do this quickly and minimize the chance of dust fouling your sensor.

USING SENSOR CLEANING EQUIPMENT

If you're a do-it-yourself (DIY) kind of photographer, you may want to consider cleaning your sensor with commercially available products. Lots of products — brushes, swabs, and chemicals — that you can use to manually clean the camera sensor are on the market. Yes, that does mean you physically touch the sensor with something. Therefore, the product you choose needs to be made from material that can't scratch the camera sensor. You must also have a *very* steady hand when using these products.

I've used sensor-cleaning products manufactured by VisibleDust (www.visibledust.com). VisibleDust manufactures the Quasar Plus Sensor Loupe, which you place over the lens opening to examine the sensor for any visible dust — hence, the company name. The loupe is made of glass and makes it easy to see any specs of dust on your lens. VisibleDust also manufactures the Arctic Butterfly Sensor Brush, which runs on two AAA batteries and illuminates the sensor, making it easier to control the brush.

I've used both products with a good outcome on my cameras. For more information, visit www.visibledust.com or ask your favorite camera retailer for information.

Accessorizing Your Nikon D780

Your Nikon D780 is a mechanical and technological masterpiece. The camera comes with a nice cardboard box, which is great for shipping the camera, but not so great for storing the camera on a day-to-day basis. And the camera ships with this nice strap that tells the world you're shooting with a Nikon D780, but the strap is thin — and with a long telephoto lens, it will feel like you're carrying a brick around your neck. So, first and foremost, you need a decent camera case and a good strap. There are lots of other goodies you can invest in that will make using your camera more enjoyable. This section has you covered.

Nikon accessories

Nikon sells lots of goodies in its online store that may also be available from other sources such as your local camera retailer or your favorite online camera store. Here are a few items you may want to put on your wish list:

>> **An extra EN-EL15b battery:** If you shoot lots of pictures, having an extra fully charged battery in your camera bag can save the day.

>> **HC-E1 HDMI cable:** Use this cable to view images and movies on your TV monitor.

>> **Speedlight:** The following Nikon Speedlights are compatible with your D780:

- SB-5000 AF Speedlight
- SU-800 Wireless Speedlight Commander
- SB-700 AF Speedlight
- SB-500 AF Speedlight
- SB-300 AF Speedlight
- SB-R200 Wireless Speedlight
- R1 Wireless Close-Up Speedlight System
- R1C1 Wireless Close-Up Speedlight System

>> **Microphones:** If you record lots of movies, an external microphone will give you better sound quality than the built-in stereo microphone. The following Nikon microphones are compatible with your D780:

- ME-1 Stereo Microphone
- ME-W1 Wireless Microphone

>> **Eyepieces and viewfinders:** Nikon makes eyepieces with built-in optics that will make it easier for you to view the viewfinder without glasses. It also offers a 90-degree viewfinder, which is a handy option if you shoot with the camera mounted on a tripod and close to the ground.

>> **Remote controllers:** You can find the following remote controllers on Nikon's website:

- WR-R10 Wireless Remote Controller

- WR-R10 Wireless Remote Controller (transceiver)

- WR-T10 Wireless Remote Controller (transmitter)

- WR-1 Wireless Remote Controller

- MC-DC2 Remote Release Cord

>> **WT-7A Wireless Transmitter:** You use this device to transfer or view image files and control certain functions of the camera.

More accessories may become available in the future. To view all Nikon accessories compatible with your Nikon D780, go to www.nikonusa.com/en/nikon-products/product/dslr-cameras/d780.html#tab-ProductDetail-ProductTabs-System.

Third-party accessories

Nikon makes great accessories for your D780, but you'll need other accessories, too, such as tripods, camera cases, camera bags, and more. Nikon offers some of these accessories, but I've been at this photography game for some time and I offer the following list for your consideration:

TIP

>> **Camera strap:** This is the first item I suggest you buy. In fact, I suggest you don't ever use the strap that came with the camera. Leave it in pristine condition in its little plastic bag. Then, if you ever decide to sell the camera on eBay, you can offer it for sale with an unused camera strap.

I recommend a sling strap such as those offered by Carry Speed (www.carryspeed.com) or BLACKRAPID (www.blackrapid.com). A sling strap distributes the weight of the camera and lens over your shoulder and places the camera at your hip. If you shoot for long periods of time and with long lenses, a comfortable camera strap is a must-have accessory. When you need to use your camera, you can quickly grab it from your side and bring it to your eye. The Carry Speed strap features a mounting system that doesn't let the strap touch the camera, which could possibly mar the finish. Another great thing about the Carry Speed strap is the actual strap: It's wide and has a neoprene backing, which holds the strap in place.

>> **Camera case:** If you end up purchasing lots of accessories for your camera (such as additional lenses, additional batteries, and so on), you'll need a place for your stuff. A hard-shell camera case is the ideal place to store your gear when you're not using it. Pelican (www.pelican.com) makes a wide variety of cases that you can customize to fit your gear. NANUK (www.nanukcase.com) also sells a line of customizable hard-shell cases. I own both and can vouch for their quality.

>> **Camera bag:** A camera bag is a place to put your stuff when you're out on a photo shoot. If you don't own a lot of gear, you can get by with a small camera bag. However, if you do end up owning a lot of gear, plus the obligatory kitchen sink, you'll need one bag that can hold lots of stuff, or perhaps two bags: one that will hold most of your gear and accessories, and a smaller bag to use when you're going commando (shooting with just your camera, one or two lenses, and a minimum of accessories).

Before you buy a camera bag, try it on for size and make sure it's comfortable. Purchase a sturdy camera bag from which you can quickly access your most frequently used gear.

My favorite bags are in the Retrospective series (shown at the top of Figure 3-15) and Street Walker series (shown at the bottom of Figure 3-15), both made by Think Tank Photo (www.thinktankphoto.com). The bags are made of durable material, have zippers that don't jam, and lots of hidey holes for your accessories. Lowepro (www.lowepro.com) also makes a good camera bag.

A rain hood is another good option to look for when purchasing a camera bag. Rain and digital equipment are like oil and water; they don't mix.

>> **Tripod:** If you shoot landscapes or high dynamic range (HDR) images, create time-lapse movies, record video, or shoot in low light, a tripod is a useful accessory. A tripod steadies your camera when you shoot at slow shutter speeds. When you shoot with a tripod, you'll also want a remote-control device to trigger the shutter (see the preceding section).

When you purchase a tripod, buy a device that will support the weight of your camera body plus the heaviest lens you anticipate purchasing or using. Then add 50 percent to that figure. If you purchase a tripod that will only handle the weight of your camera and its heaviest lens, you'll run into an issue known as *tripod creep,* which is when the tripod slowly sinks, resulting in blurry images when you shoot at slow shutter speeds.

You also need a sturdy tripod when photographing in windy conditions. Most tripods have a hook underneath the tripod head to which you can attach a sand bag, which helps steady the tripod in windy conditions.

Photographs courtesy of Think Tank Photo

FIGURE 3-15:
A comfortable
camera bag
is a must for
any serious
photographer.

You also have to consider the weight of the tripod. If you use your car as a base of operations, or photograph in studio conditions, tripod weight isn't that much of a factor. But if you photograph wildlife and nature and do a lot of hiking, lugging a heavy tripod will quickly wear you out. If this is the case, consider purchasing an aluminum or carbon-fiber tripod. I purchased a carbon-fiber tripod as a gift for my girlfriend and she loves it. The tripod will support her camera plus a 400mm lens. The light weight makes it possible for her to hike several miles with the tripod and a camera bag in absolute comfort.

Another useful option for a tripod is a built-in spirit level. Even though your camera has a built-in virtual horizon, sometimes it's easier to take a quick look at the tripod.

A good tripod head is also a must. If you can afford a lightweight tripod with a ball head, you'll have everything you need to capture blur-free photos with ease.

>> **Accessory-shoe level:** This is yet another way of making sure your camera is straight. Sometimes I like to shoot from a low vantage point, but I don't feel like being prone on the ground. When I run into this scenario, I use a small dual-axis bubble level that slides into the camera's accessory shoe.

TIP

Even though your camera has a built-in virtual horizon, it will be hard to use in scenarios like this.

» **Extra memory cards:** Memory cards are cheap. Buy a couple of extra SD cards so you have a fresh card when you're photographing your favorite place or a place you've never been to before.

» **Lens cleaning kit:** Purchase a microfiber cloth that is designed to clean optical equipment. You can also purchase lens cleaning fluid to use in conjunction with your microfiber cloth.

» **LCD protector:** Your tilting monitor is a vulnerable part of your camera. It can be chipped or otherwise damaged. Consider purchasing a screen to protect your tilting monitor from damage.

Video accessories

Video is a whole different kettle of fish. DSLRs were not designed to capture video, so they're not user-friendly for videographers, but on the other hand, DSLRs can capture incredible video that rivals conventional video cameras. Here are a few options to consider if you're going to create video with your Nikon D780:

» **Tripod:** Review the information about tripods in the preceding section. You can use the same tripod for still images and video. The only difference will be that you'll need to purchase a fluid ball head like the Manfrotto 504HD Fluid Video Head. When you purchase a video head, make sure it supports the weight of your camera body, plus the heaviest lens you anticipate using for shooting video; then add 50 percent to that number.

» **Video shoulder rig:** In addition to shooting from a tripod, you can shoot video using a rig that mounts the camera on your shoulder, or you can purchase a device that will hold the camera steady — also known as a Steadicam — while you move. There are lots of rigs available in all different price ranges. My advice is to get one you can afford and that will hold your camera steady. This may involve considerable research. I don't personally own a video rig, so I'm not in a position to make a recommendation. However, if you visit an online camera store like B&H Photo (www.bhphotovideo.com) or Adorama (www.adorama.com), look at the various models that are available. If there are reviews posted by users, read them. When you've narrowed it down to a couple of devices, call the camera store and ask them for their opinions, or take your camera to your favorite local camera shop and try a couple to determine which one is best suited for your needs.

» **Video viewfinder:** When you shoot video with your Nikon D780, the tilting monitor is your viewfinder. However, the tilting monitor can be difficult to view in bright light. So, a video viewfinder is a useful accessory. Hoodman

(www.hoodmanusa.com) makes an affordable video viewfinder called the HoodLoupe 3.2, which fits the tilting monitor on your D780. You can combine this with a kit called HoodLoupe Mounting Cords that will mount the HoodLoupe to your camera to create a fairly inexpensive video viewfinder.

» **High-speed memory card:** When you capture video with your Nikon D780, your camera is capturing video at a rate from 24 to 60 frames per second (fps) in regular mode, or up to 120 fps when creating a slow-motion video. A standard memory card may not be able to keep up with the fast frame rate. For video, it's recommended that you use a card with a data-transfer rate of 170 Mbps. SanDisk (www.sandisk.com) offers a memory card series called Extreme Pro that is ideal for capturing video.

Keeping the Camera Body Clean

You've invested a considerable amount of money in your Nikon D780 and accessories. To maintain your investment, and to keep the camera in top operating condition, you need to take care of your purchase. As mentioned earlier, you can clean your lenses with a lens cleaning fluid and microfiber cloth. However, you should never use a solvent on your camera body.

TIP

When you want to clean your camera body, wet a soft cloth and then wring it almost dry. Gently rub the cloth over the camera body to remove any residue from skin oil or airborne pollutants. Some areas of your camera (such as the multi selector) have ridges that are traps for dirt and debris from your skin. You can clean these areas with a soft dry toothbrush (skip the toothpaste!). It's also recommended that you clean your camera body with a soft, almost-dry cloth whenever you're photographing near the ocean when there's a salty mist in the air.

WARNING

Digital cameras and moisture are like oil and vinegar. If you're going to shoot in the rain or heavy fog, consider purchasing a rain hood that protects the camera and lens (see "Third-party accessories," earlier in this chapter). In a pinch, you can use a clear plastic bag big enough to cover camera and lens. Poke a hole for the lens and use a rubber band to secure the bag to the lens. Cut a small hole for the viewfinder, and use gaffer tape (it's like duct tape, but it can be removed easily) to secure the plastic bag to the area around the viewfinder. Finally, if you're going to that much trouble to shoot during inclement conditions, don't leave home without a good poncho.

IN THIS CHAPTER

» Using camera menus

» Capturing your first image

» Using Picture Controls

» Seeing how exposure and focal length affect your images

» Setting the focus

» Being part of the picture with the self-timer

Chapter **4**

Automatically Capturing Great Photographs

The Nikon D780 is definitely *not* a point-and-shoot camera. You can use your smartphone if all you want to do is point and shoot. However, you may still want to quickly capture an image with your D780. If so, you'll be happy to know that there are some things you can do automatically to make your fancy Nikon behave like a point and shoot. If this is your first time using the Nikon D780, or your first time using a Nikon camera, creating pictures automatically will familiarize you with the plethora of buttons and dials and menus, oh my.

If you're an experienced photographer, breeze through this chapter and you can show someone else how to create great pictures with your high-tech camera — that is, if you can part company with it long enough to allow someone else to use it.

Ordering from Your Camera Menu

Some of your picture-taking tasks involve using the camera menu. For example, when you format a memory card, you use the menu. You also use the menu to specify image size and quality, as well as set the parameters for tasks, such as creating stunning photos using Active D-Lighting and high dynamic range (HDR). I give you a brief introduction to the camera menu in Chapter 3, where I show you how to format a memory card and change the date and time. In this section, I give you a brief overview of the menu system. Throughout this book, I show you how to use the menu to perform specific tasks.

Using the multi selector

The multi selector (see Figure 4-1) is a very important tool, one that you use frequently to select menu items, highlight menu icons, and navigate from one menu command to another. You use the multi selector with the OK button to access menu items and invoke menu commands.

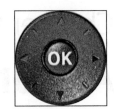

FIGURE 4-1:
The multi selector is a multifaceted workhorse.

The multi selector has the following parts:

>> **Left arrow:** The left arrow is used to highlight a menu icon and to navigate to the left when a submenu has multiple choices, such as when setting the date or time.

>> **Up arrow:** The up arrow is used to select the desired menu option and to highlight a menu option. It's also used to increase a value (for example, when setting the camera clock to the hour of the day). When you see an up arrow in a menu option, you use the multi selector up arrow to increase the value.

>> **Right arrow:** The right arrow is used to position the cursor in the selected menu and to display options for a selected menu.

>> **Down arrow:** The down arrow is used to select the desired menu option, to highlight a menu option, or to decrease a numeric value. When a down arrow is displayed in a menu option, you use the multi selector down arrow to decrease the value.

>> **OK button:** The OK button is used to select a highlighted option or to apply a menu command.

Using the keyboard

The keyboard (see Figure 4-2) is used when creating a copyright, changing a folder name, changing image names, and so on. To enter text with the keyboard, follow these steps:

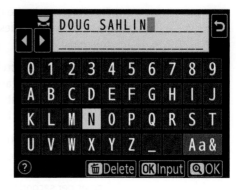

FIGURE 4-2:
The Nikon D780 keyboard.

1. **Use the multi selector arrows to navigate to the desired letter on the keyboard.**

 The selected letter is highlighted.

2. **Press the OK button.**

 The letter appears in the area at the top of the keyboard.

3. **Repeat Steps 1 and 2 to add additional text to the text display area.**

TIP

Here are some tips for working with the keyboard:

>> To switch from uppercase to lowercase or to add a symbol to the text, use the multi selector to move the cursor to the keyboard selection area at the lower-right side of the keyboard, and press OK until the character set you need is displayed.

>> To move the cursor left or right in the text display area, rotate the main command dial.

>> To delete the letter under the cursor in the text display area, press the delete button (it looks like a trash can).

>> To complete a text entry, press the zoom in/QUAL button.

>> To exit without making an entry, press the MENU button.

Using the menu

When you need to change camera options, format memory cards, and so on, you use a menu command. To access the camera menu, follow these steps:

1. **Press the mode dial lock release and then rotate the mode dial to P (see Figure 4-3).**

 This is programmed auto (P) mode. Most of the menu commands are available with this mode.

2. **Press the MENU button.**

The tilting monitor refreshes and you can access the desired menu command.

3. **Use the multi selector (refer to Figure 4-1) to navigate to a menu option, view the submenu, select an option, and put it into effect.**

For the purpose of this tutorial, I'll show you how to use the multi selector to specify how many frames per second the camera captures in continuous low speed, which occurs when you select CL from the release mode dial. (Continuous low speed is explained in detail in Chapter 9.)

4. **Press the down arrow on the multi selector until the Custom Setting option is selected.**

5. **Press the left arrow on the multi selector to highlight the option, then press the right arrow on the multi selector to place the cursor inside the menu (see Figure 4-4).**

In this case, the a1 AF-C Priority Selection option is selected.

6. **Press the down arrow on the multi selector to highlight d1 CL Mode Shooting Speed (see Figure 4-5).**

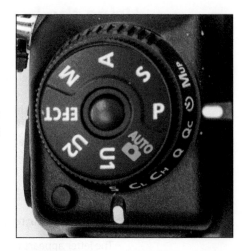

FIGURE 4-3:
Use the dial to select a shooting mode.

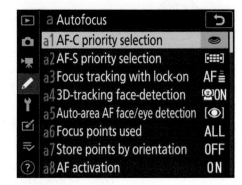

FIGURE 4-4:
Use the right arrow to place the cursor inside a menu.

7. **Press the right arrow on the multi selector to view the d1 CL Mode Shooting Speed options (see Figure 4-6).**

8. **Press the up arrow on the multi selector to increase the number of frames captured per second in continuous low speed mode; press the down arrow on the multi selector to decrease the number of frames captured per second in continuous low speed mode.**

9. **Press OK.**

The option will be in effect until the next time you access this option and change the setting.

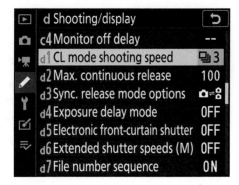

FIGURE 4-5:
Use the down arrow to select the desired menu option.

Now that you're up to speed with using a menu item, here's an overview of each menu you see after pressing the MENU button and what can be accomplished with the many options in each menu:

>> **Playback menu:** The playback menu has commands you use to manage your images. From this menu, you can delete multiple images, specify the playback folder, copy images, choose image review options, create a slideshow, rate images and more.

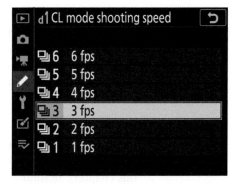

FIGURE 4-6:
Use the right arrow to view the options for the selected item.

>> **Photo shooting menu:** The photo shooting menu has commands you use to create storage folders; rename images; specify options for shooting with two cards; and specify image area, image quality, and image size. In addition, you use this menu to enable RAW shooting, set ISO sensitivity, set white balance, choose Picture Control, enable Active D-Lighting, set HDR options, create time-lapse movies, and more.

>> **Movie shooting menu:** The movie shooting menu goes a long way toward making you the next Steven Spielberg. In this menu, you specify frame size, frame rate, movie quality, file type, microphone sensitivity, and more.

>> **Custom Settings menu:** The Custom Settings menu is used to customize menus; assign functions to programmable buttons; and choose metering options, shooting and monitor options, and much more.

>> **Setup menu:** The setup menu has commands you use to format memory cards; set language, time zone, time, and date; enable the virtual horizon; clean the image sensor; add comments to images; add copyright information to images; and more.

>> **Retouch menu:** The retouch menu has commands you use to retouch images in your camera. From this menu, you can resize images, straighten images, correct perspective, and more.

>> **My Menu:** My Menu enables you to create a custom menu of frequently used commands.

Taking Your First Picture

You can easily get great results with your Nikon D780 automatically. In Auto mode, all you have to do is compose the picture, focus, and press the shutter-release button. The camera takes care of everything else. You don't have to mess with choosing the shutter speed, aperture, ISO, or anything else for that matter. The camera meters the amount of light coming into the camera and makes every decision for you.

When you're shooting in Auto mode, the camera chooses the Picture Control deemed ideal for the subject matter (for more information about manually choosing a Picture Control, see the upcoming "Choosing a Picture Control" section of this chapter). In Auto mode, the camera chooses the shutter speed, aperture, and ISO used to create the image. The camera chooses a shutter speed and aperture to ensure a properly exposed image (see "Understanding Exposure and Focal Length" later in this chapter) and the ISO, which is determined by the amount of available light. When you're taking pictures in dim lighting or at night, the camera will attempt to choose a shutter speed that ensures a blur-free image (see the sidebar "Shutter speed and image sharpness" later in this chapter). If the shutter speed is too slow, you need to mount the camera on a tripod to ensure a blur-free image.

Depending on the lighting conditions, the camera may have to increase the ISO, which makes the camera more sensitive to light. An ISO above 2,000 may result in digital noise in the darker areas of the image. When you shoot in Auto mode, the camera also determines the aperture, which, combined with the focal length of the lens you're using, determines how much of the image is in apparent focus from front to back.

When you unpacked your camera and started exploring the controls, you probably noticed the mode dial on the upper-left side of the camera as you looked at it from behind — the same position from which you take pictures. The default setting for this dial is Auto, which of course, is short for *automatic*. To take a photograph automatically, follow these steps:

1. **Insert at least one memory card in the camera, power on the camera, format the card, and then attach a lens to the camera.**

 If you're not familiar with inserting or formatting a memory card or attaching a lens to the camera, check out Chapter 3.

2. **If you're using a lens with vibration reduction, move the switch on the lens to VR.**

 If you bought the camera kit with the 24–120mm lens, you'll find this switch on the left side of the lens with the camera in front of you.

3. **Make sure the lens is set to M/A.**

 Most Nikon lenses have an M/A switch on the left side of the lens when the camera is pointed toward your subject. This means you can switch from automatic focus to manual focus by twisting the lens focusing ring. If the switch is set to M, manual focus is your only option.

4. **Press the mode dial lock release and then rotate the mode dial to the Auto setting.**

5. **Look through the viewfinder and compose your scene.**

 When you look through the viewfinder, you'll have a clear, uncluttered view of the subject matter in front of the camera as captured by the lens.

6. **Press and hold the shutter-release button halfway.**

 The camera achieves focus and a bunch of small rectangles appear in the viewfinder. These are the points the camera uses to focus based on the information the camera gathers through the lens. In essence, the camera looks for objects with well-defined edges. You can customize the way the autofocus system works to suit your style of photography when shooting in one of the non-automatic modes (see Chapter 10).

TIP

 Make sure your subject is under one of the autofocus squares. If you're photographing a person, you can compose the image so that the person is or isn't centered in the frame. If you want to get artsy-fartsy and place your subject on the left or right side of the frame, I show you how to do that in "Focusing on an off-center subject," later in this chapter. When your camera achieves focus, a white dot appears on the lower-left side of the viewfinder and the camera beeps. If the camera can't achieve focus, a flashing right or left arrow is displayed, which means focus is in front of or behind your subject.

When this occurs, switch to a single autofocus point (see "Focusing on an off-center subject," later in this chapter). If you see a left-pointing and right-pointing arrow, the camera can't achieve focus, which is a rare occurrence with 51 — count 'em — 51 autofocus points when shooting through the viewfinder, or a staggering 273 autofocus points when shooting in live view mode. If your camera can't achieve focus, switch to manual focus (see "Focusing manually," later in this chapter). The autofocus points that the camera uses to focus on your subject are also illuminated (see Figure 4-7).

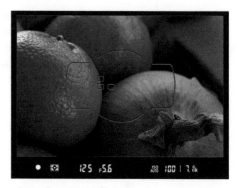

FIGURE 4-7:
Taking your first picture.

On the control panel on the upper-right side of the camera and in the viewfinder, you see the shutter speed, aperture, and ISO the camera is using for the picture. If the light is too dim and the camera can't achieve focus, you have to manually focus to capture the image. If the shutter speed is too slow to take a blur-free picture, a warning appears in the viewfinder and control panel.

7. **Press the shutter-release button fully.**

 The camera takes the picture.

WARNING

 When the camera records data to the memory card, the memory card access lamp illuminates. Do *not* turn off your camera while the light is on. If you do, the image won't be recorded to the memory card. Powering off the camera while the memory card access lamp is illuminated may also damage the memory card, the camera, or both.

8. **Review the image on the tilting monitor.**

 You can view other information regarding the image on your tilting monitor. You can view exposure information, a histogram, and much more.

In most situations, you get a beautifully exposed image with Auto mode. If, however, you're photographing a scene with tricky lighting conditions or a fast-moving object, the image may not be to your liking. Or maybe now that this brief tutorial has given you a taste of the camera's brilliance, you want to move on and get the most out of your camera. If so, head to Chapters 9, 10, and 11.

Choosing a Picture Control

When you shoot in programmed auto (P), shutter–priority auto (S), aperture–priority auto (A), or manual (M) mode, you can choose one of the following Picture Controls:

» **Standard:** The camera uses standard processing, which works well for most situations.

» **Neutral:** The camera applies minimal processing for balanced results. The mode is recommended for most situations.

» **Vivid:** The camera increases saturation of primary colors for a vivid image.

» **Monochrome:** The camera produces a black-and-white photograph.

» **Portrait:** The camera softens complexions and wrinkles. This mode is recommended for shooting portraits of your loved ones.

» **Landscape:** The camera enhances colors and produces sharp images of landscapes, foliage, and urban scenes. This mode is perfect when shooting landscapes or cityscapes.

» **Creative Picture Control:** The camera offers 20 different Creative Picture Controls, which offer a unique combination of hue, saturation, and other options. With Creative Picture Control, you can create spectacular images. The Creative Picture Control options are as follows:

- Dream
- Morning
- Pop
- Sunday
- Somber
- Dramatic
- Silence
- Bleached
- Melancholic
- Pure
- Denim
- Toy
- Sepia

- Blue

- Red

- Pink

- Charcoal

- Graphite

- Binary

- Carbon

TIP

Experiment with the different Picture Controls to get an idea of the type of images you can create with this tool. When you use a Picture Control to create an image, the camera gives you a JPEG image. The camera does *not* apply picture controls to NEF (RAW) images. To see the type of image the camera delivers with each Picture Control, take a photo walkabout to one of your favorite places and shoot images with each Picture Control. Just remember that the Picture Control used to create an image is not recorded with the image metadata, so you'll want to make a note of which image you photographed with which Picture Control.

In Figure 4-8, the image on the left was created using the Standard Picture Control, and the image on the right was created with the Binary Creative Picture Control. In Figure 4-9, the image on the top was photographed using the Pink Creative Picture Control, and the image on the bottom was photographed using the Carbon Creative Picture Control.

FIGURE 4-8:
The Standard Picture Control (left) versus the Binary Creative Picture Control (right).

FIGURE 4-9:
The Pink
Creative
Picture Control
(top) versus
the Carbon
Creative
Picture Control
(bottom).

Creating images with a Picture Control

Picture Controls are yet another tool for a creative photographer. As noted in the preceding section, you have lots of Picture Controls from which to choose. Creating a unique picture of a place, person, or thing you love is as easy as choosing a Picture Control from the menu. *Remember:* The camera only applies Picture Controls to JPEGs.

To create images with a Picture Control, follow these steps:

1. **Press the mode dial lock release, and rotate the mode dial to the desired shooting mode.**

You can use a Picture Control while shooting in P, S, A, or M mode (for more information on these modes, see Chapter 9).

2. **Press the MENU button.**

The tilting monitor refreshes, and the camera menus are displayed in the left column.

3. **Press the down arrow on the multi selector to navigate to the Photo Shooting menu and press the left arrow on the multi selector to highlight the photo shooting menu.**

4. **Press the right arrow on the multi selector to place the cursor inside the menu commands, and then press the down arrow on the multi selector to highlight Set Picture Control (see Figure 4-10).**

The menu command displays the last used Picture Control icon to the right of the menu command. In this case, Auto was the previously used Picture Control.

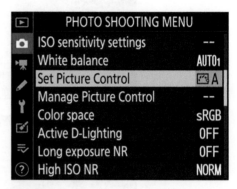

FIGURE 4-10:
The Set Picture Control command.

5. **Press the right arrow on the multi selector.**

The tilting monitor refreshes and the Picture Control options are displayed (see Figure 4-11).

6. **Press the down arrow on the multi selector to select the desired Picture Control, and then press OK.**

The next images you create will be processed as JPEGs using the desired Picture Control, until you revisit this menu and choose a different option.

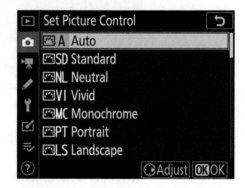

FIGURE 4-11:
Choosing a Picture Control.

Modifying a Picture Control

The Nikon camera gurus have created an awesome set of Picture Controls that you use when you want to create an image with pizzazz. Of course, like everything else on your camera, the Picture Control settings used to create the unique look are malleable and can be changed to suit your preferences.

To modify a Picture Control, follow these steps:

1. **Press the MENU button.**

The tilting monitor refreshes, and the camera menus are displayed in the left column.

2. **Press the down arrow on the multi selector to navigate to the photo shooting menu, and press the left arrow on the multi selector to highlight the photo shooting menu icon.**

3. **Press the right arrow on the multi selector to place the cursor inside the menu commands, and then press the down arrow on the multi selector to highlight Set Picture Control.**

The tilting monitor refreshes, and the icon for the last-used Picture Control is displayed to the left of the menu command (refer to Figure 4-11).

4. **Press the down arrow on the multi selector to highlight the Picture Control you want to modify, and then press the right arrow on the multi selector.**

The tilting monitor refreshes, and the options for the Picture Control you want to modify are displayed (see Figure 4-12).

5. **Press the down arrow on the multi selector to highlight the option you want to modify, press the right arrow to modify the selected setting, and then use the right and left arrows to change the setting.**

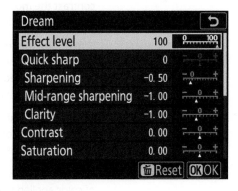

FIGURE 4-12:
Modifying a Picture Control.

You can modify the following options:

- *Effect Level:* The default option is 100 percent. If the effect is a little too strong for your preference, lower the percentage.

- *Quick Sharp:* Adjust the level of sharpening the camera applies while processing the image.

- *Sharpening:* Modify this parameter to change the level of sharpening applied to details and outlines around the objects in the image.

- *Mid-Range Sharpening:* Modify this parameter to change the level of sharpening applied to patterns and lines.

- *Clarity:* Modify this parameter to change the level of sharpening applied to thicker lines without modifying the image's brightness or dynamic range.

- *Contrast:* Modify this parameter to increase or decrease overall image contrast.

- *Brightness:* Modify this parameter to increase or decrease image brightness without losing highlight or shadow detail. Note that this option is not available for all picture controls.

- *Saturation:* Modify this parameter to increase or decrease image saturation.

- *Hue:* Modify this parameter to change the hue of colors in the image. For example, you can modify red colors to give them more of a magenta hue or more of a purple hue.

- *Filter Effects*: Modify this parameter to simulate the use of color filters on monochrome images. You can choose from the following Filter Effects: Yellow, Orange, Red, or Green. Yellow, Orange, and Red enhance contrast and reduce the brightness of the sky in landscape images. Red increases contrast the most, followed by Orange and then Yellow. Use the Green filter to soften skin tones when creating portraits.

TECHNICAL STUFF

Film photographers threaded filters onto the lenses they were shooting with to darken the sky or soften skin. Master landscape photographer Ansel Adams used a red filter to darken the skies when he photographed the breathtaking landscapes in Yosemite National Park.

- *Toning:* Modify this parameter to choose the tint applied to an image when using a Picture Control. This option is only available when modifying a Picture Control used to create a black-and-white image.

- *Toning (Creative Picture Control):* Modify this parameter to choose the shade of color applied to an image. This option is only available when modifying some Creative Picture Controls.

6. **Press OK.**

 The Picture Control is modified. An asterisk appears to the left of any modified Picture Control.

Creating a custom Picture Control

You can modify one of the default Picture Controls as noted in the preceding section. You can also create a custom Picture Control, and it appears as a new menu option.

To create a custom Picture Control, follow these steps:

1. **Press the MENU button.**

 The tilting monitor refreshes, and the camera menus are displayed in the left column.

2. **Press the down arrow on the multi selector to navigate to the photo shooting menu, and press the left arrow on the multi selector to highlight the photo shooting menu icon.**

3. **Press the right arrow on the multi selector to place the cursor inside the menu commands, and then press the down arrow on the multi selector to highlight Manage Picture Control (see Figure 4-13).**

FIGURE 4-13:
The Manage Picture Control command.

4. **Press the right arrow on the multi selector.**

 The tilting monitor refreshes, and the Manage Picture Control options appear (see Figure 4-14). The default option is Save/Edit. In this case, we want to edit a Picture Control.

5. **Press the right arrow on the multi selector.**

 The tilting monitor refreshes, and the Picture Control list appears (see Figure 4-15).

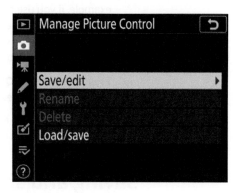

FIGURE 4-14:
Manage Picture Control options.

6. **Press the down arrow on the multi selector to navigate to the Picture Control that will be the basis for your Custom Picture Control and then press the right arrow on the multi selector.**

 The tilting monitor refreshes and displays the options you can modify (see Figure 4-16).

7. **Modify the settings as outlined in the preceding section of this chapter.**

8. **Press OK.**

The tilting monitor refreshes with destination options for your custom Picture Control (see Figure 4-17).

9. **Press the down arrow on the multi selector to select a destination.**

Your options are C1 through C9.

10. **Press OK.**

The screen refreshes and the keyboard appears. For more information on using the keyboard, see the "Using the keyboard" section, earlier in this chapter.

11. **Enter a name for the custom Picture Control.**

Choose a name that reflects the type of pictures you'll create with the custom Picture Control. For example, if you use the Dream Picture Control as the basis for your custom Picture Control, a logical name would be Dream_02.

12. **Press the zoom in\QUAL button to finish entering text.**

Your custom Picture Control is added to the Picture Control list.

Saving and sharing custom Picture Controls

After you create one or more custom Picture Controls, you can save them to a memory card. You can also share it with another photographer or use it on another Nikon camera that supports custom controls.

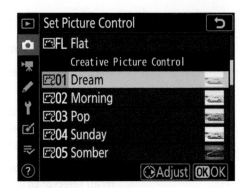

FIGURE 4-15:
Choose a Picture Control to modify.

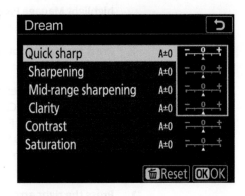

FIGURE 4-16:
Modify the Picture Control parameters to suit your needs.

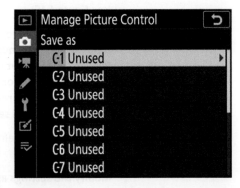

FIGURE 4-17:
Choose a destination for your custom Picture Control.

To save a custom Picture Control, follow these steps:

1. **Press the MENU button.**

 The tilting monitor refreshes, and the camera menus are displayed in the left column.

2. **Press the down arrow on the multi selector to navigate to the photo shooting menu, and press the left arrow on the multi selector to highlight the photo shooting menu icon.**

3. **Press the right arrow on the multi selector to place the cursor inside the menu commands, and then press the down arrow on the multi selector to highlight Manage Picture Control.**

4. **Press the right arrow on the multi selector.**

 The tilting monitor refreshes, and the Manage Picture Control options appear (see Figure 4-18).

5. **Press the down arrow on the multi selector to highlight Load/Save.**

6. **Press the right arrow on the multi selector to display the Picture Controls, and then use the down arrow on the multi selector to highlight the Picture Control you want to save.**

 Modified Picture Controls are preceded by an asterisk.

FIGURE 4-18:
Your options for a custom Picture Control.

REMEMBER

7. **Press OK.**

 The tilting monitor refreshes and the destination options are displayed (see Figure 4-19).

8. **Press the up arrow or down arrow on the multi selector to select one of the following options:**

 - *Copy to Camera:* Choose this option, and you can copy a custom Picture Control previously saved to a memory card to your camera.

FIGURE 4-19:
Destination options for your custom Picture Control.

- *Delete from Card:* Choose this option to delete custom Picture Controls saved to a memory card.

- *Save:* Choose this option to select a custom Picture Control on your camera, save it to a memory card, and then load it to another Nikon camera or share it with a friend.

9. **Follow the prompts for the selected option and press OK.**

Understanding Exposure and Focal Length

When you take a picture in Auto mode, the camera determines the shutter speed and aperture (see Figure 4-20). The *shutter speed* is the amount of time the shutter remains open. When you use a fast shutter speed, the shutter is open for a short amount of time, which stops action. A slow shutter speed keeps the shutter open for a long time and is needed when you don't have a lot of available light.

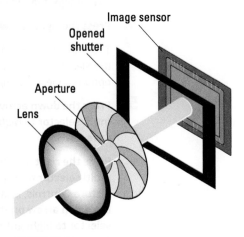

FIGURE 4-20:
The shutter speed and aperture determine the exposure.

The *aperture* determines the size of the opening in the lens that admits light through the lens to the sensor. Each aperture equates to an f-stop number. The *f-stop number* is a value. A small f-stop number, such as f/2.8, designates a large aperture, which lets a lot of light into the camera. A large f-stop number, such as f/16, is a small aperture that lets a small amount of light into the camera. I know, it's counterintuitive, but don't shoot me, I'm only the messenger. Figure 4-21 shows a comparison of apertures and the amount of light each setting sends to the camera.

The f-stop determines another important factor: the depth of field. The *depth of field* is the amount of the image that's in apparent focus in front of and behind your subject:

>> **Shallow depth of field:** A large aperture (small f-stop number) gives you a shallow depth of field, especially when you're shooting the image with a telephoto lens, which gets you closer to your subject and results in an even

shallower depth of field. Telephoto focal lenses are 70mm and greater. Large apertures and telephoto lenses are ideal for portrait photography.

>> **Large depth of field:** On the other hand, a small aperture (large f-stop number) gives you a very large depth of field, especially when you're using a wide-angle focal length. A wide-angle focal length has a large angle of view. Wide-angle focal lengths have a range of 18mm to 35mm.

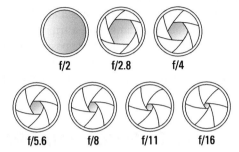

FIGURE 4-21: The aperture setting determines the size of the opening that admits light to the sensor.

TIP

When I got my first SLR — yup, I started taking pictures before the digital era — I had a hard time wrapping my head around how the f-stop value I chose would affect the resulting image. I remembered it like this: Small f-stop value equates to a shallow depth of field, and a large f-stop value equates to a large depth of field.

As you can see, a large number of factors determine what your image will look like.

The following list explains what action the camera takes when you take pictures in various modes:

>> **Auto mode:** The camera determines the shutter speed and f-stop.

>> **Non-auto modes:** These include programmed auto (P) mode, aperture-priority (A) mode, shutter-priority (S) mode, and manual (M) mode. Choosing a mode other than Auto enables you to take complete control by manually setting aperture and/or shutter speed.

>> **Programmed auto (P) mode:** The camera chooses the aperture and shutter speed to ensure optimal exposures, but both values can be changed by the photographer.

>> **Aperture-priority (A) mode:** You supply the aperture (f-stop value), and the camera calculates the shutter speed needed for a properly exposed image.

>> **Shutter-priority (S) mode:** You supply the shutter speed, and the camera provides the aperture (f-stop value) to create a properly exposed image.

The decisions the camera makes regarding shutter speed and aperture are determined by lighting conditions. If you're taking pictures in low-light situations or at night, the camera may choose a shutter speed that's too slow to ensure a blur-free picture (see the upcoming sidebar, "Shutter speed and image sharpness"). If this is the case, you have to mount the camera on a tripod to ensure a blur-free picture. But if you want complete control over the exposure, use one of the non-automatic modes: programmed auto (P) mode, aperture-priority (A) mode, shutter-priority (S) mode, or manual (M) mode, which I outline in detail in Chapter 9.

SHUTTER SPEED AND IMAGE SHARPNESS

When you take a picture with the camera cradled in your hands, a certain amount of motion is transmitted to the camera, which is caused by movement of your body. When you take pictures with a high shutter speed, the shutter isn't open long enough for your body movement to affect the sharpness of the image. However, when you shoot at a slow shutter speed, the shutter is open long enough for your body movement to be apparent in the image, which shows up as an image that isn't tack sharp. The clarity of your images depends on how steadily you hold the camera and the shutter speed used to capture the image.

The rule of thumb for handheld photography is to shoot with a shutter speed that's as fast as the reciprocal of focal length of the lens. For example, if you're using a 50mm lens, you should use a shutter speed of 1/50 of a second or faster to get a blur-free image (in this case, there is no shutter speed of 1/50 second, so the next fasted one would be 1/60 second). If the camera chooses a slower shutter speed, you need to steady the camera with a tripod.

If you use a lens with image stabilization, you can shoot at a slower shutter speed than normal. Even without image stabilization, if you hold the camera very steady, you may be able to shoot at a slower shutter speed than the rule of thumb listed here. The best way to find out how steady you are is to experiment with different shutter speeds on each lens you own. Due to the narrow angle of view, you'll find that your body movement is very apparent when you take pictures with telephoto lenses. Remember that if you shoot for an extended period of time, your arms will get tired and you won't be as steady as you were at the start of the shoot — that is, of course, unless you work out four hours a day.

Focusing on Your Subject

Nothing's worse than a blurry image. Your camera has multiple focusing options designed to ensure blur-free images. But sometimes the camera doesn't get it quite right (for example, when your subject is not smack-dab in the middle of the photo). Then there are other times, such as when shooting in dim light, that the camera cannot achieve focus. So, if your subject is off-center or you're shooting in dim light, read on.

Focusing on an off-center subject

Your Nikon D780 has 51 autofocus points when shooting through the viewfinder and 273 autofocus points when shooting in live view mode. In many instances, the camera focuses on the most important parts of the scene. However, when your subject matter is not smack-dab in the middle of the frame, the camera may not focus on it.

Here's how to focus on any subject within the frame:

1. **Undo the focus selector lock.**

 If the focus selector lock is on L, rotate the selector to the white dot (see Figure 4-22).

2. **Press the AF-mode button (see Figure 4-23) and rotate the main command dial until AF-S is displayed in the control panel.**

 This mode monitors a single autofocus point in the viewfinder.

3. **Use the multi selector to move the autofocus point over the subject you want to be in focus.**

4. **Press the shutter-release button halfway.**

 The in-focus indicator (a white dot) appears on the left side of the viewfinder when focus has been achieved; in addition, the autofocus point is illuminated and the camera beeps.

5. **Press the shutter-release button fully.**

 The camera captures the image.

FIGURE 4-22:
Undo the focus selector lock.

When you move the autofocus point to a specific point in the frame, rotate the focus selector lock to L to lock the autofocus point to that part of the frame. This prevents you from inadvertently moving the point. If you lock the autofocus point, remember to move the switch to its default position after taking the picture.

Press OK to move the autofocus point back to the center of the frame after you create the image.

AF-mode button

Focus-mode selector

Focusing manually

You can have the greatest camera and lens in the world, but if your images aren't in focus, nobody — including you — will care to look at your pictures. Your Nikon D780 has a sophisticated multipoint focus system. In Chapter 10, I show you how to modify the autofocus system to suit specific shooting scenarios.

FIGURE 4-23:
Use the AF-mode button to select the desired autofocus mode.

When you shoot images with the lens set to autofocus mode (M/A on Nikon lenses), the camera looks for areas of changing contrast (edges) or objects that are under autofocus points, and then uses these areas to focus the scene. However, in low light or when you're taking a picture of a scene with lots of detail in the foreground and background, the camera may not be able to achieve focus. The white indicator light in the viewfinder is solid when you achieve focus.

You may notice the autofocus motor on the lens is quite active as the camera tries to achieve focus. On the rare occasion when the camera can't achieve focus, or you want to manually focus the lens to creatively blur your subject while keeping other areas of the image sharp, you have no choice but to manually focus the lens. Nikon lenses and most third-party lenses give you the option of switching to manual focus.

To manually focus the lens, follow these steps:

1. **Move the focus switch on your lens to M, as shown in Figure 4-24.**

 On most Nikon lenses, you'll find this switch on the left side when the camera is facing your subject. If you're using a third-party lens, refer to the instruction manual.

2. **Rotate the focus-mode selector to M.**

 The focus-mode selector is on the left side of the camera when the lens is pointed at your subject (refer to Figure 4-22).

3. **Press the viewfinder to your eye and twist the lens focus ring until your subject is in clear focus.**

 Concentrate on areas with contrast or sharp lines. This makes it easier for you to see when your subject is in focus.

REMEMBER

 Focus on the center of interest in your scene. If you're photographing a person, focus on his eyes, or if your subject has his head turned, focus on the eye nearest the camera. The curve of your subject's eyelid should be in focus in the resulting image; it's also an easy area to focus on.

4. **Take the picture.**

 Switch the lens back to autofocus (M/A) when lighting conditions permit the camera to focus automatically and rotate the focus-mode selector to AF.

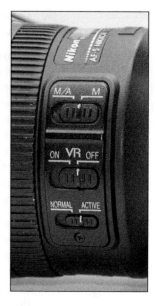

FIGURE 4-24:
Switching the lens to manual focus.

Using the Self-Timer

Your camera has a built-in self-timer that you use whenever you want to delay the opening of the shutter. This option is useful when you want to be in a picture with other people. The self-timer is also handy when you're taking pictures on a tripod, especially when the shot requires a long exposure. The countdown allows time for any camera shake that was caused by pressing the shutter to subside.

To enable the self-timer, follow these steps:

1. **Press the mode dial lock release, and then rotate the mode dial to Auto.**

2. **Press the mode dial lock release, and then rotate the release mode dial to self-timer (see Figure 4-25).**

3. **Press the AF-mode button (refer to Figure 4-23) and rotate the main command dial until AF-S is displayed in the control panel.**

 This mode monitors a single autofocus point in the viewfinder.

4. **Compose your scene in the viewfinder.**

If you're shooting a self-portrait or you'll be in the picture, mount your camera on a tripod. If you're not looking through the viewfinder when you use the self-timer, you'll also have to remove the rubber eyecup and place the eyepiece cap over the viewfinder. The eyepiece cap prevents stray light from changing the exposure.

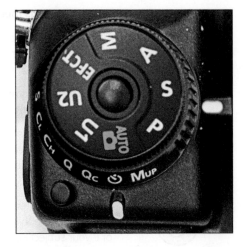

TIP

Store the eyepiece cap in your camera bag so you'll have it on hand when using the self-timer. If your eyepiece cap is not in your camera bag or you lost it, you can

FIGURE 4-25:
Choosing the self-timer release mode.

drape a dark cloth (such as a black microfiber lens cleaning cloth) over the eyepiece instead.

5. **Press the shutter-release button halfway to achieve focus.**

The in-focus indicator (a white dot) appears on the left side of the viewfinder when focus has been achieved, and the camera beeps.

6. **Press the shutter-release button all the way.**

The camera begins to count down. As the camera counts down, you hear a beeping sound and a light on the front of the camera flashes. Two seconds before the end of the countdown, the light stays on and the beeping sounds faster. If you're taking a self-portrait, say "cheese" when the red light is solid.

TIP

You can change the duration it takes for the shutter to open when shooting in self-timer release mode using the c3: Self-Timer command in the Custom Settings menu. You can change the self-timer delay, specify the number of shots captured in self-timer mode, and change the interval between shots.

Chapter **5**

Specifying Image Size and Quality

Your Nikon D780 captures images with a resolution of 24.5 megapixels, which is humongous, ginormous, or any other adjective you prefer to indicate something that's really, really big. The good news: This gives you a tremendous amount of flexibility. You can print images as large as 25.2 x 16.8 inches at the camera's native resolution of 240 pixels per inch (ppi). Think of the possibilities of decorating your house with your photographs! The bad news: The large file size takes up lots of room on your memory cards and lots of room on your computer hard drive. Fortunately, you can specify different sizes by using camera menu options if you have memory cards and hard drives with small capacities.

In addition to concerning yourself with image size, you also need to consider the file format. Your camera can capture images in the RAW or JPEG format. When you capture images in the RAW format, you must process them in some kind of software (such as Nikon Capture NX-D, Adobe Photoshop, or Adobe Lightroom), sort of like a digital darkroom. The RAW format gives you a tremendous amount of flexibility.

If you capture images in the JPEG format, the camera does the processing for you. Think of JPEGs as the digital equivalent of a Polaroid image. You get instant gratification, but you can't do much with the image except crop it and perform minimal image editing. If you capture images in the JPEG format, you also have to think about image quality. The setting you choose determines the image quality and the file size.

If you're new to digital photography, file format, image size, and quality may seem a tad overwhelming. But, hey, don't worry — in this chapter, I show you how to specify image size, image quality, and a whole lot more.

Understanding Image Size and Quality

Your camera can capture large images. The default option captures images at a size that most photographers — except professionals — won't ever need or use. But before you specify sizes, you need to understand the relationship between the image size and the resolution. The default image size your camera can capture measures 6,048 x 4,024 pixels, which translates to 24.5 megapixels. The default resolution for your camera is 240 ppi. So, the default image size and resolution equate to an image size of 25.2 x 16.8 inches.

If you're going to edit your images with software and then print them, you need to factor this into the choices you make when specifying image size and quality. You can get high-quality prints with the 240 ppi default resolution. However, some online printers prefer 300 ppi. If you're capturing images that will only be displayed on a website and will never be printed, you can get by with a much smaller image and a resolution of 72 or 96 ppi. When you use images on the web or in a blog post, you'll rarely need one that's wider than 640 pixels for your personal WordPress blog, but you may need a different size if submitting images to someone else's blog. So, if you're shooting images that will only be displayed on the web, you can specify a smaller image size, as shown in the following sections. You can resample images to a higher or lower resolution with third-party software, such as Adobe Photoshop, Adobe Photoshop Elements, or Adobe Lightroom.

The default image size is great if you're printing images and have gobs of space on your hard drive and a pocket full of 32GB memory cards. However, if your storage capacity is at a premium or you're running out of room on your last memory card with no computer readily available to download to, it's important to know how to change image size and quality, a task I show you how to do in the upcoming sections.

Specifying Image Format, Size, and Quality

Your Nikon D780 has many options that determine the dimensions, image format, quality, and file size. You can choose from two image formats: JPEG and NEF (RAW).

TECHNICAL STUFF

NEF is just Nikon's RAW file format. When you download the images to your computer, they'll have a `.nef` filename extension (as opposed to JPEG images, which have a `.jpg` or `.jpeg` filename extension).

There are three different size options for each image format and six quality options for the JPEG image format. You can capture both formats simultaneously when you shoot an image, or choose either format. If you're shooting with two cards in the camera, you have different options, which I discuss in Chapter 9.

JPEG OR RAW: WHICH IS RIGHT FOR YOU?

The answer to that question depends on how serious you are about your photography. Before you decide, let me point out the differences between the two formats.

When you capture an image in the JPEG format, the camera processes the image. The camera also compresses the image based on the quality option you specify in the camera menu. You can store more images on a card when you specify a smaller image size using image quality of normal or basic. However, you'll notice the difference when you print your images — they just won't be as detailed or sharp.

When you choose the NEF (RAW) format, you have the ultimate in flexibility. The camera sensor transmits the RAW data to your memory card using the compression method and bit depth you specify. What the sensor captures is what you get. You do have to process NEF (RAW) images with image-editing software. The software lets you fine-tune virtually everything about the photo, giving you lots of control.

One way to make the decision is to ask yourself whether, back in the days of film photography, you would have wanted to process your own film and print your own images in a darkroom, or whether you would've preferred taking your film to your local drugstore to be processed and printed. If you're looking for the equivalent of the 4-x-6-inch images you used to pick up at your local drugstore, JPEG is all you need. If you'd like more control over your images, or you want the option to print them really big, RAW is your best bet.

Your decisions regarding format, image size, and quality determine the crispness of the resulting images, the file size, and the amount of flexibility you have when editing your images. To give you an idea of the difference in file sizes, you'll end up with a file size of 7.2MB when you capture the largest size image using the JPEG format with Fine quality compared to a file size of approximately 29MB when you capture the same size image using the NEF (RAW) format.

TIP

I explain the differences between the two formats in the earlier "JPEG or RAW? Which is right for you?" sidebar.

One of the first decisions you make regarding your images is the file format. You can capture JPEG or NEF (RAW) images. When you choose the file format, you also specify the image size. If you choose the JPEG format, you specify the quality as well. You even have an option to capture both formats simultaneously, and have other options if you shoot with two cards (see Chapter 9). If you're curious about the difference between the formats, check out the "JPEG or RAW? Which is right for you?" sidebar in this chapter.

To specify the image quality, follow these steps:

1. **Press the MENU button.**

2. **Press the down arrow on the multi selector to navigate to the Photo Shooting menu (the icon looks like a camera), and then press the left arrow on the multi selector.**

 The Photo Shooting menu is highlighted.

3. **Press the right arrow on the multi selector to view the Photo Shooting menu options, and then press the down arrow on the multi selector to select Image Quality.**

 The currently selected Image Quality is displayed next to Image Quality (see Figure 5-1).

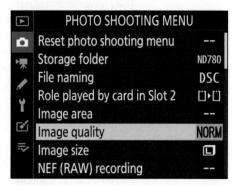

FIGURE 5-1:
Click the command to see the Image Quality options.

4. **Press the right arrow on the multi selector.**

The tilting monitor refreshes and displays the Image Quality options (see Figure 5-2).

5. **Press the down arrow on the multi selector to select one of the following Image Quality options:**

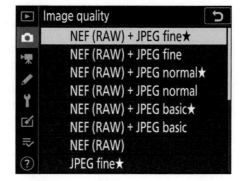

FIGURE 5-2:
Choose an Image Quality option.

- **NEF (RAW) + JPEG fine ★:** Creates a RAW file and a JPEG file with an image quality of fine. In this format, the camera creates a JPEG image that prioritizes image quality.

- **NEF (RAW) + JPEG fine:** Creates a RAW file and a JPEG file with an image quality of fine. In this format, the camera creates a JPEG image that prioritizes file size.

- **NEF (RAW) + JPEG normal ★:** Creates a RAW file and a JPEG file with an image quality of normal. In this format, the camera creates a JPEG image that prioritizes image quality.

- **NEF (RAW) + JPEG normal:** Creates a RAW file and a JPEG file with an image quality of normal. In this format, the camera creates a JPEG image that prioritizes file size.

- **NEF(RAW) + JPEG basic ★:** Creates a RAW file and a JPEG file with an image quality of basic. In this format, the camera creates a JPEG image that prioritizes image quality.

- **NEF (RAW) + JPEG basic:** Creates a RAW file and a JPEG file with an image quality of basic. In this format, the camera creates a JPEG image that prioritizes file size.

- **NEF (RAW):** Creates only a RAW file.

- **JPEG fine ★:** Creates only a JPEG file with an image quality of fine. The resulting JPEG file prioritizes image quality.

- **JPEG fine:** Creates only a JPEG file with an image quality of fine. The resulting JPEG file prioritizes file size.

- **JPEG normal ★:** Creates only a JPEG file with an image quality of normal. The resulting JPEG file prioritizes image quality.

- **JPEG normal:** Creates only a JPEG file with an image quality of normal. The resulting JPEG file prioritizes file size.

- **JPEG basic ★:** Creates only a JPEG file with an image quality of basic. The resulting JPEG file prioritizes image quality.

- **JPEG basic:** Creates only a JPEG file with an image quality of basic. The resulting JPEG file prioritizes file size.

TIP

Note that *fine* is the best image quality, *normal* is a midrange image quality, and *basic* is the lowest image quality.

6. **Press OK.**

 Images will be created using the specified quality until you return to this menu and choose a different option.

After specifying image quality, your next step is to specify image size. Follow these steps:

1. **Press the MENU button.**

2. **Press the down arrow on the multi selector to navigate to the Photo Shooting menu (the icon looks like a camera), and then press the left arrow on the multi selector.**

 The Photo Shooting menu is highlighted.

3. **Press the right arrow on the multi selector to view the Photo Shooting menu options, and then press the down arrow on the multi selector to select Image Size.**

 The currently selected Image Size is displayed next to Image Size (see Figure 5-3).

4. **Press the right arrow on the multi selector to view the different image size options (see Figure 5-4).**

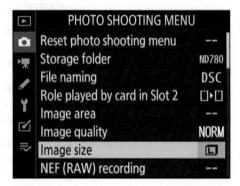

FIGURE 5-3:
The Image Size menu command.

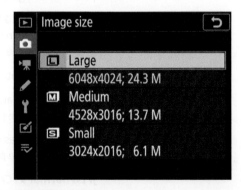

FIGURE 5-4:
Choosing an image size.

5. **Press the down arrow on the multi selector to select one of the following options:**

 - *Large:* Creates a 6,048-x-4,024-pixel image.

 - *Medium:* Creates a 4,528-x-3,016-pixel image.

 - *Small:* Creates a 3,024-x-2,016-pixel image.

6. **Press OK.**

 Images will be created using the specified size until you return to this menu and choose a different option.

Choosing an Image Area

Your camera has multiple options regarding the area of the sensor that is used to capture images. The default format has an aspect ratio of 3:2, the same as the sensor. But you can change the image area based on the type of photograph you're creating. If you're photographing a beautiful landscape, you can choose the Pano-rama setting. Creating headshots for a passport? Choose the 1:1 format.

To choose an image area, follow these steps:

1. **Press the MENU button.**

2. **Press the down arrow on the multi selector to navigate to the Photo Shooting menu (the icon looks like a camera), and then press the left arrow on the multi selector.**

 The Photo Shooting menu is highlighted.

3. **Press the right arrow on the multi selector to view the Photo Shooting menu options, and then press the down arrow on the multi selector to select Image Area (see Figure 5-5).**

FIGURE 5-5:
Choosing Image area options.

4. **Press the right arrow on the multi selector to view the different Image Area options.**

 The tilting monitor refreshes and displays the Image Area options. Choose Image Area is selected by default (see Figure 5-6).

5. **Press the right arrow on the multi selector to display the different options (see Figure 5-7).**

6. **Use the multi selector to select one of the following Image Area options:**

 - **FX (36x24):** Images are recorded using the entire sensor, with an aspect ratio of 3:2.

 - **DX (24x16):** Images are recorded using an area of the sensor equivalent to that of a Nikon DX camera, which has a smaller sensor. The aspect ratio is still 3:2. This is the equivalent of a cropped frame sensor with a focal length multiplier of 1.5. In other words, if you choose this image area option and you shoot with a 100mm lens, it's the equivalent of shooting with a 150mm lens.

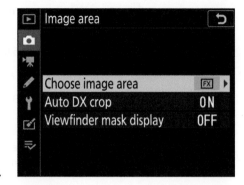

FIGURE 5-6:
Displaying the desired Image Area options.

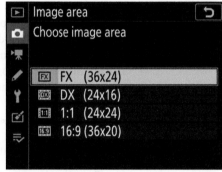

FIGURE 5-7:
See your Image Area options.

 - **1:1 (24x24):** Images are recorded with a 1:1 (square) aspect ratio.

 - **16:9 (36x20):** Images are recorded with a 16:9 aspect ratio.

7. **Press OK.**

 The specified image area will be used for all images you create until you return to this menu and choose another option.

After choosing an image area, you're returned to the previous menu choices. At this stage, you can press the shutter-release button and continue shooting, but there are two other important options on the Image Area menu.

If you choose the DX option, and you're shooting with a lens manufactured for a DX camera Auto DX crop is enabled by default. I suggest you accept the default option.

If you use an image area other than FX, I suggest you add a viewfinder mask, which will help you compose images. When you add a viewfinder mask, a red mask appears in the viewfinder that shows you which part of what you're seeing in the viewfinder will appear in the final image. To add a viewfinder mask, follow these steps:

1. Repeat the previous steps to choose an image area.

After you choose an image area, you're returned to the first Image Area menu.

2. Press the down arrow on the multi selector to highlight Viewfinder Mask Display (see Figure 5-8), and then press the right arrow on the multi selector.

The Viewfinder Mask Display Options appear (see Figure 5-9).

3. Press the down arrow on the multi selector to highlight ON, and then press OK.

The mask for the image area you specified appears in the viewfinder until you revisit this menu and choose OFF. The mask is a red overlay outside of the area the camera will use to capture the image. In other words, everything that isn't masked will be in the resulting image.

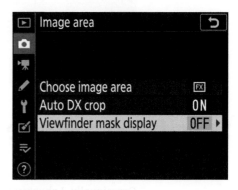

FIGURE 5-8:
This option displays a mask in the viewfinder.

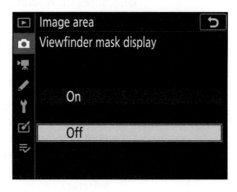

FIGURE 5-9:
Choose a Viewfinder Mask Display option.

The ability to change image area on the fly gives you yet another creative tool for your photography arsenal. Figure 5-10 shows a landscape photographed with the 16:9 (36x20) Image Area option.

FIGURE 5-10:
Shooting a landscape with the 16:9 (36x20) image area.

Specifying a Bit Depth

I shoot NEF (RAW), because it gives me more latitude with the images I create. Occasionally, I shoot images using one of the Picture Controls or one of the options from the EFCT mode, but primarily, I'm a RAW shooter. And one thing I love about the Nikon is the fact that I can specify the bit depth of the NEF (RAW) image, which determines the resulting file sizes of the images I capture. To get the smallest RAW file possible, specify that your NEF (RAW) images are 12-bit compressed files.

To specify bit depth, follow these steps:

1. **Press the MENU button.**

2. **Press the down arrow on the multi selector to navigate to the Photo Shooting menu (the icon looks like a camera), and then press the left arrow on the multi selector.**

 The Photo Shooting icon is highlighted.

3. **Press the right arrow on the multi selector to view the Photo Shooting menu options, and then press the down arrow on the multi selector to highlight NEF (RAW) Recording (see Figure 5-11).**

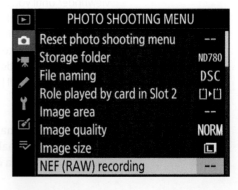

FIGURE 5-11:
The NEF (RAW) Recording menu.

4. **Press the right arrow on the multi selector to display the NEF (RAW) Recording options (see Figure 5-12).**

 The NEF (RAW) Compression option is selected by default.

5. **Press the right arrow on the multi selector to change NEF (RAW) Compression.**

 The tilting monitor refreshes and the NEF (RAW) Compression options are displayed (see Figure 5-13).

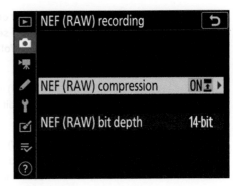

FIGURE 5-12:
Specifying NEF (RAW) Recording options.

6. **Use the up arrow or down arrow on the multi selector to select one of the following compression options:**

 - **Lossless Compressed:** NEF (RAW) files are compressed using a lossless algorithm. The resulting file size is approximately 20 percent to 40 percent smaller than uncompressed files. This setting gives you the best-quality image and it's what I use.

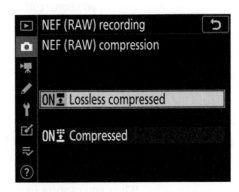

FIGURE 5-13:
To compress or not to compress.

 - **Compressed:** NEF (RAW) files are compressed. The resulting file size is approximately 35 percent to 55 percent smaller than uncompressed files.

7. **After choosing your desired option, press OK.**

 The option will be applied to all images until you visit this menu again and choose a different option. After choosing an option, the previous menu is displayed.

8. **If it isn't already selected, use the down arrow on the multi selector to highlight NEF (RAW) Bit Depth (see Figure 5-14) and press the right arrow on the multi selector.**

 The NEF (RAW) bit depth options are displayed (see Figure 5-15).

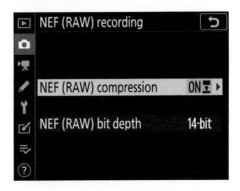

FIGURE 5-14:
Change NEF (RAW) bit depth.

9. **Press the up arrow or down arrow on the multi selector to choose one of the following options:**

- **12 Bit:** NEF (RAW) images are captured with a bit depth of 12 bits.

- **14 Bit:** NEF (RAW) images are captured with a bit depth of 14 bits. These images have more color data at the expense of a larger file size. This is the option I use because of the additional color data, which is useful when I edit my images.

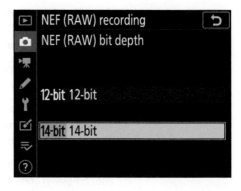

FIGURE 5-15:
Choose one of these bit depth options.

10. **Press OK.**

The specified bit depth will be applied to all RAW images you create until you visit this menu again and choose a different option.

Comparing Image Formats and File Sizes

When you capture images with a large image size, the file size is bigger and the images take up more room on your memory card. The image format also enters into the equation, and if you choose to capture images with the JPEG format, the image quality is a factor. Photographers also like to know the maximum number of images they can capture on a card. The number of images depends on the image format, dimensions, and quality, which equates to the file size. When you capture smaller images in the JPEG format that have been compressed to normal or basic quality, the file size is considerably smaller, so the maximum number of images you can capture before the card is filled is greater.

Table 5-1 shows you how many images you can fit on a 32GB card for each available image format. The table is based on choosing FX for the image area and capturing images with an ISO of 100. This table is only for reference. Your mileage may vary based on the subject matter and ISO speed setting you're using.

TABLE 5-1 ## How Many Images Fit on a 32GB Card

Image Format	Image Size	File Size	Number of Shots
JPEG fine	Large	9.8MB	3,200
JPEG fine	Medium	6.7MB	6,000
JPEG fine	Small	4.1MB	11,200
JPEG normal	Large	6.6MB	7,000
JPEG normal	Medium	4.0MB	11,700
JPEG normal	Small	2.2MB	21,900
JPEG basic	Large	2.3MB	13,700
JPEG basic	Medium	1.7MB	21,900
JPEG basic	Small	1.2MB	40,100
NEF (RAW), lossless compression, 14 bit	Large	27.7MB	1,400
NEF (RAW), lossless compression, 12 bit	Large	21.7MB	1200
NEF (RAW), compressed, 14 bit	Large	24.1MB	1,500
NEF (RAW), compressed, 12 bit	Large	19.4MB	1,800

MY RECOMMENDATIONS

When I take a photograph, I think of all possible uses. My first option is to post an image I like to my blog. Eventually, I make prints of my best images. Some of those prints may be 4 x 6 inches for a small album, or I may have the image printed on a 30-x-20-inch canvas to decorate my home. I may also select images for a photo book, which range in size from 3 x 5 inches to 11 x 13 inches. Therefore, I always capture images with the (NEF) RAW option. This enables me to do almost anything I want with the image. Yes, the images take up a lot of room, but memory cards and hard drives are fairly inexpensive. The hard drive on my computer is 2 terabytes (TB), and I store my images in a special folder and back them up religiously to an external hard drive in case the computer hard drive crashes.

Sometimes I photograph events that require me to produce images quickly, but I still want to edit them to perfection at some point down the road. When I run into a scenario like this, I capture (NEF) RAW and JPEG images simultaneously. If the images will be printed (say, in a local newspaper or magazine), I use the NEF (RAW) + JPEG fine ★ option

(continued)

(continued)

to capture (NEF) RAW and JPEG images simultaneously. This option enables me to give the client a JPEG image almost immediately and then edit RAW images for other outputs at a later date.

If you photograph an event, such as a wedding, you have other considerations. In this case, I recommend that you use the (NEF) RAW format for all the standard wedding images, such as exchanging vows and rings, walking down the aisle, and so on. I also recommend you use (NEF) RAW when shooting the formal shots of the family members with the bride and groom. However, when you're photographing the reception, capture large (NEF) RAW images for the first dances, and then switch to the medium image size for the candid shots of people at tables and the guests dancing. These photographs are generally ordered as 4-x-6-inch images. So, you don't need a full 24.5-megapixel capture for a high-quality print. Switching to a smaller image size for the less important shots saves room on your memory cards.

Managing Image Files

By default, your images are numbered continuously until 9999 and then the file number is reset to 0001. Your images are also stored in a single folder on your memory card. You can, however, create folders in which to store your images and then change the file-numbering method. I show you how in the following sections.

Creating folders

By default, your camera creates the 100ND780 folder on your memory card where images are stored. You can, however, create as many folders as you want. A folder can hold a maximum of 9,999 images. When you exceed the maximum allowable images in a folder, a new one is created automatically. You can have a maximum of 999 folders on a card. Organizing your work in folders is a good idea if you work with large memory cards and want to store images from multiple shoots in separate folders.

The following steps show you how to create your first new folder: 101ND780. To create a folder, follow these steps:

1. **Press the MENU button.**

2. **Press the down arrow on the multi selector to navigate to the Photo Shooting menu (the icon looks like a camera), and then press the left arrow on the multi selector.**

 The Photo Shooting menu is highlighted.

3. Press the right arrow on the multi selector to view the Photo Shooting menu options, press the down arrow on the multi selector to highlight Storage Folder (see Figure 5-16), and then press the right arrow on the multi selector.

The Storage Folder options are displayed (see Figure 5-17).

4. Use the multi selector to highlight the Select Folder by Number option and then press the right arrow on the multi selector.

The Select Folder by Number screen appears and the number is selected by default (see Figure 5-18).

5. Press the down arrow on the multi selector to select a folder number and then press OK.

To create your first new folder, press the down arrow on the multi selector to select 1.

After you've created a new folder, it's ready to accept images. To store images in a different folder, follow Steps 1 through 3 and choose the Select Folder from List option; then select the folder in which you want to store the images.

There is also an option to rename folders. You cannot rename an existing folder, but you can choose a new name to be assigned to new folders.

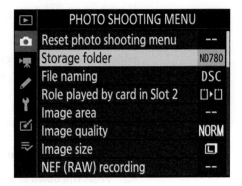

FIGURE 5-16:
The Storage Folder menu option.

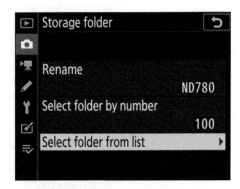

FIGURE 5-17:
Choose one of these Storage Folder options.

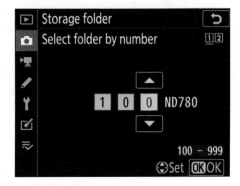

FIGURE 5-18:
The Select Folder by Number screen.

Setting file numbering

The files you create are numbered from 0001 to 9999. When you create a new folder, or insert a new card, by default, file numbering continues from the last number used. If desired, you can change the file number sequence using a custom setting.

To change the file numbering sequence, follow these steps:

1. **Press the MENU button.**

2. **Press the down arrow on the multi selector to navigate to the Custom Settings menu (the icon looks like a pencil), and then press the left arrow on the multi selector to highlight the menu.**

3. **Press the right arrow on the multi selector to display the Custom Settings menu commands, and then press the down arrow on the multi selector to select the File Number Sequence option (see Figure 5-19).**

FIGURE 5-19:
Use this menu option to change the file number sequence.

4. **Press the right arrow on the multi selector.**

 The File Number Sequence options are displayed (see Figure 5-20).

5. **Use the multi selector to select one of the following options:**

 - **On:** File numbering continues from the last number used.

 - **Off:** File numbering starts from 001 when you create a new folder or insert a new memory card. This option is useful if you rename and renumber your images when you import them to your computer.

FIGURE 5-20:
Choose one of these File Number Sequence options.

 - **Reset:** If the current folder is empty, file numbering is reset to 0001. If there are images in the current folder, the next image you create will be assigned the next number. When you create a new folder or insert a new memory card, file numbering continues from the last number used.

6. **Press OK.**

The next images you create will conform to the File Number Sequence option chosen until you revisit this menu and choose a different option.

Naming images

Each image you create uses the DSC prefix, followed by a four digit number using the default file-naming sequence, or one you choose (see the preceding section) followed by .nef (if you shoot RAW) or .jpg (if you shoot JPEG). You can change the prefix to suit your needs. For example, if you're part of a team that photographs events like weddings, you can change the prefix to your initials.

To change the names of images you create with your camera, follow these steps:

1. **Press the MENU button.**

2. **Press the down arrow on the multi selector to navigate to the Photo Shooting menu (the icon looks like a camera), and then press the left arrow on the multi selector.**

The Photo Shooting menu is highlighted.

3. **Press the right arrow on the multi selector to display the Photo Shooting menu.**

4. **Press the down arrow on the multi selector to navigate to the File Naming option (see Figure 5-21) and then press the right arrow on the multi selector.**

The tilting monitor refreshes, and the File Naming menu (see Figure 5-22) is displayed. Note that File Naming is the only option you can change. The references to sRGB and Adobe RGB show you how the files will be named if you choose one of those color spaces.

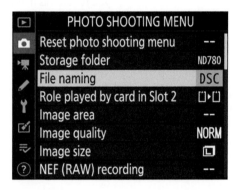

FIGURE 5-21:
Use this menu option to change file names.

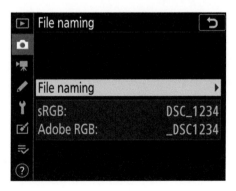

FIGURE 5-22:
Use the camera keyboard to enter a new name for your images.

5. **Press the right arrow on the multi selector.**

The keyboard appears (see Figure 5-23).

6. **Enter the new name for your images.**

For more information about using the keyboard, see Chapter 4.

7. **Press the zoom in/QUAL button to finish creating the new name.**

The next images you create will be named with the new prefix until you revisit this menu and enter a new filename.

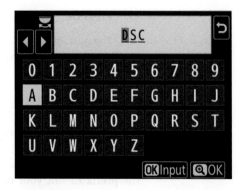

FIGURE 5-23: Enter the new name for your images.

IN THIS CHAPTER

» **Understanding what you can do with the playback _i_ menu**

» **Reviewing images and movies and information about them**

» **Using touch controls**

» **Setting the tilting monitor's brightness**

» **Deleting and protecting images**

» **Viewing images as a slide show or on a TV**

» **Getting to know live view**

Chapter **6**

Using the Tilting Monitor

D igital photography is all about instant gratification. You snap a picture, and it appears on the camera's monitor almost instantaneously. This gives you a chance to see whether you captured the image you envisioned or something not quite to your liking, also known as a _dud._ On the Nikon D780, your tilting monitor can do much more than just display your images. You can get all sorts of useful information, such as the shutter speed, aperture, and other pertinent information about the image. You can even display a spiffy graph, known as a _histogram,_ that shows the distribution of pixels from shadows to highlights.

The information you can display on the tilting monitor gives you the opportunity to examine each image and make sure you got it right in the camera.

REMEMBER

Photographers should always do their best to get it right in the camera and rely as little as possible on programs such as Adobe Photoshop or Adobe Lightroom to correct exposure problems and other issues that could've been avoided when taking the picture. After all, _Photoshop_ is a noun, not a verb. So instead of taking the picture and saying you'll "Photoshop it," rely on the information your camera supplies to determine whether you got the exposure right. Programs like Photoshop are designed to _enhance_ images, not fix them.

In this chapter, I show you how to use the Nikon D780's tilting monitor to review images, display image information, and much more. I also show you how to erase, rotate, and protect your images from accidental deletion.

Using the Playback *i* Menu

The playback *i* menu (shown in Figure 6-1) is accessed by pressing the *i* button. The playback *i* menu enables you to perform tasks such as rating images, retouching images, and choosing which slot and folder images are stored in. When reviewing a movie, the playback *i* menu offers different options, such as trimming a movie and editing a movie. To use the playback *i* menu while reviewing images, press the *i* button to display the menu on your tilting monitor, and then use the multi selector to navigate to the desired command.

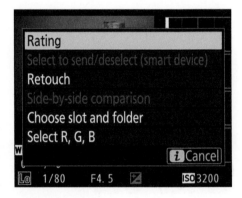

FIGURE 6-1:
The playback *i* menu.

Reviewing Images and Movies

Your Nikon D780 has a large, 3.2-inch tilting monitor, which is ideal for reviewing images and movies. In addition, information about the image or movie is displayed on the monitor. You can also use it to view a *histogram*, which is a visual graph of the distribution of pixels from shadow areas to highlight areas.

Enabling image review

Image review is not enabled by default. To review an image or movie after you shoot a picture, you use a menu command to make this happen. To enable image review, follow these steps:

1. **Press the MENU button.**

2. **Press the down arrow on the multi selector to select the playback menu, and then press the left arrow on the multi selector.**

 The playback menu is highlighted.

3. **Press the right arrow on the multi selector to place the cursor inside the playback menu, and then press the down arrow on the multi selector to highlight the Image Review command (see Figure 6-2).**

4. **Press the right arrow on the multi selector to view the image review options.**

 The default option is Off.

5. **Press the up arrow on the multi selector to highlight On (see Figure 6-3), and then press the OK button.**

 Image review is now enabled. Images appear almost immediately on the tilting monitor after you press the shutter-release button.

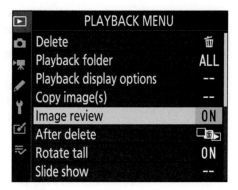

FIGURE 6-2:
The Image Review command.

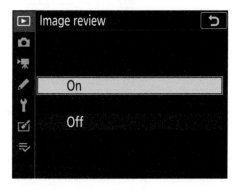

FIGURE 6-3:
Choosing an image review option.

Reviewing an image

When you enable image review, an image appears on the tilting monitor immediately after the camera processes it and saves it to your memory card. You can review the images captured on your card at any time by pressing the play button. To review images on your memory card:

1. **Press the play button (the leftmost button on the back of your camera).**

 An image appears on your tilting monitor (see Figure 6-4).

FIGURE 6-4:
Reviewing an image.

2. **Press the left arrow or right arrow on the multi selector or rotate the main command dial to review additional images.**

3. **Press the shutter-release button halfway to stop reviewing images.**

TIP

When reviewing an image in full-frame playback, you can use the up arrow and down arrow on the multi selector to display different information screens. You can cycle through eight screens that file information, exposure data, shooting data, and more.

Reviewing a movie

If you record movies with your Nikon D780, they're saved with your images. When you navigate to a movie on your card, an icon of a movie camera appears in the upper-left corner of the thumbnail (see Figure 6-5).

To review a movie, follow these steps:

1. **Press the OK button.**

 The movie begins to play.

FIGURE 6-5:
Reviewing a movie.

2. **Press the down arrow on the multi selector to pause the movie.**

3. **Press the right arrow on the multi selector to fast-forward the movie or press the left arrow on the multi selector to rewind it.**

 The fast-forward or rewind speed increases each time you press the button, from 2X to 4X to 8X to 16X.

4. **Press the down arrow on the multi selector when the movie is paused to replay the movie in slow motion.**

5. **Rotate the main command dial one click to skip ahead 10 seconds or back 10 seconds.**

6. **Rotate the sub-command dial to advance to the first or last frame.**

7. **Press the zoom in/QUAL button to increase the volume, or the zoom out/ metering button to decrease the volume.**

8. **Press the shutter-release button halfway to stop playing the movie.**

 The movie stops playing and you're returned to shooting mode.

Choosing image display options

When you review images on your tilting monitor, you can specify the type of information that is displayed with the image. For example, you can display the focus point, exposure info, an RGB histogram, or just the image.

To choose display options, follow these steps:

1. **Press the MENU button.**

2. **Press the down arrow on the multi selector to select the playback menu, and then press the left arrow on the multi selector.**

 The playback menu is highlighted.

3. **Press the right arrow on the multi selector to place the cursor inside the playback menu, and then press the down arrow on the multi selector to highlight the Playback Display Options command (see Figure 6-6).**

FIGURE 6-6:
The Playback Display Options command.

4. **Press the right arrow on the multi selector to place the cursor in the playback display options list (see Figure 6-7).**

5. **Press to select one or more of the following options to display:**

 - *Focus point:* The focus points used to focus the subject are displayed on the image.

 - *Exposure info:* The shutter speed, aperture, and ISO used to capture the image are displayed on the image.

 - *Highlights:* Any blown-out highlights (bright areas of the image such as clouds that are overexposed) are displayed on the image.

FIGURE 6-7:
Choosing playback display options.

- *RGB histogram:* A histogram for the R (Red), G (Green), and B (Blue) channels is displayed with the image.

- *Shooting data:* Displays the settings in place when the image was captured. Information such as metering, shutter speed, aperture, shooting mode, ISO sensitivity, and more is displayed.

- *Overview:* This is kitchen-sink mode. Every setting used to capture the image, plus a histogram, the date and time the image was captured, and much more are displayed. In my humble opinion, this is too much information, but if you like lots of information, knock yourself out!

- *None [Image only]:* Displays the image with no additional information.

6. **Press the right arrow on the multi selector to select an option.**

 After you select an option, a check mark appears in the check box to the left of the option. Note that you can select multiple options.

7. **Press OK.**

 The selected options display when you review an image.

Using the histogram

Even though your Nikon D780 is a very capable camera, it can get it wrong when you're shooting under difficult lighting conditions. That's why your camera lets you display a histogram with the image on your camera's tilt-ing monitor (see Figure 6-8). Your camera can display a single histogram and display a histogram for the red, green, and blue channels.

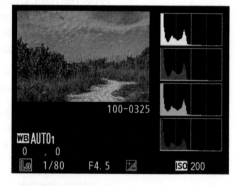

FIGURE 6-8:
Analyzing exposure with the histogram.

As noted in the preceding section, you can display one histogram when you choose Overview as a display option, or an RGB histogram when you choose that as a display option. A histogram is a wonderful thing: It's a graph — well, sometimes it looks more like a mountain — that shows the distribution of pixels from shadows to highlights. Study the histogram to decide whether the camera — or you, if you manually exposed the image — properly exposed the image. The histogram can tell you whether the image was underexposed or overexposed.

A peak in the histogram shows a lot of pixels for a brightness level. A valley shows fewer pixels at that brightness range. Where the graph hits the floor of the

histogram, you have no data for that brightness range. If you see a sharp spike on the right wall of the histogram, this indicates that the image is overexposed and all detail has been lost in some of the highlights. If you see a sharp spike on the left wall of the histogram, the image is underexposed and detail has been lost in the shadow areas of your image.

REMEMBER

You can correct for overexposure and underexposure to a degree in your image-editing program, but it's always best to get it right in the camera. If you analyze a histogram and notice that the image is overexposed or underexposed, you can use your camera's exposure compensation feature to rectify the problem. For more information on exposure compensation, see Chapter 9.

WARNING

The histogram is a tool. Use it wisely. When you're analyzing a scene that doesn't have any bright highlights, you may end up with a histogram that's relatively flat on the right side. When that happens, judge whether the image on the tilting monitor looks like the actual scene. If you rely on the histogram when you see a flat area in the highlights and add exposure compensation, you may make the image brighter than the scene actually was.

Rotating vertical images

Many photographers — myself included — rotate the camera 90 degrees when taking a picture of an object that's taller than it is wide. When these images are displayed on the tilting monitor, you must rotate the camera 90 degrees to view them in the correct orientation. If you don't like doing this, a menu command will rotate the images for you. After you invoke this command, images display on your monitor in the proper orientation.

To have the camera rotate images automatically, follow these steps:

1. **Press the MENU button.**

2. **Press the down arrow on the multi selector to select the playback menu, and then press the left arrow on the multi selector.**

 The playback menu is highlighted.

3. **Press the right arrow on the multi selector to place the cursor inside the playback menu, and then press the down arrow on the multi selector to highlight the Rotate Tall menu command (see Figure 6-9).**

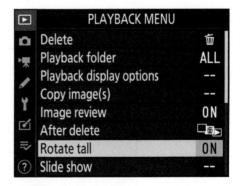

FIGURE 6-9:
The Rotate Tall menu command.

4. **Press the right arrow on the multi selector.**

 The Rotate Tall options are displayed (see Figure 6-10).

5. **Press the up arrow on the multi selector to highlight On and press OK.**

 Images that are taller than they are wide will be rotated when you review them.

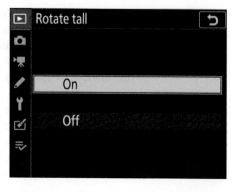

FIGURE 6-10:
The Rotate Tall options.

Setting image review options

When you review an image, it's displayed full size on the tilting monitor. However, you have options when reviewing images. For example, if you want to see if you've nailed the focus, you can zoom in. If you want to review multiple images, you can display thumbnails on the monitor.

To change the image review options, follow these steps:

1. **Press the play button.**

 An image appears on your tilting monitor.

2. **Press the zoom in/QUAL button to zoom in on the image.**

 Each time you press the button, the magnification increases.

 The left side of Figure 6-11 shows the full-size image, while the right side of the figure shows an area of the image magnified.

FIGURE 6-11:
Zoom in to see areas of the image in greater detail.

3. **Use the multi selector to move to different parts of the frame.**

If you press and hold one of the multi selector areas while zoomed in, you can rapidly move through the frame.

4. **Press the zoom out/metering button to zoom out.**

Each time you press the button, magnification decreases until the full image is displayed. Press the button again to view multiple images. The number of images increases from 4 to 9 to 72.

5. **Use the multi selector to highlight images.**

TIP

If you like to cut to the chase and zoom in to 100 percent to check focus, use the f4: OK button custom control menu option to change the function of the OK button to zoom to 1:1 during playback. After zooming to 1:1, you use the multi selector arrows to navigate to different areas of the image. For more information on customizing buttons, refer to Chapter 14.

Rating images and movies

You can rate images and movies — from 1 star to 5 stars — while reviewing them. Ratings aren't visible in applications like Adobe Lightroom, but you can see them in Nikon ViewNX-i or Nikon Capture NX-D.

To rate an image, follow these steps:

1. **Press the play button and use the multi selector to view images on your memory card.**

Alternatively, you can use the main command dial to scroll from one image to the next.

If you have image review after shooting a picture enabled (see the "Enabling image review" section, earlier in this chapter), you can also rate an image after shooting it.

REMEMBER

You can view multiple images and select the one you want to rate.

2. **Press the *i* button.**

The playback *i* menu appears on the tilting monitor (refer to Figure 6-1).

3. **Select Rating and press the right arrow on the multi selector.**

 Stars appear under your image (see Figure 6-12).

4. **Press the right arrow on the multi selector to assign a rating from 1 to 5 stars, and then press OK.**

 The image is rated.

TIP

In my opinion, your best bet is to rate images using an image-editing program such as Adobe Lightroom. Rating images is much easier on a large computer monitor. Plus, it frees up your time for shooting.

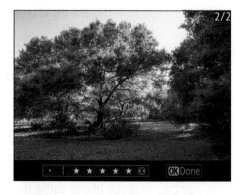

FIGURE 6-12:
What rating are you worth, my lovely?

Reviewing Images with Touch Controls

You can control the tilting monitor just by touching it. Yes, Virginia, it's just like your iPad or smartphone. Touch controls make it easy for you to review images, zoom in on images, and view thumbnail images. You can even use touch controls to focus and shoot a picture (see Chapter 7). In the following sections, I show you how to set up and use your camera's touch controls.

Setting up touch controls

To reap the many benefits of touch controls, you specify whether touch controls are used for playback only, or whether you enable it for live view shooting and playback and after setting up, how the tilting monitor responds to your touch when using the flick gesture.

To set up touch control, follow these steps:

1. **Press the MENU button.**

2. **Press the down arrow on the multi selector to select the setup menu, and then press the left arrow on the multi selector.**

 The setup menu is highlighted.

3. **Press the right arrow on the multi selector to place the cursor inside the setup menu, and then press the down arrow on the multi selector to highlight the Touch Controls option (see Figure 6-13).**

4. **Press the right arrow on the multi selector.**

The touch controls command is displayed (see Figure 6-14).

5. **Press the right arrow on the multi selector.**

The touch controls command options are displayed (see Figure 6-15).

6. **Choose one of the following options:**

- *Enable:* Enables touch controls for playback and shooting.

- *Playback only:* Enables touch controls for playback only.

- *Disable:* You can no longer get touchy-feely with the tilting monitor.

7. **Press OK.**

You're returned to the previous menu.

8. **If not already highlighted, select full-frame playback flicks (see Figure 6-16) and press the right arrow on the multi selector.**

The full-frame playback flicks options are displayed (see Figure 6-17).

9. **Choose an option and press OK.**

You're ready to flick up a storm.

FIGURE 6-13:
Enabling touch controls.

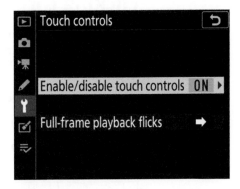

FIGURE 6-14:
The touch controls command.

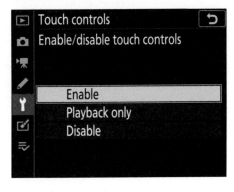

FIGURE 6-15:
The touch controls command options.

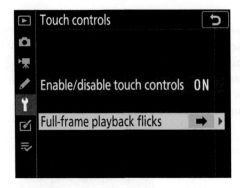

FIGURE 6-16:
Flicking for fun and profit.

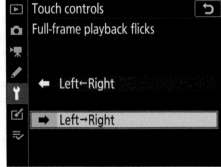

FIGURE 6-17:
Do I want to flick left or right?

Flicking through images

After enabling touch controls, you use it during playback to scroll through images. You can use touch controls to change image magnification, and scroll from one image to the next. Here's how to use touch controls during playback:

1. **Press the play button.**

 An image appears on your tilting monitor.

2. **Flick left or right to scroll through images (see Figure 6-18).**

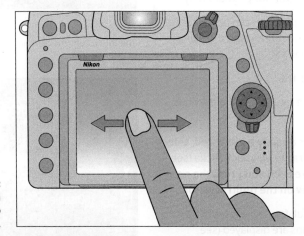

FIGURE 6-18:
Using touch controls to review images.

3. **Touch the bottom of the tilting monitor to display a frame advance bar (see Figure 6-19), and slide your finger left or right to quickly scroll to other images.**

FIGURE 6-19:
Using touch
controls to
review images.

4. **Stretch your thumb and forefinger to zoom in (see Figure 6-20).**

 Alternatively, you can tap the display twice to zoom in.

 After you zoom in, you can move your finger to scroll to different parts of the image.

 After zooming in, double-tap the screen to cancel zoom and display the full image.

TIP

5. **Pinch your fingers to zoom out.**

 After the image fills the screen, continue pinching to view 4, 9, or 72 thumbnails.

FIGURE 6-20:
Using a stretch
gesture to
zoom in.

You can also use touch gestures when reviewing movies. When you navigate to a movie, which is indicated by an icon that looks like a movie camera, tap the icon on the screen to play the movie and tap the screen to pause the movie.

When you finish reviewing images, press the shutter-release button halfway to stop reviewing images and resume creating photographs.

Changing the Brightness of the Tilting Monitor

Your tilting monitor can be viewed easily in most lighting conditions. However, if you want to increase or decrease the tilting monitor's brightness to suit your personal preference, or to deal with bright light, you can.

To change the tilting monitor's brightness, follow these steps:

1. **Press the MENU button.**

2. **Press the down arrow on the multi selector to select the setup menu, and then press the left arrow on the multi selector.**

 The setup menu icon is highlighted.

3. **Press the right arrow on the multi selector to place the cursor inside the setup menu, and then press the down arrow on the multi selector to select Monitor Brightness (see Figure 6-21).**

FIGURE 6-21:
The Monitor Brightness command.

4. **Press the right arrow on the multi selector to view the monitor brightness options (see Figure 6-22).**

5. Press the up arrow or down arrow on the multi selector to select a higher or lower value.

Choose a higher value to increase monitor brightness or a lower value to decrease monitor brightness.

6. Press OK.

The monitor brightness changes.

FIGURE 6-22:
Choose the desired monitor brightness.

Deleting Images

When you review images and find some you don't like, you can delete them from the memory card. You can delete a single image or multiple images. The easiest way to delete an image you're currently reviewing is to press the delete button on the back of your camera (it looks like a trash can).

TIP

Unless an image is an obvious dud, I advise you to do all your deleting on a computer.

If you want to delete multiple photos when you're reviewing images, follow these steps:

1. Press the MENU button.

2. Press the down arrow to select the playback menu, and then press the left arrow on the multi selector.

The playback menu is highlighted.

3. Press the right arrow on the multi selector to place the cursor inside the playback menu (see Figure 6-23).

Delete is the first menu command.

FIGURE 6-23:
Choose this command when you need to delete some duds.

4. **Press the right arrow on the multi selector to display the delete command options (see Figure 6-24).**

5. **Choose one of the following options:**

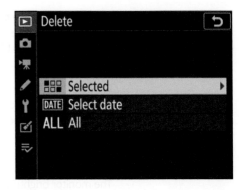

FIGURE 6-24:
Choose the manner in which you want to delete the duds.

 - *Selected:* The screen refreshes and displays thumbnails of images on the card. Use the multi selector to navigate the images, and use the zoom out/metering button to tag an image for deletion. Continue reviewing and selecting images and then go to Step 6.

 - *Select Date:* Choose this option if you have images shot on more than one date on the card. With this option, you can select a date and delete all images from that date.

 - *All:* Choose this option and you can delete all images from one card, or both if you have two cards in the camera.

6. **Press OK.**

 A warning dialog appears asking you if you want to delete the selected images.

7. **Select Yes to select the option, and OK to delete the image(s).**

 Whoosh! The image(s) go bye-bye.

Protecting Images

When you photograph a person, place, or thing, you're freezing a moment in time, a moment that may never happen again. So, you need to be very careful when you delete images from a card because after they're deleted, they're lost forever. That's why I recommend doing the majority of your deleting in an image-editing program. However, if you decide to delete lots of your images with camera erase options (see the preceding section), you can protect an image to prevent accidental deletion.

WARNING

When you protect an image, it will still be deleted when you reformat the card.

To protect an image, follow these steps:

1. **Press the play button.**

2. **Review images as outlined in the preceding section.**

3. **When you see an image you want to protect, press the help/protect/WB button (see Figure 6-25).**

 The image is protected from deletion and a lock icon appears on the image overlay.

FIGURE 6-25:
Press this button to protect an image.

Viewing Images as a Slide Show

If you're the type of photographer who likes to razzle and dazzle yourself and your friends by viewing images you've just shot on the camera monitor — also known as chimping because of the noises photographers sometimes make when they see a cool image — you'll love viewing images on the tilting monitor as a slide show.

To view images as a slide show, follow these steps:

1. **Press the MENU button.**

2. **Press the down arrow on the multi selector to select the playback menu, and then press the left arrow on the multi selector.**

 The playback menu is highlighted.

3. **Press the right arrow on the multi selector to place the cursor inside the playback menu and press the down arrow on the multi selector to select Slide Show (see Figure 6-26).**

FIGURE 6-26:
Get the popcorn! We're gonna have a slide show.

4. Press →.

The Slide show options are displayed (see Figure 6-27). The default option plays all images on the card, including movies, for a duration of 2 seconds per image and Start is highlighted.

5. Choose one of the following options:

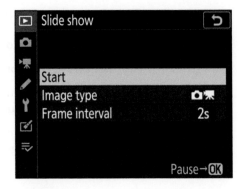

FIGURE 6-27:
The slide show options.

- *Start:* Press OK to begin a slide show with the default parameters.

- *Image Type:* Choose this option, press the right arrow on the multi selector, and then choose what to include in the slide show — still images and movies; still images; movies only; or by rating. After choosing an option, press OK, select Start, and then press OK to begin the slide show.

- *Frame interval:* Choose 2 seconds, 3 seconds, 5 seconds, or 10 seconds. After choosing an option, press OK, select Start, and then press OK to begin the slide show.

6. Press the MENU button.

The slide show ends and you're returned to the playback menu.

While playing a slide show, you have the following options:

» Press the right arrow on the multi selector to advance to the next frame or the left arrow on the multi selector to view the previous frame.

» Press OK to pause the slide show. To restart the show, highlight Restart and press OK.

» Press the zoom in/QUAL button to increase the volume when viewing a slideshow with movies.

» Press the zoom out/metering button to decrease the volume when viewing a slide show with movies.

>> Press the MENU button to exit the slide show and return to the playback menu.

>> Press the play button to exit the slide show and continue reviewing images.

>> Press the shutter-release button halfway to exit the slide show and return to shooting mode.

Viewing Images on a TV Monitor

You have a digital camera capable of capturing colorful images with an impressive resolution of 26.5 megapixels. Your TV is a grand medium on which to display your images. You can display still images or a slide show on your TV screen and knock your socks off — and, for that matter, the socks of your friends and any-body else within viewing distance — by viewing your precious images onscreen. Video also looks awesome on a TV.

To view your images on an HDMI TV, follow these steps:

1. **Open the HDMI slot on the side of your camera.**

2. **Insert an HDMI cable into the HDMI terminal.**

 The camera HDMI port accepts a male mini HDMI plug, and your TV accepts a male HDMI plug. You can purchase a video-quality cable with these plugs from your favorite store that sells video equipment.

3. **Connect the other end of the HDMI cable to your TV set.**

 Refer to your TV's user manual to choose video as the input source.

4. **Press the play button on your camera.**

 An image displays on your television set.

5. **Press the right arrow on the multi selector to view the next image.**

 You can also use touch controls to advance from image to image or use the main command dial to scroll through images.

You can also set up a slide show (see the preceding section), and view the slide show on your TV using the preceding steps.

Introducing Live View

The live view on your Nikon D780 is extremely sophisticated. When you press the live view button, the camera mirror locks up and the view captured by your sensor appears on the tilting monitor. You use live view to compose your images, focus the image, and shoot the picture. Live view is used in still photography (see Chapter 7) and movie making (see Chapter 8). Figure 6-28 shows live view as used to create an image.

FIGURE 6-28:
Creating an image with live view.

2

Taking Control of Your Nikon D780

Create images using live view.

Record movies using live view.

Get the most out of your camera.

Take advantage of your camera's advanced features.

Learn how to shoot like a pro.

Chapter **7**

Creating Images with Live View

I f you like, you can use the tilting monitor to compose your pictures. This way of shooting has some definite advantages. For example, you can place the camera close to the ground and compose an image through the monitor, or you can hold the camera over your head to do the same. Your Nikon D780 has a tilting monitor, which makes it even easier to compose images from unique vantage points with live view.

Live view adds lots of benefits to shooting, but it has a few disadvantages, too. First, when you shoot in live view mode, the battery life diminishes. Also, to shoot using live view, you hold the camera in front of you at arm's length, which, unless you work out at the gym five days a week, can be a bit tiring. Because of this, many people use tripods when shooting images and recording movies using live view.

In addition to taking great pictures in live view mode, you can also capture high-definition (HD) movies (see Chapter 8). In this chapter, I show you how to take pictures and more using live view.

Using Live View to Create Images

To take pictures using live view, follow these steps:

1. **Press the release mode dial lock release, and then rotate the mode dial to the desired shooting mode.**

 For more information about shooting modes, see Chapter 9.

 TIP

 Unless you've used live view before, shoot in Auto mode until you're familiar with live view. In Auto mode, the camera makes all the decisions.

2. **Rotate the live view selector to live view photography.**

 It's the icon that looks like a camera (see Figure 7-1).

 FIGURE 7-1:
 Set the live view selector to live view photography.

3. **Press the live view button.**

 The mirror locks up and what you see on the LCD monitor is what you get when you take a picture.

4. **Move the camera to compose the picture.**

 If you're using a zoom lens, hold the camera steady with one hand, and rotate the lens with the other.

 REMEMBER

 If you're shooting with a long zoom lens, it will be difficult to hold the camera and use the zoom control at the same time. In situations like this, a tripod is your best friend.

5. **Press the shutter-release button halfway.**

 The camera focuses, and the focus point used to achieve focus is displayed in green. If the camera is unable to focus, the focus point will flash red.

6. **Press the shutter-release button fully.**

 The monitor turns off momentarily, and the camera captures the image.

7. **When you're finished taking pictures, press the live view button.**

 The mirror locks down and the tilting monitor turns off.

TIP

Due to the fact that the live view takes a toll on the battery, I recommend carrying an extra battery when shooting in this mode.

REMEMBER

When shooting in live view, you may see some anomalies on the tilting monitor. Moving subjects may appear distorted and you may notice bright spots on the monitor. Any distortions you notice on the monitor will not show up in the final picture.

TIP

When shooting in live view, use the eyepiece cap that shipped with your camera to prevent stray light from entering the viewfinder. If you left your eyepiece cap at home, use a dark piece of paper or a dark piece of cloth as a makeshift eyepiece cap.

WARNING

When shooting in live view mode, don't point the camera at the sun. Doing so may damage the camera's internal circuitry.

Choosing a Live View AF-Area Mode

When you create images with your camera, the default autofocus (AF) mode is AF-A (automatic), which means the camera switches from AF-S (single AF) when you photograph a stationary subject, or AF-C (continuous AF) when you photograph a moving object. You have other AF options (see Chapter 10).

In this section, I show you how to choose an AF-area mode to suit your working preference and subject matter. When you shoot in live view, you have six AF-area modes to choose from. To choose an AF-area mode when creating images or recording movies in live view mode, press and hold the AF-mode button, rotate the sub-command dial, and then choose one of the following options:

>> **Pinpoint AF:** This is the smallest AF point available. This option is only available when you choose AF-S for the AF mode when shooting still photography. This option is recommended for shooting things like buildings, products, and close-ups, as well as for macro photography. The icon for pinpoint AF is a small unfilled rectangle with *PIN* underneath.

>> **Single-point AF:** Choose this option for a larger AF point when shooting stationary subject matter. The icon for single-point AF is an unfilled rectangle.

>> **Wide-area AF (S):** This option is similar to single-point AF, but the camera focuses on a slightly larger area. Use this option for stationary objects that are hard to focus with single-point AF. If more than one subject is in the AF point, the camera assigns focus priority to the nearest subject. The icon for wide-area AF (S) is an unfilled rectangle with *WIDE-S* underneath.

>> **Wide-area AF (L):** This option is similar to wide-area AF (S), but it uses a larger area for focusing. This option is used for photographing stationary objects. If more than one subject is in the AF point, the camera assigns focus priority to the nearest subject. The icon for wide-area AF (L) is an unfilled rectangle with *WIDE-L* underneath.

>> **Dynamic-area AF:** With this option, the camera focuses on a single AF point selected by the user. If the subject move away from the AF point, the camera uses information from surrounding focus points to achieve focus. This option is ideal for photographing athletes and other subjects who are difficult to photograph using single-point AF. This option is only available when the AF-A or AF-C mode is selected. The icon for dynamic-area AF is a rectangle with square dots above, below, and to the left and right of the rectangle.

>> **Auto-area AF:** With this option, if you frame a person for a portrait, an amber point appears on the subject's face indicating the focus point. If your subject is close to the camera, and the camera detects eyes, an amber point appears around one of the subject's eyes. The icon for auto-area AF is a filled rectangle.

Choose wide-area AF (S) or wide-area AF (L) when making movies where you pan or tilt the camera.

TIP

Using the Live View Framing Grid

When shooting in live view, you can display a framing grid on the tilting monitor. A framing grid is useful when shooting objects with vertical or horizontal edges, such as buildings. It's also useful for creating landscape images with a level horizon line. Use the lines on the framing grid to align vertical and/or horizontal lines on objects within the frame.

To enable the live view framing grid, follow these steps:

1. **Press the MENU button to display the camera menus, and then use the multi selector to navigate to the Custom Settings menu.**

2. **Press the left arrow on the multi selector.**

 The icon is highlighted.

3. **Press the right arrow on the multi selector to place the cursor inside the Custom Settings menu and press the down arrow on the multi selector to highlight the d10: Framing Grid Display command (see Figure 7-2).**

FIGURE 7-2:
Displaying a framing grid when shooting live view.

4. Press the right arrow on the multi selector to display the options (see Figure 7-3).

5. Select On and then press OK.

A framing grid is displayed when shooting live view (see Figure 7-4) and in your viewfinder.

Using the Live View *i* Menu

The live view *i* menu (shown in Figure 7-5) gives you the ability to quickly change frequently used settings. The *i* menu displays on the tilting monitor when you press the *i* button.

You can change the following settings using the live view *i* menu:

» **Set Picture Control:** Select the Picture Control you use to create the image (see Chapter 4).

» **Image Quality:** Select the image quality used to create the image (see Chapter 5).

» **Flash Mode:** Select the flash mode used with a supported Nikon Speedlight (see Chapter 11).

» **Wi-Fi Connection:** Connect to a local Wi-Fi network (see Chapter 10).

» **Autofocus Mode:** Select your desired autofocus mode (see Chapter 10).

FIGURE 7-3:
Select On to enable the framing grid.

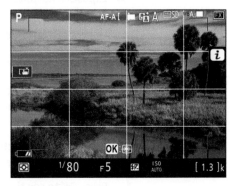

FIGURE 7-4:
Use the framing grid to help compose your images.

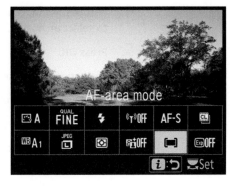

FIGURE 7-5:
The live view *i* menu.

>> **Negative Digitizer:** Digitize film negatives with your camera. The Negative Digitizer is beyond the scope of this book, but you can learn more about it in the Nikon D780 Reference Manual, which came with your camera.

>> **White Balance:** Specify the white balance setting used to capture images (see Chapter 11).

>> **Image Size:** Specify the size of the images you create (see Chapter 5).

>> **Metering:** Select the metering mode used to create images (see Chapter 9).

>> **Active D-Lighting:** Enable Active D-Lighting (see Chapter 12).

>> **AF-Area Mode:** Select the AF-area mode (see "Choosing a Live View AF-Area Mode," earlier in this chapter).

>> **Exposure Review:** Display a histogram when shooting in live view.

To change a setting using the live view *i* menu, follow these steps:

1. **Press the *i* button.**

The live view still photography *i* menu appears on the tilting monitor.

2. **Use the multi selector to highlight the desired setting.**

3. **Press OK to see the options.**

Figure 7-6 shows the options for the image quality.

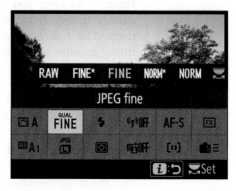

FIGURE 7-6:
The live view *i* menu option for setting image quality.

4. **Rotate the main command dial to select an option.**

5. **Press OK.**

The option you chose is now in effect, and you're returned to the *i* menu.

6. **Press the shutter-release button halfway to exit the *i* menu.**

You can customize the live view *i* menu to suit your working preference. When you press the *i* button, the *i* menu appears on your tilting monitor. To modify the setting for each position of the live view *i* menu, follow these steps:

1. **Press the MENU button to display the camera menus, and then use the multi selector to navigate to the Custom Settings menu.**

2. Press the left arrow on the multi selector.

The icon is highlighted.

3. Press the right arrow on the multi selector to place the cursor inside the Custom Settings menu, and then press the down arrow on the multi selector to select f2 Customize i Menu (Lv) (see Figure 7-7).

4. Press the right arrow on the multi selector to display the Customize *i* Menu (Lv) options.

The tilting monitor refreshes and displays the *i* menu (Lv) icons.

5. Use the multi selector to navigate to the position you want to modify (see Figure 7-8).

6. Press OK.

The available options are displayed on the tilting monitor (see Figure 7-9).

7. Press the down arrow on the multi selector to navigate to the desired option and press OK.

The option for that position of the *i* menu is now modified to suit your working preference.

8. Repeat Steps 5 through 7 to modify other *i* menu settings.

9. Press the MENU button to save the changes and return to the previous menu, or press the shutter-release button halfway to save the changes and resume shooting.

FIGURE 7-7:
The Customize i Menu (Lv) command.

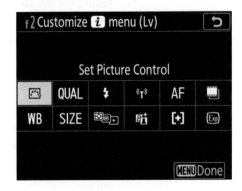

FIGURE 7-8:
Choosing a setting to modify.

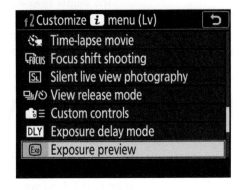

FIGURE 7-9:
Modifying a setting for a position on the *i* menu.

Creating Pictures with Touch Controls

When you create images or movies using live view, you can focus by touching and release the shutter by touching the tilting monitor. These options free you from having to use the shutter-release button to focus and take a picture.

By default, touch controls are enabled for shooting and playback. In Chapter 6, I show you how to enable touch controls for playback only. If you haven't changed the default options, you can focus and shoot using touch controls, as shown in this section.

To focus and release the shutter by touch, follow these steps:

1. **Rotate the live view selector to the icon that looks like a camera.**

2. **Press the live view button (see Figure 7-10).**

 The mirror locks up and the view captured by the lens appears on the tilting monitor.

3. **Compose the image.**

4. **Touch the part of the screen that contains the focal point of your image to achieve focus.**

 For example, if you're photographing a person, touch the eye.

5. **Remove your finger from the tilting monitor.**

 The shutter releases and the camera processes an image.

FIGURE 7-10:
Press the live view button to enable live view mode.

TIP

While shooting in live view, touch the icon that looks like a hand with a pointing forefinger to modify touch control settings.

Making Live View Work for You

Live view is a great option for creating images and recording movies. The default live view settings work well for many photographers, but you can explore other options, as I show you in the upcoming sections.

Displaying shooting information

When you create images in live view, you have easy access to shooting information and the virtual horizon. To access different screens of information, press the Info button. You have four displays at your disposal:

» **Complete shooting information:** The first time you press the Info button, you see a screen (see Figure 7-11) that displays the following:

- Autofocus area
- Whether face detection is enabled
- Picture Control
- White balance
- Image area and size
- Exposure information
- ISO
- Battery life

FIGURE 7-11:
All the shooting information.

» **Simplified shooting information:** The second time you press the Info button, you see a simplified screen (see Figure 7-12), which displays the following:

- Shooting mode
- Exposure information
- Battery life
- ISO

FIGURE 7-12:
Shooting information simplified.

» **Histogram:** The third time you press the Info button, a histogram is displayed (see Figure 7-13) when you shoot in programmed auto (P), shutter-priority auto (S), aperture-priority auto (A), or manual (M) mode. To display this screen, you must first choose On

FIGURE 7-13:
Displaying the histogram.

for the Custom Setting menu command d9: Exposure Preview (Lv) command.

» **Virtual horizon:** The fourth time you press the Info button, the virtual horizon appears on the tilting monitor (see Figure 7-14), which enables you to visually level the camera.

FIGURE 7-14:
Using the virtual horizon.

The display screens are identical when you record a movie, with the exception of the first screen, which displays the movie frame size, frame rate, and minutes remaining.

Using zoom preview

When you shoot in live view, you can quickly cut to the chase and see what certain parts of the scene you're about to photograph look like by using zoom preview. When you use zoom preview, you can zoom in on the view the lens is currently pointed at, and then scroll to different areas.

To use zoom preview, follow these steps:

1. **Rotate the live view selector to live view photography or movie live view, and then press the live view button.**

 I know that seems obvious, especially because this is a chapter on live view, but my editor says I need to cover the bases.

2. **Press the zoom in/QUAL button to zoom in.**

 Each time you press the button, the level of magnification increases.

 REMEMBER

 When you increase magnification in live view mode, a navigation window appears in the lower-right side of the display. Inside the window is a gray area, which indicates the part of the scene you've zoomed to.

3. **Use the multi selector to scroll to parts of the frame that are not visible in the monitor.**

Exploring other useful live view options

Live view photography can be the bee's knees for certain picture-taking situations. And the fact that you can touch the tilting monitor to focus and take a picture makes live view a handy option for many photographers.

The following list shows some useful options when shooting in live view.

» **Auto-area AF face/eye detection:** When shooting with auto-area AF, you can enable face and eye detection from the Custom Settings menu. The menu option is a5: Auto-Area AF Face/Eye Detection. The default option is On, but you can choose one of the following options:

- Face and eye detection on

- Face detection on

- Off to disable face and eye detection

When either of these options is enabled, and the camera detects faces or eyes, an amber-colored focus point appears around the subject's face or eyes.

» **Flicker reduction:** Enable flicker reduction if you notice flickering or banding on the tilting monitor when the scene you're photographing is lit with fluorescent, mercury vapor, or sodium lamps. You find the flicker reduction command on the photo shooting menu.

» **Focus peaking:** When you create close-up photographs of subjects like jewelry, antiques, and other small objects (macro photography) or shoot in low-light conditions, you may have to resort to manual focus (see Chapter 4). When you focus manually, you can enable focus peaking, which places a colored outline around objects that are in focus.

To enable focus peaking, go to the Custom Settings menu and enable d11: Peaking Highlights. When you choose this option, you can specify sensitivity (high, standard, or low) and choose the following peaking highlight colors: red, yellow, blue, or white. Choose a color that is different than the subject matter you're photographing.

» **Low-light AF:** If your camera is having a difficult time achieving focus in low-light conditions, and you don't want to focus manually, this option may work for you if you're shooting with AF-S mode. You find the low-light AF command on the Custom Settings menu.

You can only use low-light AF when shooting still photography. It isn't available when shooting in Auto, when using special effects mode, when creating a time-lapse movie, or during interval-timer photography.

SHOOTING IN LIVE VIEW IF YOU WEAR GLASSES

If you wear glasses, creating images using live view can be difficult, especially if you wear bifocals, trifocals, or progressive lenses. Trying to find the right distance to clearly see the tilting monitor is a challenge. I totally empathize with you because I have the same issue. The way I solved this problem was to take my camera to a store that sells reading glasses. My first step was to try on a pair of glasses that fit comfortably and enabled me to read the fine print on the package. My next step was to enable live view on my camera. If the tilting monitor looked clear and I could read the information, I bought the glasses and put them in my camera bag for the next time I wanted to shoot using live view.

» **Silent live view photography:** When you're shooting an event where you need to be as unobtrusive as possible (like a wedding), you can enable the electronic shutter. With this option, the shutter is muted, and the camera is relatively quiet when the shutter-release button is pressed. You find the silent live view photography option in the photo shooting menu. When you enable silent live view photography, the number of frames you can capture per second is fewer than when shooting in continuous low speed (CL) or continuous high speed (CH) release mode.

Chapter **8**

Recording Movies with Live View

I n addition to being an excellent camera for still photography, your Nikon D780 is a superb video camera. You can create movies automatically, or drill down and use settings to create high-definition (HD) video. You can specify video quality, frame rate, file format, and much more.

In this chapter, I show you everything you ever wanted to know about creating videos on your D780 but were afraid to ask. I explain the settings used to create squeaky-clean video for the Internet or for viewing on your TV monitor. In addition, I share some tips for creating *better* movies. If you want to be the next Steven Spielberg, read on.

Making Movies with Your Camera

With your Nikon D780, you hold in your hands (or your camera bag!) a tool that allows you to make amazing movies — the kinds of movies you pay big bucks to see in movie theaters! In the following sections, I show you how to capture video and perform other movie-shooting tasks with your camera.

Recording movies

Recording movies on your Nikon D780 is easy: Flip a switch, push a button, and you're recording. You see the whole movie unfold on the tilting monitor. When you've finished your candidate for next year's Academy Awards, push the button again to stop recording. You can preview the movie on the tilting monitor to decide whether you want to keep it.

When recording movies in Auto mode, the camera automatically determines the aperture, shutter speed, and ISO based on the current ambient lighting conditions. If you need to record a movie quickly without mucking with a bunch of settings, this option is for you. Think of this as the equivalent of a point-and-shoot camera.

To quickly record a movie using your D780, follow these steps:

1. **Press the mode dial lock release, and rotate the mode dial to Auto.**

 The camera automatically chooses the optimal settings for the subject matter and lighting conditions.

 TECHNICAL STUFF

 You can also shoot movies in shutter-priority auto (S) mode, where you set the shutter speed and ISO and the camera provides the aperture, or aperture-priority auto (A) mode, where you provide the aperture and ISO and the camera automatically sets the shutter speed. And finally, you can shoot in manual (M) mode, where you set the ISO, shutter speed, and aperture. All these modes are similar to shooting still pictures in modes other than Auto (see Chapter 9).

2. **Rotate the live view selector to movie live view (the icon looks like a movie camera shown), as shown in Figure 8-1.**

3. **Press the live view button.**

 The mirror locks up, and the view captured by the lens appears on the monitor.

4. **Press the movie-record button (the red button near the power switch).**

 A recording indicator appears in the monitor. A time remaining indicator also appears in the monitor.

 FIGURE 8-1:
 Press this button to enable live view.

5. **To stop recording, press the movie-record button again.**

 The camera stops capturing video.

6. **Press the live view button.**

 You exit live view.

A movie is a collection of still images that are compiled into the file format you specify and then played back. If you've ever created stick figures on a pad of paper, and then flipped through the pages to see them move, this is similar to what happens when you create a movie with your camera.

To capture a JPEG image while recording a movie, press the shutter-release button.

When shooting video set the ISO sensitivity to auto ISO. When you choose this option and create a video in a place with different brightness values, the camera automatically adjusts the ISO to compensate for different lighting as you pan the camera. This ensures sharp, blur-free video.

Displaying video shooting information

When recording video, you can display a lot of shooting information, a little shooting information, or no shooting information. You can display the aperture and shutter speed, battery information, exposure compensation scale, autofocus mode, and much more, depending on which information screen you access.

To view information when recording movies, press the Info button. You have four displays at your disposal:

>> **Complete shooting information:** The first time you press the Info button, you see a screen that displays the following:

- Shooting mode

- AF-area mode

- Active D-Lighting

- White balance mode

- Image area

- Frame size and rate

- Time (total amount of time that can be recorded, which counts down after you press the shutter-release button)

- Attenuator mode

- Audio mode

- Audio amplitude indicators

- Battery life

- Metering mode

- Shutter speed

- Aperture

- ISO

>> **Simplified shooting information:** The second time you press the Info button, you see a simplified screen, which displays the following:

- Shooting mode

- Battery life

- Metering mode

- Shutter speed

- Aperture

- ISO

>> **Histogram:** The third time you press the Info button, a histogram is displayed. To display this screen, you must first choose On for the Custom Setting menu command d9: Exposure Preview (Lv).

>> **Virtual horizon:** The fourth time you press the Info button, the virtual horizon appears on the tilting monitor, which enables you to visually level the camera.

Using the movie *i* menu

The movie *i* menu (see Figure 8-2) gives you the ability to quickly change frequently used settings. The *i* menu appears when you press the *i* button. You can change the following settings using the movie *i* menu:

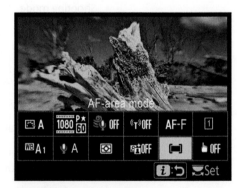

>> **Set Picture Control:** Select the Picture Control you use to create the image.

>> **Frame Size and Rate/Image Quality:** Select the frame size, frame rate, and image quality used to create movies.

FIGURE 8-2:
The movie *i* menu.

>> **Wind Noise Reduction:** Enable wind noise reduction.

>> **Wi-Fi Connection:** Connect to a local network (see Chapter 10).

>> **Autofocus Mode:** Select your desired autofocus mode (see Chapter 10).

>> **Destination:** Specify which memory card your movies will be stored on.

>> **White Balance:** Specify which white balance mode will be used when creating a movie.

>> **Microphone Sensitivity:** Specify microphone sensitivity to suit current conditions (see "Changing audio recording options," later in this chapter).

>> **Metering:** Specify the metering mode (see Chapter 9).

>> **Active D-Lighting:** Enable Active D-Lighting (see Chapter 12).

>> **AF-Area Mode:** Select the AF-area mode.

>> **Electronic VR:** Enable electronic vibration reduction.

To change a setting using the movie *i* menu, follow these steps:

1. **Press the *i* button.**

 The movie *i* menu appears on the monitor (refer to Figure 8-2).

2. **Use the multi selector to highlight the desired setting.**

3. **Press OK to see the options.**

4. **Rotate the main command dial to select an option.**

5. **Press OK.**

 The option you chose is now in effect, and you're returned to the *i* menu.

6. **Press the shutter-release button halfway to exit the *i* menu.**

REMEMBER

You can modify the movie *i* menu by using the g1: Customize *i* Menu command in the Custom Settings menu. The technique is the same as I show you for modifying the live view still photograph *i* menu in Chapter 7.

Changing video dimensions and frame rate

Your camera can capture high-definition video with dimensions of up to 3,840 x 2,160 pixels and a frame rate up to 120 fps. You can modify the video dimensions and frame rate to suit your intended destination. To change video dimensions and frame rate, follow these steps:

1. **Press the MENU button.**

 The camera menus appear on the tilting monitor.

2. **Press the down arrow on the multi selector to select the Movie Shooting menu, and then press the left arrow on the multi selector to highlight the icon.**

3. **Press the right arrow on the multi selector to place the cursor inside the menu, and then press the down arrow on the multi selector to highlight Frame Size/Frame Rate (see Figure 8-3).**

FIGURE 8-3:
The Frame Size/Frame Rate command.

4. **Press the right arrow on the multi selector to display the Frame Size/Frame Rate options (see Figure 8-4).**

 There are many options from which to choose. In most cases, a setting of "1920x1080; 30p" will yield excellent results. If you're a newcomer to video, I suggest you use that option.

 I discuss frame rates in the "Understanding frame rates" sidebar, later in this chapter.

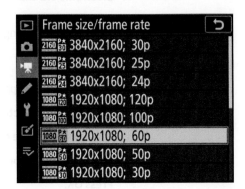

FIGURE 8-4:
Choosing the frame size and frame rate of your movie.

5. **Press the down arrow on the multi selector to select the desired frame size and frame rate and then press OK.**

 Movies will be recorded with the specified frame size and frame rate.

After you choose an option, the amount of recording time is displayed on the monitor when you enable live view and move the live view selector to movie live view. This is the maximum duration for a movie with the specified frame size and frame rate.

TECHNICAL STUFF

The maximum duration for a movie recorded with a frame size of 3,840 x 2,160 pixels and a frame rate of 24p, 25p, 30p, 100p, or 120p or a frame size of 1,920 x 1,080 pixels and a frame rate of 24p, 25p, 30p, 50p, or 60p is 29 minutes and 56 seconds. If you choose a frame size of 1,920 x 1,080 pixels and a frame rate of 30p x 4, 25p x 4, or 24p x 4 (these frame rates are for slow-motion movies), the maximum duration of the movie is 3 minutes.

UNDERSTANDING FRAME RATES

Your camera is capable of recording video at multiple frame rates. This gives you tremendous flexibility, but at the same time it can be somewhat daunting. When you choose a higher frame rate, the resulting video is smoother, which is important if you're creating videos of subjects that move. Video frame rate is a complicated subject. If you decide you want the highest-quality video, which is HD 4K (your D780 records 4K video with dimensions of 3,840 x 2,160 pixels), your only frame rate options on the D780 are 24 fps, 25 fps, or 30 fps.

Unless you're a pro at editing video, I suggest you stick to a frame rate of 24 fps or 30 fps for videos displayed on the Internet or for broadcast on a TV set, or 25 fps if you create video for broadcast where the PAL format is used. The higher frame rates can be used to good effect in a video-editing program like Adobe Premiere Pro or Adobe Premiere Elements. You can use the higher frame rates to create special effects like slow motion by editing them at a slower frame rate in a video-editing program. But if you really want to do slo-mo, your camera can deliver that automatically as discussed earlier. So, when you're going to record some video with your camera, keep calm and eat a cupcake.

TIP

To create a slow-motion movie, choose one of the following:

>> 1920x1080; 30p x 4

>> 1920x1080; 25p x 4

>> 1920x1080; 24p x 5

TECHNICAL STUFF

When you choose one of the slow-motion options, the camera records the video at a higher frame rate but processes the video so that it plays back at a lower frame rate. For example, if you choose "1920x1080; 30p x 4," the camera records the footage at 120 frames per second (fps), but when it's played back, the frame rate is 30 fps, which slows everything way down.

TIP

You can access the frame size and frame rate settings from the movie *i* menu.

Choosing the movie quality

In addition to specifying the frame size and frame rate, you can specify the quality of the movie. The quality of the movie determines the bit rate and file size. To specify movie quality, follow these steps:

1. **Press the MENU button.**

 The camera menus appear on the monitor.

2. **Press the down arrow on the multi selector to select the Movie Shooting menu, and then press the left arrow on the multi selector to highlight the icon.**

3. **Press the right arrow on the multi selector to place the cursor inside the menu, and then press the down arrow on the multi selector to highlight Movie Quality (see Figure 8-5).**

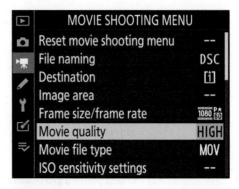

FIGURE 8-5:
Specifying movie quality.

4. **Press the right arrow on the multi selector to display the Movie Quality options (see Figure 8-6) and choose one of the following:**

 - *High quality:* Choose this option for movies you're going to play on a TV monitor. These files will be larger than movies recorded at normal quality.

 - *Normal:* Choose this option for movies you're going to upload to the Internet.

REMEMBER

Movies with a frame size of 3,840 x 2,160 pixels will only be recorded at high quality. If you try to choose normal for that frame size, the option will not be available.

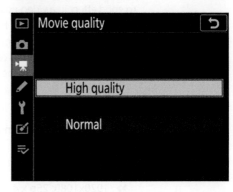

FIGURE 8-6:
Choosing the desired movie quality.

5. **Press OK.**

 Movies will be recorded at the specified quality until you revisit this menu and choose a different option.

TECHNICAL
STUFF

The frame size and frame rate, combined with the movie quality, determine the maximum bit rate, in megabits per second (Mbps), that the movie is recorded with. A higher bit rate means better quality at the expense of a larger file size.

Choosing the movie file format

When you record a movie with your D780, you have two file formats from which to choose. One format is readymade for uploading to the web or YouTube and the

other is ideal if you want to edit the movie using third-party software like Adobe Premiere.

To specify the movie file format, follow these steps:

1. **Press the MENU button.**

 The camera menus appear on the tilting monitor.

2. **Press the down arrow on the multi selector to select the Movie Shooting menu, and then press the left arrow on the multi selector to highlight the icon.**

3. **Press the right arrow on the multi selector to place the cursor inside the menu, and then press the down arrow on the multi selector to highlight Movie File Type (see Figure 8-7).**

4. **Press the right arrow on the multi selector to display the file type options (see Figure 8-8) and choose one of the following:**

 - *MOV:* Choose this file type if you want to edit the movie.

 - *MP4:* Choose this file type if you're going to upload the movie to the Internet.

5. **Press OK.**

 Movies will be recorded in the specified file type.

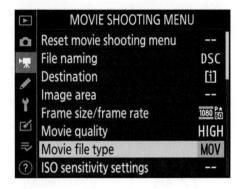

FIGURE 8-7:
Choosing the desired file type.

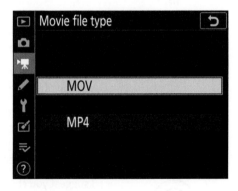

FIGURE 8-8:
Choose MOV or MP4.

Changing audio recording options

When you record video with your Nikon D780, you record audio as well. You can change the recording level, disable audio, and enable a wind filter and a sound attenuator. And you thought those little holes in the front of the camera were just a dinky microphone!

To beef up the audio in your movies, follow these steps:

1. **Press the MENU button.**

 The camera menus appear on the tilting monitor.

2. **Press the down arrow on the multi selector to select the Movie Shooting menu, and then press the left arrow on the multi selector to highlight the icon.**

3. **Press the right arrow on the multi selector to place the cursor inside the menu, and then press the down arrow on the multi selector to highlight one of the following options:**

 - *Attenuator:* This option enables you to record in loud environments by reducing microphone gain. This prevents audio distortion. Your options are to enable or disable this feature.

TIP

 If you enable this option to record in an environment with loud noises, remember to disable the option when you record in a normal environment.

 - *Frequency Response:* This command has two options, wide and vocal range. I recommend using the default wide option, unless you're creating instructional videos.

 - *Headphone Volume:* This command enables you to increase or decrease the volume of audio sent to an external headphone connected to the camera.

 - *Microphone Sensitivity:* This command enables you to let the camera automatically set the microphone volume to the current environment. With this option, you may notice a fluctuation in volume if you're recording an event or subject that is silent for periods and then talks.

TIP

 I suggest you choose the manual option, which enables you to adjust the sensitivity from 1 to 20 with the multi selector up and down arrows. When you do this, you have two meters that show the amplitude for the left and right channels. Adjust the gain (think microphone sensitivity) so that the meters bounce to 12 or slightly higher on the scale, but don't go into the red. If you see red when the volume is the loudest, choose a lower value. Your other option is to disable the camera microphone.

 - *Wind Noise Reduction:* This command lets you enable the camera's wind noise reduction option, which is probably adequate for a gentle breeze but not so much for a strong wind. If you're in a really strong wind, your best option is an external microphone with a *windshield* (a piece of foam rubber that fits snugly over the microphone).

4. **Follow the prompts to enable the command and then press the shutter-release button halfway to resume shooting or recording video.**

If you use your camera to record events for clients, or you record a lot of video and want the best audio quality possible, consider purchasing an external microphone that will plug into the camera audio port and slide into the camera's accessory shoe.

If you purchase an external microphone for your camera, make sure it comes with a foam windscreen.

Choosing a Picture Control

When you record a video in Auto mode, you can let the camera make all the decisions for you, which is the easy way out. However, if you're a creative videographer, you can choose a Picture Control to create a unique video.

Here's how you do it:

1. **Press the MENU button.**

 The camera menus appear on the tilting monitor.

2. **Press the down arrow on the multi selector to select the Movie Shooting menu, and then press the left arrow on the multi selector to highlight the icon.**

3. **Press the right arrow on the multi selector to place the cursor inside the menu, and then press the down arrow on the multi selector to highlight Set Picture Control (see Figure 8-9).**

4. **Press the right arrow on the multi selector.**

 The Picture Control options appear on your monitor (see Figure 8-10).

5. **Press the down arrow on the multi selector to choose the desired Picture Control.**

 By default, the camera uses the same Picture Control as specified

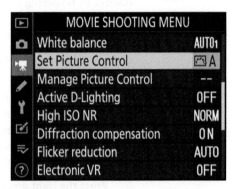

FIGURE 8-9:
Use a Picture Control to spice up your video.

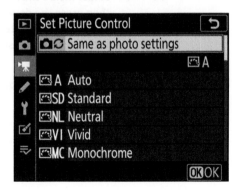

FIGURE 8-10:
Create a cool video by using a Picture Control.

in Photo Settings, but you can choose a different one for video. All the other Picture Control options are also available.

6. **Press OK.**

The Picture Control is used for future videos until you choose a different option.

Reducing flicker

If you shoot scenes or subjects illuminated by sodium lamps, mercury lamps, or fluorescent lamps, you may notice some flickering due to the nature of the light sources.

TIP

Always record 15 or 20 seconds of video as a test, just to make sure the end product will be satisfactory. If you notice flickering in your test video, you can reduce the amount by following these steps:

1. **Press the MENU button.**

The camera menus appear on the tilting monitor.

2. **Press the down arrow on the multi selector to select the Movie Shooting menu, and then press the left arrow on the multi selector to highlight the icon.**

3. **Press the right arrow on the multi selector to place the cursor inside the menu, and then press the down arrow on the multi selector to highlight Flicker Reduction (see Figure 8-11).**

4. **Press the right arrow on the multi selector.**

The Flicker Reduction options appear on your monitor (see Figure 8-12).

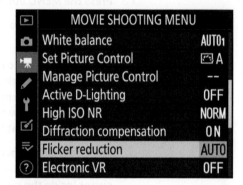

FIGURE 8-11:
The flicker Rx.

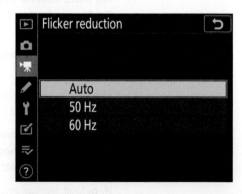

FIGURE 8-12:
Choosing a Flicker Reduction option.

5. **Choose the desired option.**

Auto is the default option. If that doesn't do the trick, choose the option that matches the frequency (50 HZ or 60 HZ) of the local power supply.

6. **Press OK.**

Flicker Reduction is now in effect.

Using Active D-Lighting

If you're recording video in an area with dark shadows and bright highlights, your camera may have a hard time compensating for the vast difference in brightness. Fortunately, your camera has an option that will bring out the details in shadow areas known as Active D-Lighting. If the shadow areas in your test video don't have enough details, here's how to compensate for it:

1. **Press the MENU button.**

The camera menus appear on the monitor.

2. **Press the down arrow on the multi selector to select the Movie Shooting menu, and then press the left arrow on the multi selector to highlight the icon.**

3. **Press the right arrow on the multi selector to place the cursor inside the menu, and then press the down arrow on the multi selector to highlight Active D-Lighting (see Figure 8-13).**

4. **Press the right arrow on the multi selector.**

The Active D-Lighting options appear on your monitor (see Figure 8-14).

5. **Choose the desired option.**

I recommend starting with normal and recording a few seconds of video. If the video still isn't satisfactory, choose a different setting.

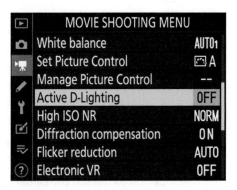

FIGURE 8-13:
Using Active D-Lighting to brighten the shadows.

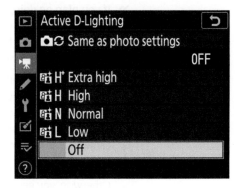

FIGURE 8-14:
Choosing an Active D-Lighting option.

6. **Press OK and then press the shutter-release button halfway.**

You're ready to record more video.

Making the Best Movies You Can

Your camera captures awesome video. I've used my Nikon D780 to capture some beautiful video from nearby beaches. When winter arrives here in Florida, where I live, I'll send a copy of the video to my relatives who live north of the Mason–Dixon Line to show them how the other half lives. I've also seen some awesome videos on the web that were shot with this camera.

TIP

Here are a few tips for making your movies even better:

>> **For the best results, consider purchasing a high speed UDMA card that writes data at a speed of 120MB per second.**

>> **If you're shooting in aperture-priority auto (A) mode or shutter-priority auto (S) mode, make sure the shutter speed is faster than the chosen frame rate.** You get the best results if the shutter speed is twice the frame rate, or as close as you can get to the frame rate. For example, if the frame rate is 30 fps, make sure the shutter speed is 1/60 of a second.

>> **Don't point the camera directly at the sun when shooting video.** Doing so can damage the camera sensor.

>> **Mount the camera on a tripod.** It's hard to hold a camera steady for a long time while recording video. If your tripod has a pan head, you're in business.

>> **Pan slowly.** If you pan too fast, your video will look amateurish.

>> **If you plan on doing a lot of video recording with your camera, consider purchasing a device that steadies the camera (such as a Steadicam) while you move.** You can find these at your favorite camera retailer that also sells video equipment. A less expensive alternative to steady your camera is a DJI gimble.

>> **You get better quality audio if you use an external microphone.** You can purchase an external microphone that will plug into the port on the side of your camera that slides into the camera's accessory shoe. In addition to capturing better-quality audio, an external microphone doesn't pick up camera operating noises.

>> **Remember to push the live view button when you're finished recording.** Otherwise, you get several minutes of very choppy video as you move to the next scene. Worst-case scenario, you capture video of your feet shuffling on the sidewalk.

Chapter **9**

Getting the Most from Your Camera

Your camera has a plethora of features that are designed to enable you to capture stunning images. If you're a geek photographer like me, who likes having complete control over every aspect of your photography, you'll love the features I show you in this chapter.

Shooting with Two Cards

The fact that your camera has two memory card slots gives you a tremendous amount of flexibility. You can

>> **Use the second memory card as overflow when you fill up the first card with images.** You can never have too much memory!

>> **Use the second memory card for backup.** Here, the images are written to both cards. That way, if one of the memory cards fails, you still have all the

images on the other card. This option is useful if you're photographing an assignment for a client, or creating images you could never replace if the card in Slot 1 failed.

>> **Store different image formats on each card.** Here, RAW images are saved on Card 1 and JPEG versions of those same images are saved in Slot 2. This option is wonderful if, for example, you're shooting a wedding and you want to post images online immediately. You can use the JPEG images for a web gallery where your client can review images and pick their favorites. When someone orders images from your online gallery, you can edit the RAW images to perfection in your favorite image-editing application.

To specify how your camera writes images to two cards, follow these steps:

1. **Press the MENU button.**

 The camera menus appear on the tilting monitor.

2. **Press the down arrow on the multi selector to select the Photo Shooting menu, and then press the left arrow on the multi selector to highlight the icon.**

3. **Press the right arrow on the multi selector to place the cursor inside the menu, and then press the down arrow on the multi selector to highlight Role Played by Card in Slot 2 (see Figure 9-1).**

4. **Press the right arrow on the multi selector.**

 The options for the role played by the card in Slot 2 are displayed (see Figure 9-2).

5. **Choose one of the following options:**

 • *Overflow:* The camera saves images to the card in Slot 2 when the card in Slot 1 is full.

 • *Backup:* The camera saves each image to the card in Slot 1, and backs up each image to the card in Slot 2.

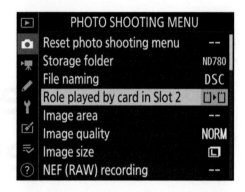

FIGURE 9-1:
Choosing what the card in Slot 2 is used for.

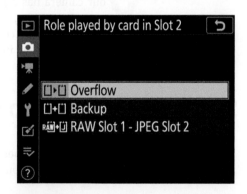

FIGURE 9-2:
The options for the card in Slot 2.

- *RAW Slot 1 – JPEG Slot 2:* When you choose NEF (RAW) + JPEG as the setting for capturing images, the RAW images are saved to the card in Slot 1, and the JPEG images are saved to the card in Slot 2.

6. **Press OK and then press the shutter-release button halfway.**

You're returned to shooting mode.

Understanding Metering

Your camera's metering device examines the scene and determines which shutter speed and f-stop combination will yield a properly exposed image. The camera can choose a fast shutter speed and large aperture, or a slow shutter speed and small aperture.

When you take pictures in Auto mode, the camera makes both decisions for you. But you're much smarter than the processor inside your camera. If you take control of the reins and supply one piece of the puzzle, the camera will supply the rest. When you're taking certain types of pictures, it makes sense to use aperture-priority auto (A) mode and determine which f-stop will be best for what you're photographing. In other scenarios, it makes more sense to use shutter-priority auto (S) mode and choose the shutter speed. When you do either, the camera meters the available light and fills in the other part of the exposure equation. The metering mode you choose determines whether the camera uses the entire frame or what part of the frame it uses to meter available light.

Understanding how exposure works in the camera

Your D780 exposes images the same way film cameras did. Light enters the camera through the lens and is recorded on the sensor. The amount of time the shutter is open and the amount of light entering the camera determines whether the resulting image is too dark, too bright, or properly exposed.

The duration of the exposure is the *shutter speed.* Your camera has a shutter speed range from as long as 30 seconds to as fast as 1/8000 second. A fast shutter speed stops action, and a slow shutter speed leaves the shutter open for a long time to record images in low-light situations. You can also use a slow shutter speeds for special effects.

TECHNICAL STUFF

You can increase the shutter speed up to 900 seconds (15 minutes) if you specify this duration in the d6: Extended Shutter Speeds (M) area of the Custom Settings menu.

The *aperture* is the opening in the lens that lets light into the camera when the shutter opens. You can change the aperture diameter to let in a lot of light or a little light. The f-stop value determines the size of the aperture. A low f-stop value (large aperture) lets a lot of light into the camera, and a high f-stop value (small aperture) lets a small amount of light into the camera. Depending on the lens you're using, the f-stop range can be from f/1.2, which sends huge gobs of light into the camera, to f/32, which lets a miniscule splash of light into the camera. The f-stop also determines the depth of field, a concept I explain in "Controlling depth of field," later in this chapter.

The duration of the exposure (shutter speed) and aperture (f-stop value) combination determines the exposure. For each lighting scenario you encounter, several different combinations render a perfectly exposed photograph. Use different combinations for different types of photography. The camera's metering device examines the scene and determines which shutter speed and f-stop combination will yield a properly exposed image. The camera can choose a fast shutter speed and large aperture, or a slow shutter speed and small aperture.

Choosing a metering mode

The metering mode you choose depends on your subject matter. You may choose one metering mode for photographing landscapes and architecture, another mode for photographing bright subjects surrounding by darkness (for example, a singer in a stage spotlight), and yet another metering mode for scenes with bright highlights.

To set the camera metering mode, follow these steps:

1. **Press and hold the zoom out/metering button (see Figure 9-3).**

2. **Rotate the main command dial to choose one of the following options:**

 - *Matrix metering:* Use this metering mode to create natural-looking images when the scene you're photographing is evenly lit. This metering mode is great for photographing landscapes and architecture.

 - *Center-weighted metering:* Use this metering mode when your center of interest is in the middle of the frame.

FIGURE 9-3:
The zoom out/metering button.

- *Spot metering:* This metering mode meters a small area of the frame. Use this metering mode when your subject is brighter or darker than the background, to properly expose your subject.

- *Highlight-weighted metering:* Use this metering mode when you need to preserve detail in the highlights (for example, when photographing a singer illuminated by spotlights on a stage).

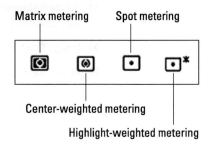

Matrix metering Spot metering

Center-weighted metering

Highlight-weighted metering

The metering mode is displayed in the viewfinder and on the control panel. Figure 9-4 shows the icons for the different metering modes.

FIGURE 9-4:
Choosing a metering mode.

3. **Release the zoom out/metering button.**

You're ready to create images with the specified metering mode.

TIP

In most instances, matrix metering should be your go-to mode. If upon reviewing an image, the results are unsatisfactory, switch to a different metering mode.

TIP

You can also choose a metering mode using the still photography *i* menu. I discuss the still photography *i* menu in the "Using the Still Photography *i* Menu" section of this chapter.

Using the Still Photography *i* Menu

The still photography *i* menu (see Figure 9-5) gives you the ability to quickly change frequently used settings. The *i* menu appears on the tilting monitor when you press the *i* button. You can change the following settings using the still photography *i* menu:

>> **Set Picture Control:** Choose the Picture Control you use to create images (see Chapter 4).

>> **Image Quality:** Choose the image quality used to create images (see Chapter 5).

>> **Flash Mode:** Choose the Flash Mode used with a supported Nikon Speedlight (see Chapter 11).

>> **Wi-Fi Connection:** Connect to a local Wi-Fi network (see Chapter 10).

>> **Autofocus Mode:** Choose the desired autofocus mode (see Chapter 10).

>> **Choose Image Area:** Choose the desired image area (see Chapter 5).

>> **White Balance:** Specify the White Balance setting used to capture images (see Chapter 11).

>> **Image Size:** Specify the size of the images you create (see Chapter 5).

>> **Metering:** Choose the metering mode used to create images (see "Choosing a metering mode," earlier in this chapter).

>> **Active D-Lighting:** Enable Active D-Lighting (see Chapter 12).

>> **AF-Area Mode:** Choose the AF-area mode (see Chapter 10).

>> **Custom Controls:** Assign the role played by buttons such as the AF-ON button.

To change a setting using the still photography *i* menu, follow these steps:

1. **Press the *i* button.**

 The still photography *i* menu appears on the tilting monitor (see Figure 9-5).

2. **Use the multi selector to highlight the desired setting.**

3. **Press OK to see the options.**

 Figure 9-6 shows the options for Image Quality.

4. **Rotate the main command dial to select an option.**

5. **Press OK.**

 You're returned to the *i* menu.

6. **Press the shutter-release button halfway to exit the *i* menu.**

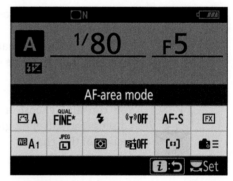

FIGURE 9-5:
The still photography *i* menu.

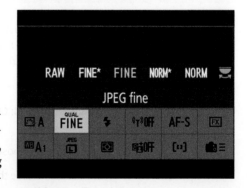

FIGURE 9-6:
The still photography *i* menu options for Image Quality.

You can customize the still photography *i* menu to suit your working preference. When you press the *i* button, the *i* menu appears on your tilting monitor. You have access to 12 settings you can change. You can modify the setting for each position of the still photography *i* menu as follows:

1. **Press the MENU button to display the camera menus, and then press the down arrow on the multi selector to navigate to the Custom Settings menu.**

2. **Press the left arrow on the multi selector.**

 The icon is highlighted.

3. **Press the right arrow on the multi selector to place the cursor inside the Custom Settings menu, and then press the down arrow on the multi selector to select f1: Customize *i* Menu (see Figure 9-7).**

4. **Press the right arrow on the multi selector to display the Customize *i* Menu options.**

 The tilting monitor refreshes and displays the *i* menu icons.

5. **Use the multi selector to navigate to the position you want to modify (see Figure 9-8).**

6. **Press OK.**

 The available options are displayed on the tilting monitor (see Figure 9-9).

7. **Press the down arrow on the multi selector to navigate to the desired option and press OK.**

 The option for that position of the *i* menu is now modified to suit your working preference.

8. **Repeat Steps 5 through 7 to modify other *i* menu settings.**

9. **Press the MENU button to save the changes and return to the previous menu, or press the shutter-release button halfway to save the changes and resume shooting.**

FIGURE 9-7:
The Customize *i* Menu command.

FIGURE 9-8:
Choosing a setting to modify.

FIGURE 9-9:
Modifying an *i* menu setting.

Choosing an Exposure Mode

You're reading this chapter because you're ready to take the training wheels off and take matters into your own hands. Auto mode works well in many instances, but there are times when you need to be creative and control depth of field or freeze an object moving faster than a speeding bullet. When these situations occur, you should choose an exposure mode that yields the result you're looking for. My favorite exposure mode is aperture-priority auto (A). The following sections describe each exposure mode and give you tips on when to use each.

Using programmed auto (P) mode

When you take pictures with the programmed auto (P) mode, the camera determines the shutter speed and aperture (f-stop value) that yields a properly exposed image for the lighting conditions. This may sound identical to Auto mode, but P mode, you can change the shutter speed and aperture to suit the scene or subject you're photographing.

To take pictures in programmed auto (P) mode, follow these steps:

1. **Press the mode dial lock release and then rotate the mode dial to P (see Figure 9-10).**

2. **Press the ISO button and rotate the main command dial to change the ISO sensitivity to the desired setting.**

 A higher ISO makes the camera's sensor more sensitive to light, which is ideal when you're photographing in dim light or at night. For more information on changing the ISO, turn to Chapter 10.

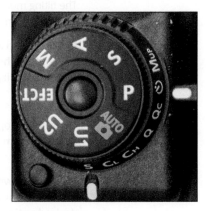

FIGURE 9-10:
Rotating the mode dial to P.

3. **Press the shutter-release button halfway to achieve focus.**

 The white dot on the left side of the viewfinder appears when the camera achieves focus. If you see a flashing right or left arrow, the camera can't achieve focus and you must manually focus the camera.

4. Check the shutter speed and aperture.

You can use the viewfinder or tilting control panel (see Figure 9-11) to check the shutter speed and aperture. If the combination will cause the image to be overexposed, the exposure indicator on the control panel and in the viewfinder will show a vertical line to the right of center. If the image is underexposed, the exposure indicator on the control panel and in the viewfinder will show a vertical line to the left of center.

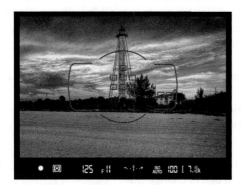 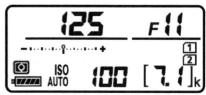

FIGURE 9-11:
Check the
shutter speed
and aperture.

5. Press the shutter-release button fully to take the picture.

The image displays almost immediately on your tilting monitor.

You can shift the exposure and choose a different shutter speed and aperture combination. Use this option when you want to shoot with a faster shutter speed to freeze action or a different aperture to control depth of field. This is known as *flexible program mode.* To shift the flexible program mode, follow these steps:

1. Follow Steps 1 through 3 of the preceding instructions and then press the shutter-release button halfway.

The camera achieves focus.

2. Rotate the main command dial.

As you rotate the dial, different shutter speed and aperture combinations appear on the control panel and in the viewfinder. If you're trying to freeze a fast-moving object, rotate the main command dial until a fast shutter speed appears. If depth of field is your goal, rotate the main command dial until a large aperture (low f-stop value) appears for a shallow depth of field, or until a small aperture (high f-stop value) appears for a large depth of field.

3. When you see the desired combination of shutter speed and aperture, press the shutter-release button fully to take the picture.

The image appears almost immediately on your tilting monitor.

Using aperture-priority auto (A) mode

If you like to photograph landscapes, aperture-priority auto (A) mode is right up your alley. When you take pictures using aperture-priority auto (A) mode, you choose the desired f-stop and the camera supplies the correct shutter speed to achieve a properly exposed image. A large aperture (small f-stop value) lets a lot of light into the camera, and a small aperture (large f-stop value) lets a small amount of light into the camera. The benefit of shooting in A mode is that you have complete control over the depth of field (see "Controlling depth of field," later in this chapter). You also have access to all the other options, such as setting the ISO, choosing a Picture Control when shooting in JPEG mode, choosing an AF mode or a release mode, and so on.

To take pictures with aperture-priority auto (A) mode, follow these steps:

1. **Press the mode dial lock release and then rotate the mode dial to A (see Figure 9-12).**

2. **Press the ISO button and then rotate the main command dial to change the ISO to the desired setting.**

 A higher ISO makes the camera sensor more sensitive to light, which is ideal when you're photographing in dim light or at night. For more information on changing ISO, see Chapter 10.

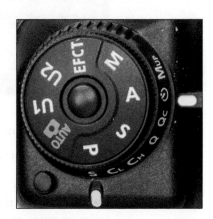

FIGURE 9-12:
Rotating the mode dial to A.

3. **Rotate the sub-command dial to select the desired f-stop.**

 As you change the aperture, the camera calculates the proper shutter speed to achieve a properly exposed image. The change appears on the control panel and in the viewfinder. As you rotate the main command dial, monitor the shutter speed in the viewfinder (see Figure 9-13). If the combination will cause the image to be overexposed, the exposure indicator on the control panel and in the viewfinder will show a vertical line to the right of center. If the image is underexposed, the

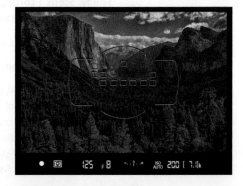

FIGURE 9-13:
Make sure the shutter speed is fast enough for a blur-free picture.

exposure indicator on the control panel and in the viewfinder will show a vertical line to the left of center.

4. **Press the shutter-release button halfway to achieve focus.**

A white dot appears in the viewfinder when the camera achieves focus.

5. **Press the shutter-release button fully to take the picture.**

The image appears on your tilting monitor almost immediately.

Controlling depth of field

Depth of field is how much of your image looks sharp and is in apparent focus in front of and behind your subject. When you're taking pictures of landscapes on a bright sunny day, you likely want a depth of field that produces an image in which you can see the details for miles and miles. . .. If you're taking portraits, where the person matters more than what's in front of or behind her, you want to have a very shallow depth of field in which your subject is in sharp focus but the foreground and background are a pleasant out-of-focus blur.

You control the depth of field in an image by selecting the f-stop in aperture-priority auto (A) mode and letting the camera do the math to determine which shutter speed will yield a properly exposed image. You get a limited depth of field when using a small f-stop value (large aperture), which lets a lot of light into the camera. A fast lens with a smaller aperture lets you shoot at a faster shutter speed. A fast lens:

» Has an f-stop value of f/2.8 or smaller

» Gives you the capability to shoot in low-light conditions

» Gives you a wonderfully shallow depth of field

When shooting at a lens's smallest f-stop value, you're letting the most amount of light into the camera, which is known as shooting "wide open." The lens you use also determines how large the depth of field will be for a given f-stop. At the same f-stop, a wide-angle lens has a greater depth of field than a telephoto lens does. When you're photographing a landscape, the ideal recipe is a wide-angle lens and a small aperture (large f-stop value). When you're shooting a portrait of someone, you want a shallow depth of field. Therefore, a telephoto lens with a focal length that is 85mm to 120mm with a large aperture (small f-stop value) is the ideal solution.

Figure 9-14 shows two pictures of the same subject. The first image was shot with an exposure of 1/640 second at f/1.8, and the second image was shot with an exposure of 1/80 second at f/10. In both cases, I focused on the subject. Notice how

much more of the image shot at f/10 is in focus. The detail of the flowers in the second shot distracts the viewer's attention from the subject. The first image has a shallow depth of field that draws the viewer's attention to the subject.

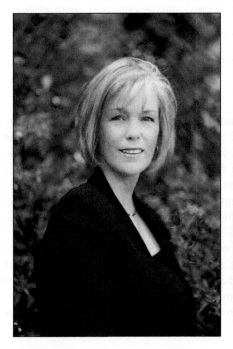

FIGURE 9-14:
The f-stop you choose determines the depth of field.

Using depth-of-field preview

When you compose a scene through your viewfinder, the camera aperture is wide open, which means you have no idea how much depth of field you'll have in the resulting image. You can preview the depth of field for a selected f-stop by pressing the Pv button on your camera, which closes the aperture to the f-stop you use to take the picture.

To preview depth of field, follow these steps:

1. **Compose the picture and choose the desired f-stop in aperture-priority auto (A) mode.**

See "Using aperture-priority auto (A) mode," earlier in this chapter if you need help.

2. **Press the shutter-release button halfway to achieve focus.**

A white dot appears on the left side of the viewfinder when the camera focuses on your subject.

3. **Press the Pv button (see Figure 9-15).**

 The button is conveniently located on the front right side of the camera near the sub-command dial when your camera is pointed toward your subject. You can easily locate the button by feel.

 When you press the button, the image in the viewfinder may become dim, especially when you're using a small aperture (large f-stop number) that doesn't let a lot of light into the camera. Don't worry — the camera chooses the proper shutter speed to compensate for the f-stop you select, resulting in a perfectly exposed image.

FIGURE 9-15: The Pv button.

TIP

When you use depth-of-field preview, pay attention to how much of the image is in apparent focus in front of and behind your subject. To see what the depth of field looks like with different f-stops, select what you think is the optimal f-stop for the scene you're photographing. Then press the shutter-release button halfway to achieve focus, as I outline earlier, and then rotate the main command dial to choose different f-stop values.

As long as you hold down the Pv button while you're choosing different f-stops, you can see the effect each f-stop has on the depth of field. I know, it's a bit of a juggling act, but given some practice, you'll get the hang of it. The alternative is to take several pictures of the subject with different f-stops and keep the one you like best.

Using shutter-priority auto (S) mode

When your goal is to accentuate an object's motion, choose shutter-priority auto (S) mode. When you take pictures in shutter-priority auto (S) mode, you choose the shutter speed and the camera supplies the proper f-stop value to properly expose the scene. Your camera has a shutter speed range from 30 seconds to 1/8000 second. When you choose a slow shutter speed, the shutter is open for a long time. When you choose a fast shutter speed, the shutter is open for a short duration and you can freeze action.

TECHNICAL STUFF

You can increase the shutter speed up to 900 seconds (15 minutes) if you specify this duration in the d6: Extended Shutter Speeds (M) area of the Custom Settings menu.

To take pictures in shutter-priority auto (S) mode, follow these steps:

1. **Press the mode dial lock release and then rotate the mode dial to S (see Figure 9-16).**

2. **Rotate the main command dial to choose the desired shutter speed.**

 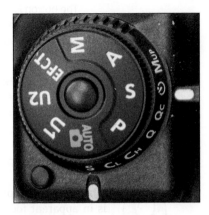

 FIGURE 9-16:
 Rotating the mode dial to shoot in shutter-priority auto (S) mode.

 As you change the shutter speed, the camera determines the proper f-stop to achieve a properly exposed image. If you notice that the shutter speed is too slow for a blur-free picture, you have to put the camera on a tripod or increase the ISO sensitivity setting. If the combination of shutter speed and aperture will cause the image to be overexposed, the exposure indicator on the control panel and in the viewfinder will show a vertical line to the right of center. If the image is underexposed, the exposure indicator on the control panel and in the viewfinder will show a vertical line to the left of center.

3. **Press the ISO button and then rotate the main command dial to change the ISO to the desired setting.**

 Choose an ISO that enables you to achieve the desired shutter speed. For more information on changing ISO, see Chapter 10.

4. **Press the shutter-release button halfway to achieve focus.**

 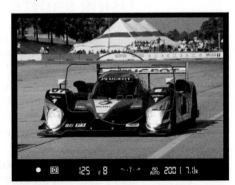

 FIGURE 9-17:
 Adjusting the shutter speed.

 A white dot appears in the left side of the viewfinder. If you see a flashing left or right arrow, the camera can't achieve focus. If this occurs, switch the lens to manual focus and twist the focusing barrel until your subject snaps into focus. Figure 9-17 shows the viewfinder when working in shutter-priority auto (S) mode.

5. **Press the shutter-release button fully to take the picture.**

 The image appears on your tilting monitor almost immediately.

Shutter-priority auto (S) mode is the way to go whenever you need to stop action or show the grace of an athlete in motion. You'd use shutter-priority auto (S) mode in lots of scenarios. Figure 9-18 shows the effects you can achieve with different shutter speeds. The image on the left was photographed with a slow shutter speed, and the image on the right was photographed with a fast shutter speed to freeze the action. For more information on using shutter-priority auto (S) mode when photographing sporting events, check out Chapter 13.

FIGURE 9-18:
A tale of two shutter speeds.

Using manual (M) mode

You can also manually expose your images. When you choose manual (M) mode, you supply the f-stop value *and* the shutter speed. You can choose from several combinations to properly expose the image for the lighting conditions. Your camera meter gives you some assistance to select the right f-stop and shutter speed combination to properly expose the image. (For a refresher on how your camera determines exposure, check out "Understanding how exposure works in the camera" earlier in this chapter.)

To manually expose your images, follow these steps:

1. **Press the mode dial lock release button and then rotate the mode dial to M (see Figure 9-19).**

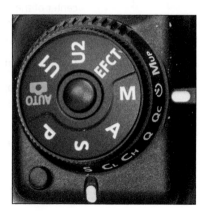

FIGURE 9-19:
Manually exposing the image.

2. Rotate the main command dial to set the shutter speed.

The shutter speed determines how long the shutter stays open. A slow shutter speed is perfect for a scene with low light. A fast shutter speed freezes action. As you change the shutter speed, review the exposure indicator on the control panel or, if you have the shutter-release button pressed halfway, in the viewfinder.

When the exposure is correct for the lighting conditions, the exposure level mark aligns with the center of the scale. Figure 9-20 shows the exposure indicator as seen in the control panel. If the exposure level mark is to the right of center, the image will be overexposed. If the exposure level mark is to the left of center, the image will be underexposed. Of course, you're in control. You may want to intentionally overexpose or underexpose for special effects. For example, if you slightly underexpose the image, the colors will be more saturated. You can also monitor exposure in the viewfinder using the scale on the right side of the viewfinder.

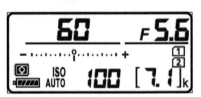

FIGURE 9-20:
Monitor the exposure on the control panel.

3. Rotate the sub-command dial to set the f-stop value.

The f-stop value determines how much light enters the camera. A small f-stop value, such as f/2.8, lets a lot of light into the camera and also gives you a shallow depth of field. A large f-stop value lets a small amount of light into the camera and gives you a large depth of field. As you change the f-stop value, review the exposure indicator on the control panel or, if you have the shutter-release button pressed halfway, in the viewfinder. When the exposure is correct for the lighting conditions, the exposure level mark aligns with the center of the scale. If the exposure level mark is to the right of the center, the image will be overexposed. If the exposure level mark is to the left of center, the image will be underexposed.

4. Press the shutter-release button halfway to achieve focus.

A white dot appears in the left side of the viewfinder when the camera has achieved focus. If you see a flashing left and right arrow, the camera cannot achieve focus and must be focused manually.

5. Press the shutter-release button fully to take the picture.

Introducing EFCT mode

There's one setting on the mode dial that may leave you scratching your head, especially if you've never used a Nikon camera before, and that's the EFCT mode

(known as Effects on older Nikon cameras). The EFCT mode is only available when you shoot in JPEG format. But if you like to create special effects quickly, the EFCT mode is for you.

For example, if you want to create a picture that looks like a graphic illustration, you'll find a mode that suits your creative bent after rotating the mode dial to EFCT. I show you how to create images using the EFCT mode in Chapter 12.

Creating Long Exposures Using Manual Mode

Instead of freezing motion, photographing subjects with a long exposure creates a dreamy image where the motion of the subject is accentuated. You may want to create images with long exposures when shooting subjects like waterfalls. Long exposures are also wonderful for creating images of city freeways at night; the long exposure captures a colorful image of a ribbon of car headlights on one side of the freeway and taillights on the other.

In the following sections, I show you how to shoot long exposures and how to enable noise reduction for long exposures.

Shooting long exposures

When you want to create a long exposure, you have two options: a time exposure or a bulb exposure. You create long exposures while shooting in manual (M) mode. Follow these steps:

1. **Mount the camera on a tripod.**

2. **Compose the image and focus the camera.**

 You can use manual focus or use a single AF point for focus. If you use the single AF point, press the shutter-release button halfway to achieve focus. When focus is achieved, continue to hold the shutter-release button halfway and then rotate the focus selector lock to L to lock the focus before removing your finger from the shutter-release button.

3. **Place the eyepiece cap over the eyepiece.**

 This prevents stray light from reaching the sensor through the eyepiece.

4. **Press and hold the mode dial lock release and rotate the mode dial to M (see Figure 9-21).**

5. **Rotate the main command dial to select one of the following options: bulb or time.**

 Rotate the dial until you see bulb or time (designated by --) on the control panel. The image on the left in Figure 9-22 shows the control panel when shooting a bulb exposure, and the image on the right shows the control panel when shooting a time exposure.

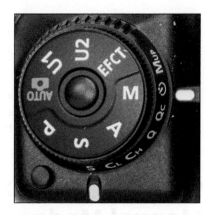

FIGURE 9-21:
Choose manual (M) mode to shoot a long exposure.

FIGURE 9-22:
Shooting a long exposure with bulb (left) or time (right).

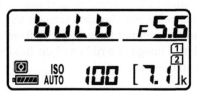

6. **Release the shutter.**

 If you choose bulb, the shutter releases when you press the shutter-release button. When shooting bulb, you hold the shutter open until the exposure is complete.

 If you choose time, the shutter releases when you press and release the shutter-release button.

7. **Close the shutter.**

 If you choose bulb, the shutter closes when you take your finger off the shutter-release button.

 If you choose time, the shutter closes when you press the shutter-release button a second time.

TIP

If you're shooting long exposures without a remote release, time is your best option. Use the self-timer to delay the release of the shutter to minimize any operator-induced blur. When you release the shutter to end the exposure, press the shutter-release button gently.

Figure 9-23 shows you the type of photograph you can create when shooting a long exposure with the bulb or time shutter option. This image is a 15-second time exposure. Notice the headlight and taillight trails.

FIGURE 9-23:
Create a
wonderfully
abstract image
with a long
exposure.

TIP

When shooting long exposures, I recommend you use a remote release to open and close the shutter.

TIP

By default, the longest exposure your D780 can capture is 30 seconds when shooting bulb or time. However, you can increase this by using the d6: Extended Shutter Speeds (M) option from the Custom Settings menu. You can increase the maximum exposure to 60 seconds, 90 seconds, 120 seconds, 180 seconds, 240 seconds, 300 seconds, 480 seconds, 600 seconds, 720 seconds, or 900 seconds.

Enabling long-exposure noise reduction

When you shoot long exposures, digital noise is a fact of life. If the images you capture using long exposures have areas of dark shadows, the noise is most noticeable in that tonal range. You may also notice areas of fog and bright lights in images captured with long exposures.

You can reduce this problem by following these steps:

1. **Press the MENU button.**

 The camera menus appear on the tilting monitor.

2. **Press the down arrow on the multi selector to select the Photo Shooting menu, and then press the left arrow on the multi selector to highlight the icon.**

3. Press the down arrow on the multi selector to highlight Long Exposure NR (see Figure 9-24).

4. Press the right arrow on the multi selector.

The long-exposure noise reduction options appear on the tilting monitor (see Figure 9-25).

5. Press the down arrow on the multi selector to highlight On, and then press OK.

Long-exposure noise reduction will be applied to image captures with long exposures.

Long-exposure noise reduction is applied after you release the shutter. This takes some time, roughly double the time it normally takes to process an image. While the image is processing, you see *Job nr* flashing on the control panel and in the viewfinder. You won't be able to take additional pictures until the processing is complete. If you turn off the camera before the processing is finished, the image will be saved but noise reduction won't be applied.

FIGURE 9-24:
The Long Exposure NR command.

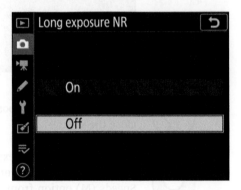

FIGURE 9-25:
Choose On to enable long-exposure noise reduction.

Modifying Camera Exposure

Your camera has a built-in metering device that automatically determines the proper shutter speed and aperture to create a perfectly exposed image for most lighting scenarios. However, sometimes you need to modify the exposure to suit the current lighting conditions. Modify camera exposure for individual shots, or hedge your bets and create several exposures of each shot.

Using exposure compensation

When your camera gets the exposure right, it's a wonderful thing. Sometimes, however, the camera doesn't get it right. When you review an image on the camera's tilting monitor and it's not exposed to suit your taste, you can compensate manually by increasing or decreasing exposure.

To manually compensate for camera exposure, follow these steps:

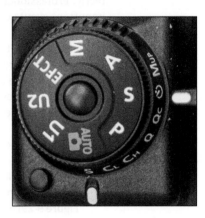

REMEMBER

1. **Press the mode dial lock release, and choose P, A, or S from the mode dial (see Figure 9-26).**

 Exposure compensation is available only when you take pictures in programmed auto (P) mode, aperture-priority auto (A) mode, or shutter-priority auto (S) mode.

2. **Press the shutter-release button halfway.**

 The camera meters the scene.

FIGURE 9-26:
Use exposure compensation with these shooting modes.

3. **Press the exposure compensation button (see Figure 9-27) and rotate the main command dial while looking in the viewfinder or at the control panel.**

 Rotate the dial clockwise to decrease exposure or counterclockwise to increase exposure. As you rotate the dial, you see the exposure indicator in the viewfinder and on the control panel move, which shows you the amount of exposure compensation you're applying (see Figure 9-28).

FIGURE 9-27:
The exposure compensation button.

4. **Press the shutter-release button fully to take the picture.**

5. **To cancel exposure compensation, press and hold the exposure compensation button, and then rotate the main command dial until the exposure indicator is in the center of the exposure compensation scale.**

 You see the exposure compensation scale in the viewfinder and on the control panel.

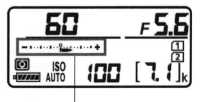

Exposure compensation indicators

FIGURE 9-28:
Using exposure compensation.

Bracketing exposure

When you're photographing an important event, properly exposed images are a must. Many photographers get lazy and don't feel they need to get it right in the camera when they have programs like Adobe Photoshop or Adobe Lightroom. But you get much better results when you process an image that's been exposed correctly. Professional photographers bracket their exposures when they photograph important events or places they may never visit again.

When you bracket an exposure, you take at least three pictures: one with the exposure as metered by the camera, one with exposure that's been decreased, and one with exposure that's been increased. You can bracket up to ±15 exposure value (EV) in ⅓ EV increments. Bracketing is only available in P, A, S, or M modes. You can also determine the number of frames that are bracketed.

To bracket your exposures, follow these steps:

1. **Press and hold the BKT button on the left side of the camera when pointed toward your subject (see Figure 9-29) and then rotate the main command dial to specify the number of images in the bracketing sequence.**

 As you rotate the dial, the number of frames appears on the control panel.

FIGURE 9-29:
Use this button to start a bracketing sequence.

2. **Press and hold the BKT button, and then rotate the sub-command dial to specify the bracketing increment.**

 Each time you rotate the dial, you increase the increment by ⅓ EV. If you choose an EV of 2 or 3, the maximum number of shots is 5. If you specify 7 or 9 in Step 1, the number of exposures is automatically set to 5. The number of frames and EV brackets are displayed on the control panel, and BKT appears in the viewfinder (see Figure 9-30).

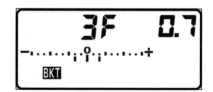

FIGURE 9-30:
Determining the number of frames in the sequence.

3. **Compose the image and press the shutter-release button halfway.**

 A white dot appears on the left side of the viewfinder when focus is achieved.

4. **Press the shutter-release button fully.**

The camera creates the number of images specified. For example, if you bracket five frames, the camera captures one image with standard exposure, two images with decreased exposure, and two images with increased exposure.

To determine the start of a bracketing sequence, place your hand in front of the lens and take a picture before you take the first picture in the sequence. Do the same after you capture the last image for the bracketing sequence. When you edit the images, the photo of your hand designates the start and end of the sequence, which is useful if you're using the image sequence to create a high dynamic range (HDR) image using third-party software.

Most third-party image-editing software will automatically align a set of bracketed exposures when merging them to an HDR image. However, for the best results, I recommend you place the camera on a tripod when bracketing exposure.

You can use Custom Menu Settings b1: EV Steps for Exposure Cntrl to change the EV value of each image bracketed from the default ⅓ EV to higher values. I recommend you stick with the default ⅓ EV, though, and not visit this option.

Locking focus and exposure

You can also lock focus and exposure on a specific part of the frame, which is handy when you want a specific part of the frame exposed correctly. For example, recently I was photographing a beautiful sunset. The camera meter averaged the exposure for the scene, and the image ended up with blown-out highlights around the sun and clouds that weren't as dark and colorful as I saw them. To compensate for this, I locked exposure on the blue sky, and the picture turned out perfectly.

To lock exposure, follow these steps:

1. **Press the AF-mode button (see Figure 9-31), rotate the main command dial, and choose AF-S.**

Your camera now has a single autofocus point in the middle of the frame.

2. **Use the multi selector to move the autofocus point over the area of the frame where you want to lock focus and exposure.**

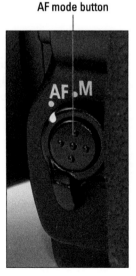

AF mode button

FIGURE 9-31:
Switching to AF-S mode.

3. **Press the AE-L/AF-L button (see Figure 9-32).**

 The AE-L icon appears in the viewfinder.

4. **Press the shutter-release button halfway to achieve focus.**

 A white dot in the viewfinder tells you that the camera has achieved focus.

5. **Press the shutter-release button fully to take the picture.**

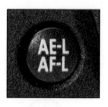

FIGURE 9-32:
Use this button to lock exposure and focus.

Choosing a Shutter-Release Mode

When you press the shutter-release button, the shutter opens once and captures an image. However, when photographing some subjects, such as sports, you may want to capture a sequence of images. If you're photographing a wedding, you may want to capture multiple images when pressing the shutter-release button, but do it as quietly as possible.

You can change release modes by doing the following:

1. **Press and hold the release mode dial lock release (see Figure 9-33).**

 This unlocks the release mode dial.

2. **Rotate the release mode dial (see Figure 9-33), and choose one of the following options:**

 - *S* (single frame): With this option the camera captures a single frame when you press the shutter-release button.

 - *CL* (continuous low speed): With this option, you press and hold the shutter-release button to capture up to 3 frames per second (fps).

 - *CH* (continuous high speed): With this option, you press and hold the shutter-release button to capture up to 7 fps.

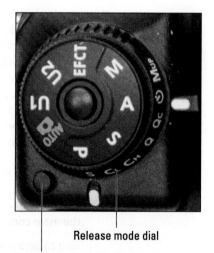

Release mode dial

Release mode dial lock release

FIGURE 9-33:
Choosing the shutter-release mode.

- *Q* (quiet shutter-release): With this mode, the camera captures a single frame when you press the shutter-release button, and the camera noise is reduced.

- *Qc* (quiet continuous shutter-release): With this mode, you press and hold the shutter-release button to capture up to 3 fps, and the camera noise is reduced.

- *Self-timer:* Capture images with the self-timer (see Chapter 4).

- *Mup* (mirror up): With this option, the mirror is raised to minimize blur caused by camera operation. This option is useful when shooting long exposures. When you choose this release option, you press the shutter-release button halfway to achieve focus, press the shutter-release button fully to raise the mirror, and then press the shutter-release button fully again to take the picture. The mirror lowers after the camera captures the image.

REMEMBER

Release the shutter-release button to stop capturing images in C∟, Cн, or Qc mode.

REMEMBER

The maximum number of images you can capture when shooting in one of the continuous modes (also known as burst photography) is 100 frames.

REMEMBER

When you choose On for Silent Live View Photography in the Photo Shooting menu and enable live view photography while shooting RAW, the frame rate at which you can capture images shooting with the Cн (continuous high speed) release option varies depending on the bit-depth option you choose: If you choose 14-bit, you can capture up to 8 fps; if you choose 12-bit, you can capture up to 12 fps.

• **Quiet shutter release:** With this mode, the camera captures a single frame when you press the shutter-release button, and the mirror returns quietly.

• **Quiet continuous shutter release:** You choose ... release. You hold down the shutter-release button for as long as you want to keep capturing images.

Mirror up to prevent camera shake with long exposures.

Mirror lockup: When you choose this mode, the camera introduces a delay between the mirror movements. This option is used when you do long, large exposures. When you choose it, press the shutter-release button halfway to achieve focus, press the shutter-release button fully to raise the mirror and then press the shutter-release button fully again to take the picture. The mirror lowers after the camera captures the image.

Release the shutter-release button to stop capturing images in CL, CH, or Q mode.

The maximum number of images you can capture when shooting in one of the continuous modes (also known as burst photography) is 100 frames.

When you choose On for Silent Live View Photography in the Photo Shooting menu and enable live view photography while shooting RAW, the frame rate at which you can capture images shooting with the CH (continuous high speed) release option varies depending on the bit-depth option you choose. If you choose 14-bit, you can capture up to 6 fps; if you choose 12-bit, you can capture up to 12 fps.

IN THIS CHAPTER

» Using the virtual horizon

» Understanding autofocus

» Setting the ISO sensitivity

» Using the camera's Wi-Fi option

» Using Bluetooth to control the camera

Chapter **10**

Using Advanced Camera Features

Your camera has lots of features that enable you to take great pictures. When you shoot in a mode other than Auto, you can modify lots of things. If the light is a bit dim and you don't feel like flashing your subject, you can increase the ISO sensitivity. You can also change the autofocus system to suit your taste and the type of photography you do. In short, the sky's the limit when you employ the advanced features of your camera.

To bring you up to speed on all the advanced features you can use, read the sections in this chapter in which I show you how to harness lots of the cool features. If you don't find what you need in this chapter, I cover more cool stuff in Chapter 11.

Leveling Your Images with the Viewfinder Virtual Horizon

The virtual horizon enables you to take pictures with your camera level and plumb. This ensures that the camera isn't tilted right, left, up, or down. The end result is images that look correct and not like a drunken sailor photographed them.

The virtual horizon is available whenever you need it when shooting live view (see Chapter 7).

Enabling the virtual horizon in the viewfinder

The virtual horizon isn't available in the viewfinder by default, but you can display it there. Some photographers prefer doing their composing and shooting through the viewfinder, especially if they're old school like your friendly author.

If you want the virtual horizon in your viewfinder, you have to change the function of a programmable button. Here's how to do it:

1. **Decide which customizable button you rarely use.**

 You can assign the virtual horizon to the following buttons:

 - *Pv:* The default use of this button is to stop down the camera to the chosen f-stop to display depth of field.

 - *Fn:* The default use of this button is to choose the image area.

2. **Press the MENU button.**

 The camera menus appear on the tilting monitor.

3. **Press the down arrow on the multi selector to highlight the Custom Settings menu, and then press the left arrow on the multi selector.**

 The Custom Settings menu icon is highlighted.

4. **Press the right arrow on the multi selector to place the cursor inside the menu, press the down arrow on the multi selector to highlight f3: Custom Controls, and press the right arrow on the multi selector.**

 An illustration of the camera appears on the tilting monitor (see Figure 10-1).

5. **Use the multi selector to highlight the button to which you want to assign the virtual horizon.**

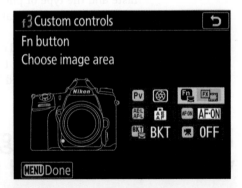

FIGURE 10-1:
Assigning the virtual horizon to a button.

6. **Press the right arrow on the multi selector.**

 The options for the button appear.

7. **Press the down arrow on the multi selector to highlight Virtual Horizon (see Figure 10-2) and then press OK.**

8. **Press the shutter-release button halfway to return to shooting mode.**

 When you press the Fn button, the virtual horizon appears in the viewfinder (see Figure 10-3).

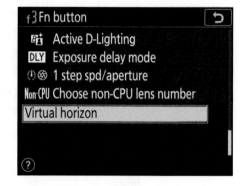

FIGURE 10-2:
Assigning the virtual horizon to a button.

When you assign the virtual horizon to the viewfinder, pitch and roll indicators appear. The roll indicator is the horizontal line with hash marks in the bottom of the viewfinder. The pitch indicator is the vertical line with hash marks on the right side of the viewfinder. Notice there is a slightly longer hash mark on each indicator. The camera is level when the longer marks align with the center of each indicator.

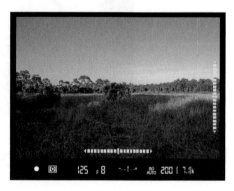

FIGURE 10-3:
The virtual horizon in the viewfinder.

TIP

If you decide not to display the virtual horizon in the viewfinder, open the camera menus, and from the setup menu, choose Virtual Horizon. This displays the virtual horizon on a black background on the tilting monitor. You can then adjust the camera until the virtual horizon shows that the camera is level and take a picture.

Using the virtual horizon when shooting in live view

If you shoot in live view and you want to make sure your images are on the level, you can do so with the virtual horizon. Follow these steps:

1. **Mount your camera on a tripod.**

 You can also use the electronic level when handholding the camera. However, it's more difficult to get accurate results, and you can't hold the camera as steady because it's away from your body.

2. **Press the Info button until the virtual horizon appears in the center of the tilting monitor.**

 The image on the left in Figure 10-4 illustrates what the level looks like when the camera isn't level.

3. **Adjust the legs and head of your tripod until a solid yellow line appears in the center of the virtual horizon.**

 This tells you the camera is level (see the right image shown in Figure 10-4).

FIGURE 10-4: Aligning your camera with the virtual horizon.

Using the Fn Button

The default use of the Fn button is to choose the image area. Press the button and rotate the main command dial to choose one of the image areas discussed in Chapter 4.

TIP

The Fn button is customizable. If you don't use the image area option frequently, you can assign a different setting to the button. As shown earlier, you can use the button to display the virtual horizon in the viewfinder. The button is conveniently placed so that you can assign a setting you use frequently to the button. For example, if you frequently use Active D–Lighting, you can assign that function to the Fn button. (I show you how to customize camera controls in Chapter 14.)

Tailoring Autofocus to Your Shooting Style

Your camera has a truly advanced autofocus system that is highly customizable. You can choose the autofocus mode, choose how autofocus points are displayed in the viewfinder, choose the type of autofocus, and much more. In the following

sections, I show you how to tailor the camera's autofocus system to shoot the types of subjects you photograph and your shooting style.

Choosing an autofocus mode

Your camera focuses automatically on objects that intersect autofocus points. You have three autofocus modes on your camera. One is ideally suited for still objects and another is ideally suited for objects that are moving. You have yet a third autofocus mode that's a chameleon: You use it for still objects that may move.

To choose an autofocus mode, follow these steps:

AF-mode button

1. **Press and hold the AF-mode button (see Figure 10-5).**

2. **Rotate the main command dial and choose one of the following options:**

 - *AF-A (autofocus auto):* This option works well for a variety of subjects. The camera uses AF-S (single AF) when photographing stationary objects, but switches to AF-C (continuous AF) when the camera detects a moving subject. This option is only available for still photography.

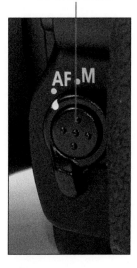

 - *AF-S (single AF):* This option works best when you're photographing stationary subjects. Focus locks when the shutter-release button is pressed halfway.

 - *AF-C (continuous AF):* This option works best when you photograph subjects like kids playing, athletes, and moving vehicles. The camera continuously focuses as the subject moves through the frame, toward the camera or away from the camera.

FIGURE 10-5:
The AF-mode button.

 - *AF-F (full-time AF):* This option is only available when recording movies. The camera adjusts focus continuously as a subject moves, or you move the camera to change composition. When using this mode, press the shutter-release button halfway to focus on your subject, and then press the shutter-release button fully to begin recording your movie. As your subject moves, or you move the camera, focus is automatically updated.

If your camera can't automatically achieve focus, you'll have to manually focus the camera, a task I show you in Chapter 4.

TIP

Choosing an AF-area mode

You can choose the autofocus area the camera uses to achieve focus. The mode you choose depends on your subject matter and whether your subject is moving.

To choose an AF-area mode, follow these steps:

1. **Press and hold the AF-mode button (refer to Figure 10-5).**

2. **Rotate the sub-command dial, and choose the desired option.**

As you rotate the sub-command dial, keep your eye on the control panel to see each option appear. Stop rotating the dial when you see the desired option.

You can choose from the following AF-area modes:

- *Single-point AF:* Use this option when photographing stationary subjects. Move the AF point over your subject, and then press the shutter-release button halfway to achieve focus.

WARNING

If the AF point doesn't move, make sure the focus selector lock is not in the L position.

- *Dynamic-area AF:* You have three options with dynamic-area AF — 9 points, 21 points, or 51 points. The different options appear as you rotate the sub-command dial. Dynamic-area AF 9 points is a useful option when photographing a subject with predictable movement, such as a runner on a track. Dynamic-area AF 21 points is used when you're photographing subjects that move unpredictably, such as soccer players. Dynamic-area AF 51 points is the option to choose when photographing subject matter such as birds that move quickly and can't be framed. With this option, you use the multi selector to place the autofocus group over your subject. The camera uses the middle point to track the subject, and switches to an adjacent point if the camera can't hold focus on the middle point.

TIP

When shooting with dynamic-area AF, start with the fewest number of points, and increase to the next option only if the camera has difficulty tracking your subject as it moves.

- *3D-tracking:* Use this option when you use the AF-A or AF-C modes. With this option, the camera uses 51 autofocus points. The camera locks focus on the subject, and then when the subject moves, it uses adjacent points to refocus. This option works well when photographing tennis players or other subjects that move unpredictably from side to side. With this option, you place the AF point over the subject. As your subject moves across the frame, the camera uses adjacent autofocus points to track your subject.

With the 3D-tracking mode, your camera relies on color differences to track your subject. This is not the ideal AF-area mode to use when photographing subjects that are similar in color to the background (for example, a deer in a field of dry grass).

- *Group-area AF:* Use this option when photographing subjects that are difficult to photograph using the AF-S mode. In this mode, the camera takes a group of autofocus points and treats them as a single autofocus point. Group-area AF differs from dynamic-area AF in the fact that the camera gives equal priority to all points in the group, whereas dynamic-area AF gives priority to the center autofocus point. With this option, face detection is enabled and the camera gives priority to any faces it detects. This option is also useful when photographing subjects that are dimly lit, subjects that don't contrast well with the background, or subjects that are difficult to track with other AF-area modes.

After choosing an AF-area mode, take several shots of your subject, and then examine the images closely to make sure your subject is in focus. If you program the OK button to zoom to 1:1 when reviewing images (see Chapter 4), you can quickly see if the focal point is in sharp focus. If it isn't, choose another AF-area mode.

The AF-area modes for live view photography are slightly different (see Chapter 7).

Using the AF-ON button for back-button focus

By default, the camera achieves focus when you press the shutter-release button halfway. But photographers who photograph sporting events and wildlife use what is known as *back-button focus.* This has two advantages:

>> You can use it to continuously track a moving object.

>> You can press and release the button to lock focus on your subject.

Some photographers, including me, think you get sharper images when using the AF-ON button for focus. By default, you press the shutter-release button halfway to achieve focus, and can also use the AF-ON button to achieve focus. When you program the AF-ON button to achieve focus, the shutter-release button can no longer be used to achieve focus.

Use this option when shooting with a single autofocus point. The beauty of using the AF-ON button for back focus is that as long as you have your finger on the AF-ON button, the camera continues to focus. If your subject stops, you can move the autofocus point over the area you want to be in sharp focus (for example, your dog's eye), and then press the AF-ON button to lock focus. You can also use this to lock focus on a subject, and then move the camera to compose the image.

To enable back-button focus, follow these steps:

1. **Press the MENU button.**

 The menus appear on your tilting monitor.

2. **Press the down arrow on the multi selector to navigate to the Custom Settings menu and then press the left arrow on the multi selector.**

 The Custom Settings menu icon is highlighted.

3. **Press the right arrow on the multi selector.**

 The cursor is in the Custom Settings menu.

4. **Press the down arrow on the multi selector to navigate to the f3: Custom Controls option, and then press the right arrow on the multi selector.**

 A graphic illustration of the camera appears on your tilting monitor.

5. **Use the multi selector to navigate to the AF-ON button (see Figure 10-6).**

6. **Press the right arrow on the multi selector.**

 The AF-ON options are displayed on your tilting monitor (see Figure 10-7).

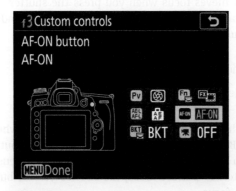

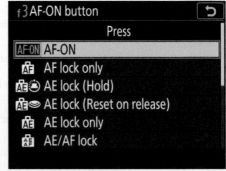

FIGURE 10-6:
Programming the AF-ON button for back-button focus.

FIGURE 10-7:
Choose AF-ON for back-button focus.

7. **Press the down arrow on the multi selector to highlight AF-ON and press OK.**

Your AF-ON button is now programmed for back-button focus.

Shooting with a single autofocus point

If you prefer shooting through the viewfinder, and you enable back-button focus as outlined in the preceding section, your next step is to choose single-point AF (see the "Choosing an AF-area mode" section, earlier in this chapter) for your autofocus area mode. When combined with back-button focus, shooting with a single autofocus point enables you to create wonderful images of stationary objects and moving objects.

This enables you to shoot stationary objects such as buildings, statues, and other landmarks. Simply place the autofocus point over the focal point in the scene, press and release the AF-ON button, and recompose your image. Focus is locked where you placed the autofocus point. Now all you need to do is press the shutter-release button to capture the image.

If you're creating a portrait, place the autofocus point over your subject's eye that's closest to the camera (see Figure 10-8), press the AF-ON button, release it, recompose your image, and press the shutter-release button. *Wunderbar*, you have a beautiful portrait, unless of course your subject was blinking. One of these days, they'll invent a blink detector for cameras that prevents the shutter from releasing when your subject is blinking.

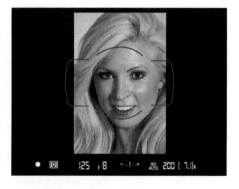

FIGURE 10-8:
Create a portrait using a single autofocus point and back-button focusing.

Shooting with a single autofocus point and back-button focusing is also an ideal way to photograph moving subjects. Simply place the autofocus point over your subject, and press and hold the AF-ON button while tracking your subject. Press the shutter-release button when the action is peak, or as Henri Cartier-Bresson called it, at "the decisive moment," and you have a compelling action shot.

If your subject is a race car, and the camera can't focus on the subject, find a spot on the track, such as an expansion joint, place the autofocus point over the expansion joint, and then press the AF-ON button. Focus is now locked on that point. Wait until the car is close to the expansion joint, and press the shutter-release button. With practice, you'll be able to anticipate the right time to press the shutter-release button, and the car will be where you focused when the shutter releases (see Figure 10-9).

FIGURE 10-9:
Create images of moving objects using a single autofocus point and back-button focusing.

Setting the ISO Sensitivity

The ISO speed determines how sensitive your camera's sensor is to light. When you specify a high ISO speed, you can capture images in dark conditions and extend the range of a flash unit mounted on the camera's accessory shoe. However, when you specify a high ISO speed, you also run the risk of adding digital noise to your images.

Here's how to set the ISO:

1. **Press the ISO button (see Figure 10-10).**

 The button is conveniently placed behind the shutter-release button so you can find it by feel.

2. **Rotate the main command dial to specify the ISO setting while viewing the control panel to see the settings as you rotate the dial.**

 You can choose an ISO setting from 100 to 51,200 or use the extended ISO range (see "Extending the ISO range," later in this chapter, for more details). Figure 10-11 shows the control panel after setting the ISO to 200. Note that auto ISO is also enabled. I discuss auto ISO in the next section.

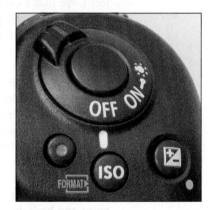

FIGURE 10-10:
Press this button to set the ISO.

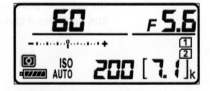

FIGURE 10-11:
Manually setting the ISO sensitivity.

Enabling auto ISO sensitivity control

Let's face it, when you photograph a person, place, or thing that you love, the less you have to fiddle with the camera, the better. I mean after all, you can miss a shot when you're pressing buttons and turning dials. You'll be happy to know that your Nikon D780 was designed by some knowledgeable photo folks who have a menu command that will override your manual setting if the exposure settings you choose can't be achieved. Yup, you guessed it, auto ISO sensitivity control. Your camera has auto ISO by default, but if you've changed that option, here's how to enable it:

1. **Press the ISO button (refer to Figure 10-10).**

2. **Rotate the sub-command dial until you see ISO AUTO on the control panel.**

 Your camera is now locked and loaded to automatically choose the proper ISO sensitivity for the available light.

You can select the minimum shutter speed before auto ISO sensitivity overrides the ISO you choose from the camera menu. To do this, follow these steps:

1. **Go to the ISO sensitivity settings section of the Photo Shooting menu.**

2. **Choose Auto ISO Sensitivity Control.**

3. **Choose Minimum Shutter Speed.**

4. **Choose the lowest allowable shutter speed before the camera bumps the ISO to prevent camera blur.**

TIP

When you choose the shutter speed, consider the longest lens you shoot with and the slowest shutter speed you can shoot at with this lens and still get a sharp image. For example, if you purchased your D780 with the kit 24–120mm lens, do not choose a shutter speed less than 1/125 of a second when you zoom to 120mm.

TIP

You can use the ISO button to manually set the ISO sensitivity as outlined in the previous section. If you also enable auto ISO, the camera will automatically increase the ISO setting if the desired exposure can't be achieved using the ISO setting you manually choose.

Extending the ISO range

Your camera can capture images in some very dismal lighting conditions. The maximum ISO sensitivity available is 51,200. But you can extend the range, which enables you to take pictures in extremely low-light situations.

To extend the ISO range of your camera, follow these steps:

1. **Press the MENU button.**

The camera menus appear on your tilting monitor.

2. **Press the down arrow on the multi selector to highlight the Photo Shooting menu and then press the left arrow on the multi selector.**

The Photo Shooting menu icon is highlighted.

3. **Press the right arrow on the multi selector to place the cursor inside the menu, and then press the right arrow on the multi selector to scroll to ISO Sensitivity Settings (see Figure 10-12).**

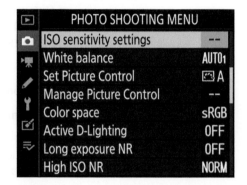

FIGURE 10-12:
Your first step to extend the ISO range of your camera.

4. **Press the right arrow on the multi selector to display the ISO sensitivity settings options, and the press the down arrow on the multi selector to highlight Maximum Sensitivity (see Figure 10-13).**

5. **Press the right arrow on the multi selector.**

The maximum sensitivity options are displayed on your tilting monitor (see Figure 10-14).

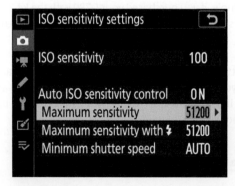

FIGURE 10-13:
Choose this option to increase the ISO sensitivity of your camera.

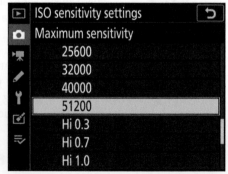

FIGURE 10-14:
Choose the maximum ISO sensitivity for your camera.

6. Choose an option.

If desired, you can decrease the maximum ISO sensitivity. Your other options are Hi 0.3 (ISO 64000), Hi .07 (ISO 80000), Hi 1 (ISO 12800), and Hi 2 (25600).

7. Press OK.

The ISO range is now extended to your desired setting.

WARNING

When you extend the ISO range above 51,200, the camera uses internal software to process the image. You may notice details are not sharp when one of the extended ISO settings is used to compensate for low-light conditions.

TIP

Extending the ISO sensitivity enables you to shoot in dim lighting conditions. However, if you frequently shoot in low-light conditions, leave the ISO range at its default and carry a tripod with you. The result will be sharper images.

Enabling high ISO noise reduction

When you shoot in dim lighting conditions and increase the ISO sensitivity to capture images, digital noise occurs. Digital noise is most prevalent in the shadow areas of your image. Some people compare digital noise to film grain, but it's actually just ugly clumps of noise and not the lovely pattern you see with film grain. You can minimize the noise by enabling high ISO noise reduction. Follow these steps:

1. Press the MENU button.

The camera menus appear on your tilting monitor.

2. Press the down arrow on the multi selector to highlight the Photo Shooting menu, and then press the left arrow on the multi selector.

The Photo Shooting menu icon is highlighted.

3. Press the right arrow on the multi selector to place the cursor inside the menu, and then press the down arrow on the multi selector to scroll to High ISO NR (see Figure 10-15).

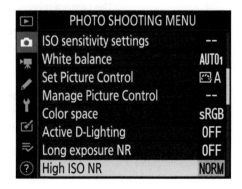

FIGURE 10-15:
The High ISO NR command.

4. Press the right arrow on the multi selector.

The High ISO NR options are displayed (see Figure 10-16).

5. **Choose the desired option.**

The default option of Normal works well in most instances, but you can increase or decrease high ISO noise reduction. Your other option is to disable it. Choose the latter option only if you have a super-duper noise reduction plug-in with your image-editing program.

6. **Press OK.**

The new setting takes affect the next time you shoot with a high ISO setting.

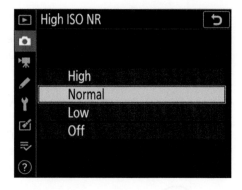

FIGURE 10-16:
Choosing a High ISO NR option.

Using Auto Distortion Control

If you shoot with a Nikon type G, D, or E *wide-angle* lens, you may experience *barrel distortion* (in which the picture looks like it's bulging in the middle. If you shoot with a Nikon type G, D, or E *telephoto* lens, you may notice *pincushion distortion* (in which the center of the image looks like it's bowing inward). You can solve both of these problems by enabling auto distortion control. Follow these steps:

1. **Press the MENU button.**

The camera menus appear on your tilting monitor.

2. **Press the down arrow on the multi selector to highlight the Photo Shooting menu, and then press the left arrow on the multi selector.**

The Photo Shooting menu icon is highlighted.

3. **Press the right arrow on the multi selector to place the cursor inside the menu, and then press the down arrow on the multi selector to scroll to Auto Distortion Control (see Figure 10-17).**

4. **Press the right arrow on the multi selector.**

The Auto Distortion Control options are displayed on your tilting monitor (see Figure 10-18).

5. **Press the up arrow on the multi selector to highlight On and press OK.**

Auto distortion control is now enabled.

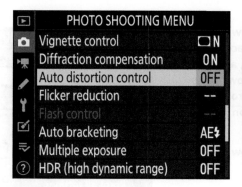

FIGURE 10-17:
The Auto Distortion Control command.

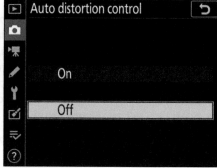

FIGURE 10-18:
Enabling auto distortion control.

Using Wi-Fi

Your D780 has Wi-Fi capabilities. If you have a Wi-Fi network at home or at work, you can connect the camera to the network and upload images directly from your camera to a computer connected to the network. In the following sections, I show you how to enable Wi-Fi and how to upload images. So, if you're ready to fly wirelessly, read on.

Enabling Wi-Fi

You can connect your camera wirelessly to a Wi-Fi network, just like you can connect your laptop to a Wi-Fi network. Before you begin, you'll need to know the password for the Wi-Fi network and be somewhat proficient at using the camera keyboard (see Chapter 4).

To connect your camera to a Wi-Fi network, follow these steps:

1. **Download and install the Wireless Transmitter Utility.**

 You can find the Mac and PC versions at https://downloadcenter. nikonimglib.com/en/products/363/SnapBridge.html.

2. **Press the MENU button.**

 The camera menus appear on your tilting monitor.

3. **Press the down arrow on the multi selector to highlight the setup menu, and press the left arrow on the multi selector.**

 The setup menu icon is highlighted.

4. Press the right arrow on the
multi selector to place the
cursor in the menu, and then
press the down arrow on the
multi selector to scroll to the
Connect to PC option (see
Figure 10-19).

5. Press the right arrow on the
multi selector.

Your option is to create a profile
(see Figure 10-20).

6. Press the right arrow on the
multi selector.

The connection wizard appears
(see Figure 10-21).

7. Choose an option.

For the purpose of this tutorial,
I show you how to connect to a
network, which enables you to
connect to any computer on the
network. The following steps are
for the Search for Wi-Fi Network
option.

8. Press OK.

Networks within range are
displayed on the tilting monitor.

9. Press the down arrow on the
multi selector to highlight your
network and then press OK.

If your network is encrypted, you're
prompted to enter the password.

10. Enter the password on the
camera keyboard and press the
zoom in/QUAL button.

The connection wizard appears
on your tilting monitor (see

FIGURE 10-19:
Your first step to connect to your local network.

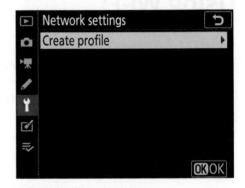

FIGURE 10-20:
Creating a profile for the network.

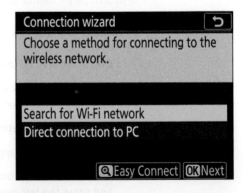

FIGURE 10-21:
Searching for a network.

Figure 10-22). You can obtain the IP address automatically (recommended) or if you're a card-carrying geek, enter it manually.

11. **Choose the manner in which you obtain the IP address for the network.**

In most cases, you can obtain the address automatically. After getting the IP address, it appears on the tilting monitor (see Figure 10-23).

12. **Press OK.**

The camera name appears in the connection wizard, and you're prompted to launch the Wireless Transmitter Utility (see Figure 10-24).

13. **Launch the Wireless Transmitter Utility.**

Figure 10-25 shows the utility on a Mac. When you launch the utility after following the previous steps, the camera name appears in the text box.

14. **Click Next.**

An authorization code appears on your camera and the Wireless Transmitter Utility refreshes.

15. **Enter the authorization code into the text box on the Wireless Transmitter Utility.**

16. **Click Next.**

A message appears on the tilting monitor informing you that the pairing is complete. You're prompted for a folder in which to store images uploaded from the camera.

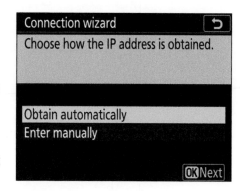

FIGURE 10-22:
Obtaining the IP address for the network.

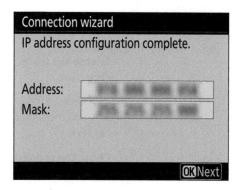

FIGURE 10-23:
Getting the IP address.

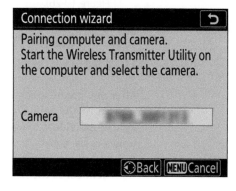

FIGURE 10-24:
Time to launch the Wireless Transmitter Utility.

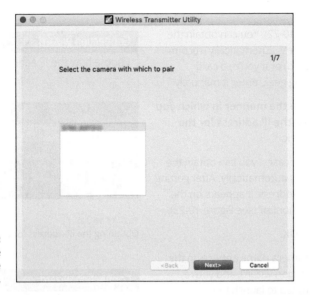

FIGURE 10-25:
Connecting the
camera to the
network.

17. **Choose the folder, and then
click Next.**

A wireless connection is created
between the camera and the
network.

18. **Check the connection on the
camera.**

When the connection is success-
ful, the network information is
displayed on the camera (see
Figure 10-26).

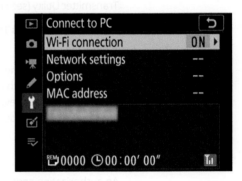

FIGURE 10-26:
Success!

Uploading images via Wi-Fi

After you create a connection to the network, you can upload images from your
camera to the folder you specified when you created the connection. You can
upload individual images or automatically upload all images. To upload images,
follow these steps:

1. **Connect to the network.**

If you powered the camera off after connecting to the network, you may have
to reconnect. To do so, open the menu, go to the setup menu, and then
choose Connect to PC ⇨ Wi-Fi Connection ⇨ On.

2. **Press the play button.**

 An image is displayed on the tilting monitor.

3. **Review the images.**

4. **When you see an image you want to upload, press the *i* button.**

 The playback *i* menu appears (see Figure 10-27).

5. **Highlight Send/Deselect (PC) and press OK.**

 The image begins to upload to your PC. The transfer icon above the image turns green during upload.

6. **Repeat Steps 3 through 5 to upload additional images.**

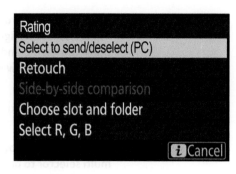

| Rating |
| Select to send/deselect (PC) |
| Retouch |
| Side-by-side comparison |
| Choose slot and folder |
| Select R, G, B |
| **i** Cancel |

FIGURE 10-27:
The playback *i* menu.

TIP

You can perform the previous steps when the camera is not connected to the network. Images will be marked for upload with an icon that looks like a lightning bolt. After making your initial selection, review the images again. If you find images that you don't want to upload, open the *i* menu again and choose Send/Deselect (PC) to remove the upload tag from the image. After reviewing all images, connect the camera to the network to upload the tagged images.

You can also upload all images automatically whenever the camera is connected to the network. To upload images automatically, open the camera setup menu, select the Connect to PC command, choose On ⇨ Options ⇨ Auto Send. Photos will now be uploaded to the specified folder. The only exceptions are movies and images captured while recording movies. These must be uploaded using the *i* menu as outlined earlier.

Using airplane mode

You can disable any Wi-Fi or Bluetooth connection to your camera. This option is useful if the connection is poor or you want to conserve the battery. To disable connections to your camera, follow these steps:

1. **Press the MENU button.**

 The menus appear on the tilting monitor.

2. Press the down arrow on the multi selector to highlight the setup menu, and then press the left arrow on the multi selector.

The setup menu icon is highlighted.

3. Press the right arrow on the multi selector to place the cursor inside the setup menu, and the press the down arrow on the multi selector to highlight airplane mode (see Figure 10-28).

4. Press the right arrow on the multi selector.

The airplane mode options are displayed (see Figure 10-29).

5. Press the up arrow on the multi selector to highlight Enable, and press OK.

Airplane mode is now enabled.

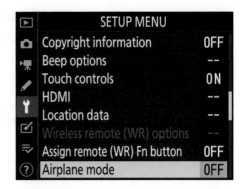

FIGURE 10-28:
The Airplane Mode command.

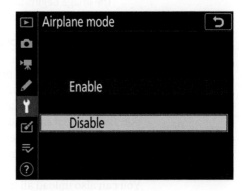

FIGURE 10-29:
Select On to enable airplane mode.

Using Bluetooth

Your camera also has Bluetooth capabilities. An interesting little tidbit is that Bluetooth was named after King Harald Bluetooth, who is credited with uniting Norway and Denmark. Bluetooth unites devices. Make good sense, methinks. But I digress.

With Bluetooth, you can connect your camera to a remote device, such as a smartphone or a tablet. After you pair the camera, you can upload images to the connected device and use the device to control the camera. Slicker than freshly spilled olive oil on waxed linoleum.

In the following sections, I show you how to pair your camera with a device, and then use the device to control the camera.

Pairing with a remote device

Nikon makes a spiffy app called SnapBridge that is used to bridge the gap between your camera and device. The app is available for Apple iOS and Android devices. To pair your camera with a remote device, follow these steps:

1. **Download the SnapBridge app and install it on your device.**

You download the iOS version of SnapBridge from the Apple App Store and the Android version from Google Play. Both apps are free. The following steps are for the iOS version. The Android version is similar.

2. **Press the MENU button.**

The menus are displayed on the tilting monitor.

3. **Press the down arrow on the multi selector to highlight the setup menu, and then press the left arrow on the multi selector.**

The setup menu icon is highlighted.

4. **Press the right arrow on the multi selector to place the cursor inside the menu, and then press the down arrow on the multi selector to highlight Connect to Smart Device (see Figure 10-30).**

FIGURE 10-30:
The Connect to Smart Device command.

5. **Press the right arrow on the multi selector.**

The Connect to Smart Device options appear on your tilting monitor (see Figure 10-31).

6. **If Pairing (Bluetooth) is not selected, select it and then press the right arrow on the multi selector.**

If you're currently connected to the network, a dialog appears warning you that the connection to the PC will be lost if you continue. If this dialog appears, highlight Yes and press the right arrow on the multi selector.

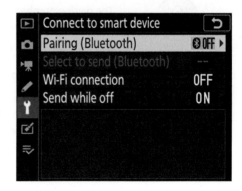

FIGURE 10-31:
Pairing to Bluetooth.

The Start Pairing option appears on your tilting monitor (see Figure 10-32).

7. Press OK.

The dialog refreshes and displays your camera name (see Figure 10-33).

8. Open the SnapBridge app on your smart device (your phone or tablet).

9. Accept the Application License Agreement and click Start.

A Welcome dialog appears with a Connect to Camera button.

10. Tap Connect to Camera.

The screen refreshes and a dialog appears with a picture of the back of the camera and instructions.

11. Click Understood.

The name of the camera appears on the SnapBridge app (see Figure 10-34). A pairing number appears on the phone or table and on your camera.

WARNING

The pairing number may not appear immediately after you click Understood. If so, be patient and wait for the number to appear.

12. If the numbers are the same, press OK on the camera.

13. Tap Pair on the app to pair the camera with the smart device.

Your options may vary depending on whether you connected to a PC or to a network. The prompts are pretty much self-explanatory. After you pair the device with the camera, you're ready to start using SnapBridge (see Figure 10-35).

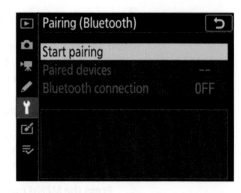

FIGURE 10-32:
The pairing is afoot, Watson.

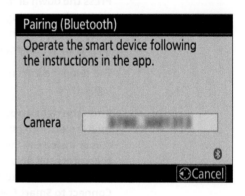

FIGURE 10-33:
This will be a peach of a pairing.

FIGURE 10-34:
Pairing your smart device with your camera.

FIGURE 10-35:
The Nikon SnapBridge app.

Controlling your camera remotely with SnapBridge

After you pair your camera with SnapBridge, you're ready to rock and roll. With SnapBridge you can control the camera remotely. You can also view images and download them from the camera's memory card to your device.

Controlling the camera remotely is useful when you're creating images of products, photographing in a studio setup with the camera on a tripod, or photographing stuff to sell on eBay. Controlling the camera remotely frees you to set up the shot.

To control your camera with SnapBridge, follow these steps:

1. **Start the smart device and open SnapBridge.**

2. **Press the MENU button on your Nikon, and from the setup menu, choose Connect to Smart Device ⇨ Pairing (Bluetooth) ⇨ Bluetooth Connection, highlight Enable, and press OK.**

 The camera is paired with the device.

3. **On SnapBridge, tap the Camera tab and then tap Remote Photography.**

The smart device's monitor refreshes, displaying what is captured by the lens (see Figure 10-36).

4. **Tap the screen on the smart device to focus the camera.**

You can tap anywhere on the screen. Be sure to tap the area you want to be in sharp focus.

5. **Press the shutter-release button on the smart device to take the picture.**

It's the big white button below the screen that shows the camera view. After you tap the button, the camera processes the image and writes it to the memory card.

6. **Continue taking pictures.**

The images you create are saved to the camera memory card.

FIGURE 10-36:
Remote photography with the SnapBridge app.

TIP

To automatically download pictures to your smart device as you create them, tap the Auto Link icon in the photo section of the SnapBridge app. Images downloaded to your phone when you shoot NEF (RAW) will be 2MB JPEG files.

TIP

You can also download individual images as long as your camera is connected to SnapBridge. To download one or more pictures currently on the camera's memory card, tap Download Pictures in the SnapBridge app, and thumbnails of the images on the card are displayed on the smart device. When you see an image you like, tap it to display it full screen, and then tap Download Picture to send it to your device. Images will be 2MB JPEG files if you shoot NEF (RAW). If you shoot JPEG, you have the option to upload images at their original size or 2MB files.

WARNING

If you shoot JPEG, you have the option to download a file to the device at its original size. I advise against this, especially if you shoot JPEG images with the large size and fine quality specified. These images are huge and will quickly gobble up the available space on your smart device.

This is just the tip of the iceberg when it comes to using SnapBridge. If you're into remote photography and you've got SnapBridge installed on your smart device, visit this web page for more information: https://nikonimglib.com/snbr/onlinehelp/en/.

Chapter **11**

Shooting Like a Pro

Your Nikon D780 is capable of creating images that are professional quality. In fact, the D780 is used by many professional photographers. But just because you have a pro camera, it doesn't mean you can create images that rival those created by the pros. You've got to pay your dues and learn how to maximize the professional features your D780 offers. If that's what's on your mind, dear reader, this chapter will enable you to get the most out of your investment.

In this chapter, I show you how to select the proper color space for your photographs, how to set the white balance, how to reduce flicker, how to create multiple exposures, and more.

Your D780 doesn't come with a flash. On-camera flashes are small and don't add a lot of light to the scene. But professional photographers use dedicated flash units to light their scenes. The D780 is compatible with Nikon Speedlights. So, if you're a flashy kind of photographer, I show you how to use a Nikon Speedlight to add a little or a lot of light to a scene.

Specifying the Color Space

Several color spaces are used in photography and image-editing applications. The *color space* determines the range of colors you have to work with. Your camera's default color space (sRGB) is ideal if you're not editing your images in an application like Adobe Photoshop or Adobe Lightroom. If you shoot NEF (RAW) images and edit your images in an application that supports the Adobe RGB color space, you can change the color space. If you do edit your images in an image-editing application and want the widest range of colors (also known as *gamut*) with which to work, specify Adobe RGB.

To specify the color space that your camera records images with, follow these steps:

1. **Press the MENU button.**

 The menus appear on your tilting monitor.

2. **Press the down arrow on the multi selector to highlight the Photo Shooting menu, and then press the left arrow on the multi selector.**

 The Photo Shooting menu icon is highlighted.

3. **Press the right arrow on the multi selector to place your cursor inside the menu, and then press the down arrow on the multi selector to highlight Color Space (see Figure 11-1).**

4. **Press the right arrow on the multi selector.**

 The Color Space options are displayed on your tilting monitor (see Figure 11-2). sRGB is the default option.

5. **Press the down arrow on the multi selector to highlight Adobe RGB and press OK.**

 Your camera now uses the Adobe RGB color space when processing images.

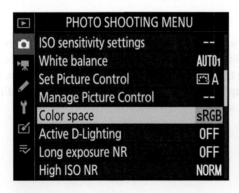

FIGURE 11-1:
Highlight Color Space in the Photo Shooting menu.

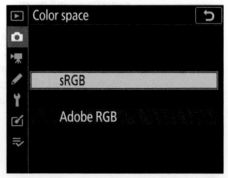

FIGURE 11-2:
Specifying the color space.

Setting White Balance

The human eye can see the color white without a colorcast no matter what type of light the white object is illuminated with. Your digital camera has to balance the lighting in order for white to appear as white in the captured image. Without white balance, images photographed with fluorescent light have a green colorcast and images photographed with tungsten light sources have a yellow/orange colorcast. Yup, your subject may be "green around the gills," or have some other ghastly colorcast, depending on the light sources used to illuminate the scene.

Your camera automatically sets the white balance, or you can choose a white balance setting to suit the scene you're photographing. You can also change the white balance when you want to create an image with some special effects. If you shoot images with the NEF (RAW) format and inadvertently choose the wrong white balance setting or your camera doesn't get it right, you can change the white balance setting in an application like Adobe Lightroom or Nikon's Capture NX-2.

To set the white balance, follow these steps:

1. **Press and hold the help/protect/WB button (see Figure 11-3).**

2. **Rotate the main command dial.**

 The white balance icons (see Figure 11-4) appear on the tilting monitor.

3. **Choose one of the following options:**

 - *Auto:* The camera automatically sets the white balance based on the lighting conditions.

 After choosing this option, rotate the sub-command dial and choose one of the following: *A0* (eliminates the warm color cast produced by incandescent lighting), *A1* (preserves some of the warm color cast produced by incandescent lighting), or *A2* (preserves the warm color cast produced by incandescent lighting). You can also use these settings creatively when photographing in natural light. For example, the A2 option can be used to warm a landscape photographed under cloud cover.

FIGURE 11-3:
Use this button to adjust the white balance.

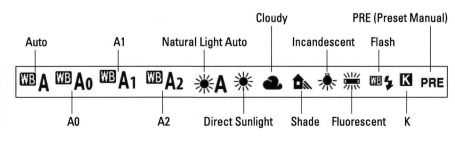

FIGURE 11-4: Choose one of these white balance options.

Auto · A1 · Natural Light Auto · Cloudy · Incandescent · Flash · PRE (Preset Manual)

A0 · A2 · Direct Sunlight · Shade · Fluorescent · K

- *Natural Light Auto*: Use this option when shooting under natural light. When you shoot a scene with natural light using this option, the resulting image will have colors that look closer to those that you see.

- *Direct Sunlight:* Use this option when photographing subjects on a bright, sunny day.

- *Cloudy:* Use this option when photographing subjects on a cloudy day.

- *Shade:* Use this option when photographing subjects in direct shade.

- *Incandescent:* Use this option when photographing subjects illuminated by incandescent (normal household) light bulbs.

- *Fluorescent:* Use this option when photographing subjects illuminated by fluorescent lights. When you choose this option, rotate the sub-command dial to choose one of the following options: Sodium-Vapor Lamps, Warm-White Fluorescent, White Fluorescent, Cool-White Fluorescent, Day White Fluorescent, Daylight Fluorescent, or High Temp. Mercury-Vapor.

- *Flash:* Use this option when photographing subjects illuminated by a flash unit.

- *K:* Use this option when you want to use a color temperature specified with a menu command. See the upcoming "Specifying color temperature" section for more information.

- *PRE (Preset Manual):* Use this option when creating a custom white balance. See "Creating a custom white balance" later in this chapter.

4. **Release the help/protect/WB button.**

 You're returned to shooting mode.

TIP

Unless you know the exact light source, I suggest you shoot using the Auto white balance setting. If the Auto setting is too cool or too warm, press the help/protect/WB button, and then rotate the sub-command dial to adjust the setting with a grid of colors, and adjust the color along the amber–blue axis or the green–magenta axis. If Auto doesn't get it right, I recommend creating a custom white balance (see the "Creating a custom white balance" section, later in this chapter).

Specifying color temperature

If you use studio lighting, you can set the color temperature to the same temperature as the light emitted from your studio flash units, also known as strobes. Color temperature is measured on the Kelvin (K) scale. For example, most studio strobes have a color temperature of 5200 K. You can easily set the color temperature for the camera white balance to match the color temperature of your studio lights with a menu command.

To specify a color temperature, follow these steps:

1. **Press and hold the help/protect/WB button.**

2. **Rotate the main command dial to, K and then rotate the sub-command dial to choose the temperature to match your light source.**

3. **Press the help/protect/WB button.**

 The white balance is set to your desired temperature until you reset it.

I recommend resetting the white balance to Auto after completing a shoot using a white balance other than Auto.

Creating a custom white balance

When you photograph a scene that's illuminated with several different light sources, your camera may have a hard time figuring out how to set the white balance. And if the camera has a hard time, chances are, you can't use one of the presets to accurately set the white balance.

You can, however, set a custom white balance. You can save up to six custom white balance presets in the camera. To create a custom white balance, follow these steps:

1. **Press the live view button.**

 Your camera is now in live view mode.

2. **Press and hold the help/protect/WB button.**

3. **Rotate the main command dial to PRE1.**

 A rectangle appears in the middle of the tilting monitor.

4. **Place a white piece of paper in front of the rectangle.**

5. **Press and hold the WB button.**

 PRE1 flashes on your tilting monitor.

6. **Press OK.**

 The message "Data Acquired" appears on your screen.

7. **Press the help/protect/WB button.**

 You're returned to shooting mode and the white balance is set to PRE1.

The next time you shoot under the same conditions, choose PRE1 to use your custom white balance. You can store up to six white balance presets on your camera.

Bracketing white balance

If you like to hedge your bets, you may consider using white balance bracketing. When bracketing white balance, you vary the color temperature of the original white balance along the amber–blue axis. In other words, when you bracket, the camera creates one exposure at the specified setting (Auto, Direct Sunlight, Shade, and so on), and bracketed copies that are warmer and cooler.

But before you can bracket white balance, you need to assign that option to the BKT button. To assign white balance to the BKT button, follow these steps:

1. **Press the MENU button.**

 A plethora of Nikon menus appears on your tilting monitor.

2. **Press the down arrow on the multi selector to select the Photo Shooting menu, and then press the left arrow on the multi selector.**

 The Photo Shooting menu icon is highlighted.

3. **Press the right arrow on the multi selector to place the cursor in the menu, and then press the down arrow on the multi selector to highlight Auto Bracketing (see Figure 11-5).**

4. **Press the right arrow on the multi selector.**

 The Auto Bracketing Set options are displayed on your tilting monitor (see Figure 11-6).

5. **Press the down arrow on the multi selector to highlight WB Bracketing (see Figure 11-7), and press OK.**

 White balance is now assigned to the BKT button.

Now that you've assigned white balance to the BKT button, you can bracket white balance when needed. To bracket white balance, follow these steps:

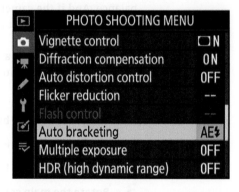

FIGURE 11-5:
The Auto Bracketing command.

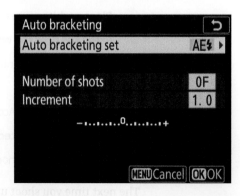

FIGURE 11-6:
The Auto Bracketing Set options.

1. **Select the desired white balance option as outlined in this section.**

2. **Press the BKT button (see Figure 11-8), located on the left side of the camera as you point it toward your subject, and then rotate the main command dial.**

 As you rotate the main command dial, the number of frames you're bracketing appears on the control panel.

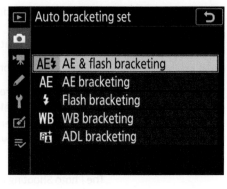

FIGURE 11-7:
Assigning white balance to the BKT button.

3. **Determine the number of frames to bracket.**

4. **Rotate the sub-command dial to determine the white balance adjustment.**

 You can choose an increment of one, two, or three steps for each frame. When you choose a higher value, the difference in white balance between the specified setting increases. In most instances, one step is perfect.

FIGURE 11-8:
The BKT button.

5. **Compose the image and then press the shutter-release button halfway to achieve focus.**

6. **Press the shutter-release button fully.**

 The camera captures the number of frames specified with white balance bracketing applied.

After capturing a set of bracketed images, review the images to make sure that one of them is satisfactory. If you don't get a good image, bracket white balance again and choose a different value in Step 4.

Enabling Flicker Reduction

Flicker reduction is useful when creating photos or movies of scenes illuminated with fluorescent or mercury-vapor lamps. These light sources can cause exposure problems when shooting in one of the continuous release modes, when creating a sequence of images, or a time-lapse movie. This problem also occurs when you have multiple lighting sources in a scene, and one or more of them are fluorescent and/or mercury-vapor lamps.

To enable flicker reduction, follow these steps:

1. **Press the MENU button.**

The menus appear on your tilting monitor.

2. **Press the down arrow on the multi selector to select the Photo Shooting menu, and then press the left arrow on the multi selector.**

The Photo Shooting menu icon is highlighted.

3. **Press the right arrow on the multi selector to place the cursor in the menu, and then press the down arrow on the multi selector to highlight Flicker Reduction (see Figure 11-9).**

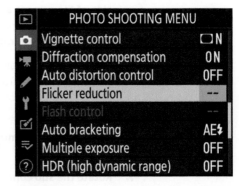

FIGURE 11-9:
The Flicker Reduction command.

4. **Press the right arrow on the multi selector.**

The flicker reduction options are displayed (see Figure 11-10). By default, flicker reduction is set to Off.

5. **Press the right arrow on the multi selector.**

The tilting monitor refreshes and you have the option to enable flicker reduction (see Figure 11-11).

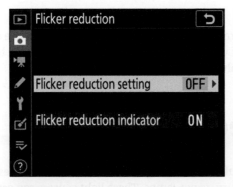

FIGURE 11-10:
The flicker reduction options.

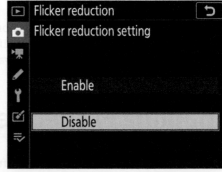

FIGURE 11-11:
Enable flicker reduction.

6. Press the up arrow on the multi selector to highlight Enable and press OK.

You're returned to the previous menu, and the Flicker Reduction Indicator is highlighted (see Figure 11-12).

7. Use the multi selector up or down arrow to set the Flicker Reduction Indicator On or Off.

By default, it's On, which means that when the camera detects flicker, a flicker warning appears on the control panel and in the viewfinder (if you're shooting in live view mode, it appears on the tilting monitor). Due to the nature of fluorescent and sodium-vapor lighting sources, the warning may flash on and off as the light source flickers. If this is disturbing, press the right arrow on the multi selector and choose Off to disable the warning.

8. Press the shutter-release button halfway to return to shooting mode.

Flicker reduction is now enabled.

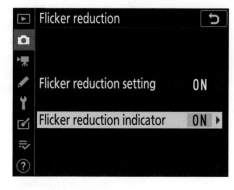

FIGURE 11-12:
Enabling the Flicker Reduction Indicator.

Creating a Multiple-Exposure Image

Back in the old days, you could create a double exposure with a film camera by holding down the rewind button and then moving the film advance lever. The combination of those two actions reset the shutter so you could take another picture on the same piece of film, creating a double exposure. You could repeat this two-finger tango to add another exposure to the same piece of film, resulting in a multiple-exposure image. Whew! Lots of work. Fortunately it's easy to create a multiple exposure on your D780. In fact, you can capture up to ten exposures in one image. You can also save each exposure as an NEF (RAW) file.

Here's how to do it:

1. Press the MENU button.

The menus appear on your tilting monitor.

2. Press the down arrow on the multi selector to select the Photo Shooting menu, and then press the left arrow on the multi selector.

The Photo Shooting menu icon is highlighted.

3. Press the right arrow on the multi selector to place the cursor in the menu, and then press the down arrow on the multi selector to highlight **Multiple Exposure Mode** (see Figure 11-13).

4. Press the right arrow on the multi selector.

The multiple exposure options are displayed (see Figure 11-14).

5. Use the multi selector to choose one of the following options:

● *On (series):* This option enables you to create a series of multiple exposures until you revisit this menu and choose Off.

● *On (single photo):* This option enables you to create a single multiple exposure.

● *Off:* You use this option after creating several multiple exposures using the On (series) option to disable the Multiple Exposure option.

The default option is Off.

6. After choosing the desired option, press OK.

You're returned to the previous menu.

7. Press the down arrow on the multi selector to highlight **Number of Shots**.

The default number of shots is 2. If you want more shots in your multiple exposure, go to Step 9. If not, go to Step 10.

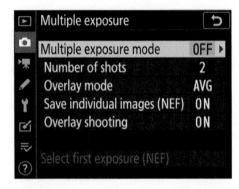

FIGURE 11-13:
The Multiple Exposure Mode.

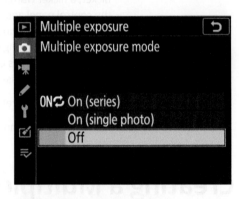

FIGURE 11-14:
The multiple exposure options.

8. **Press OK.**

The tilting monitor refreshes and you can increase the number of exposures (see Figure 11-15).

9. **Accept the default number of shots (2), or press the up arrow on the multi selector to add more exposures to the image(s) and then press OK.**

The Multiple Exposure menu is displayed.

10. **Press the down arrow on the multi selector to highlight Overlay Mode, and then press the right arrow on the multi selector.**

The Overlay modes are displayed (see Figure 11-16).

11. **Use the up arrow or down arrow on the multi selector to highlight one of the following overlay modes:**

- *Add:* The exposures are placed on top of each other and are not modified. This option doesn't work well unless one or more of the shots has a light background and the first shot is dark.

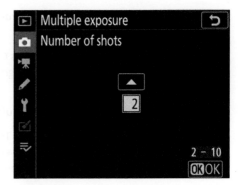

FIGURE 11-15:
Specifying the number of exposures.

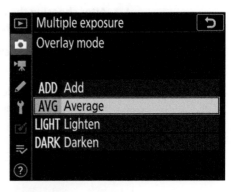

FIGURE 11-16:
Choosing the Overlay mode.

- *Average:* The exposures are stacked and the density of each image is adjusted so all exposures are noticeable in the final image. This option works best in most instances.

- *Lighten:* The camera examines the pixels in each exposure and uses only the brightest pixels.

- *Darken:* The camera examines the pixels in each exposure and uses only the darkest pixels.

12. **After choosing an overlay mode, press OK.**

You're returned to the Multiple Exposure menu.

13. **Press the down arrow on the multi selector to highlight Save Individual Exposures (NEF).**

The default option is On, which saves the individual exposures as NEF files. If desired, press the right arrow on the multi selector and choose Off to disable this option.

14. **Choose the final Multiple Exposure options.**

- *Overlay Shooting:* This option is enabled by default. With this option, earlier exposures are overlaid on the view seen through the lens, which enables you to decide whether to add this view as an exposure.

- *Select First Exposure (NEF):* If you highlight this option, you can choose the first exposure of your multiple exposure from NEF images already stored on your memory card.

15. **After choosing the options for your multiple exposure, press the shutter-release button halfway to return to shooting mode.**

16. **Compose the first exposure of your multiple exposure and take the picture.**

You can now add additional exposures to the multiple exposure up to the number you specified in Step 9. Figure 11-17 shows a multiple-exposure image.

FIGURE 11-17:
Creating multiple exposures for fun and profit.

Shifting Focus

Shifting focus is also known as *focus stacking*. Typically, to stack focus, the photographer would take a series of images and manually focus the lens for each exposure, focusing first on the foreground, and then with each successive shot, focusing a little farther out. Your camera can automatically shift focus for you. However, the camera doesn't merge the images. You have to do that in a third-party application. I show you how to merge focus-shifted images in Chapter 14.

To create a series of images with shifted focus, follow these steps:

1. **Mount the camera on a tripod.**

 The images will have to be aligned perfectly in order to merge them properly in an image-editing application.

 TIP

 When shifting focus, I recommend you shoot in aperture-priority auto (A) mode and then choose a small aperture. This gives you a greater depth of field and yields better results when combining the focus-shifted images. You can also get by with fewer images and a larger focus step width.

2. **Press the MENU button.**

 The menus appear on your tilting monitor.

3. **Press the down arrow on the multi selector to select the Photo Shooting menu, and then press the left arrow on the multi selector.**

 The Photo Shooting menu icon is highlighted.

4. **Press the right arrow on the multi selector to place the cursor in the menu, and then press the down arrow on the multi selector to highlight Focus Shift Shooting (see Figure 11-18).**

5. **Press the right arrow on the multi selector.**

 The Focus Shift Shooting options appear (see Figure 11-19). The first option you can choose is the number of shots.

FIGURE 11-18:
The Focus Shift Shooting command.

6. **Accept the default number of shots (100), or press the right arrow on the multi selector to specify a different number.**

After you press the right arrow on the multi selector, you can use the multi selector up and down arrows to specify the number of shots. If you accept the default number of shots, press the down arrow on the multi selector to highlight Focus Step Width and skip to Step 8.

TIP

I think 100 shots is way too many. Combining 100 shots in an image-editing program will tax your processor and take quite a while. Examine the scene you're shooting and determine how many shots you'll need. I suggest a maximum of 20 images unless you're photographing something with intricate detail like a still life of a small tea set.

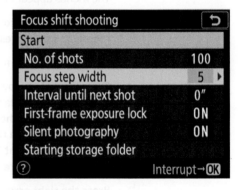

FIGURE 11-19:
The Focus Shift Shooting options.

7. **If you specified a different number of images, press OK.**

You're returned to the Focus Shift Shooting options menu.

8. **Press the down arrow on the multi selector to highlight Focus Step Width (see Figure 11-20).**

9. **Accept the default Focus Step Width or press the right arrow on the multi selector.**

This setting determines the amount the distance changes between shots. If you press the right arrow on the multi selector, the tilting monitor refreshes and you can use the left arrow on the multi selector to decrease the step width or the right arrow on the multi selector to increase the step width. If you change the Focus Step Width Value, press OK, and you're returned to the previous menu.

FIGURE 11-20:
Specifying the Focus Step Width.

10. **Press the down arrow on the multi selector to highlight Interval until Next Shot.**

The default width of 5 is good in most instances. If you're photographing a landscape with a wide-angle lens, you can choose a larger value. If you're photographing a small object, choose a smaller value.

11. If you accepted the default Focus Step Width, press the down arrow on the multi selector to highlight Interval until Next Shot (see Figure 11-21).

12. Accept the default Interval until Next Shot, or press the right arrow on the multi selector to display a menu with options to increase the interval.

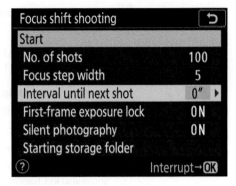

FIGURE 11-21:
The Interval until Next Shot option.

The default is 0 seconds, which means the camera will capture images at the rate of 3 frames per second (fps). This option is fine unless you have a flash mounted on the camera. In that case, you need to increase the interval to give the flash unit enough time to recycle to full power. The duration will vary depending on the flash you use and how fresh the batteries are.

13. Accept the First-Frame Exposure Lock option, or highlight the option and press the right arrow on the multi selector to display a menu with the option to disable first-frame exposure lock.

The First-Frame Exposure Lock option is On by default. This is perfect if you're photographing a landscape or another scene where lighting may change. Choose Off if lighting won't change.

14. Accept the Silent Photography option, or highlight the option and press the right arrow on the multi selector to display a menu with the option to disable silent photography.

If you accept the default option, the only time you'll hear the shutter is when the mirror raises at the start of shooting and lowers at the end of shooting.

15. Highlight Starting Storage Folder (see Figure 11-22).

If you're shooting with a freshly formatted card, and you'll download the images to your computer immediately after capturing the images, you don't need to change the starting folder and can proceed to Step 16.

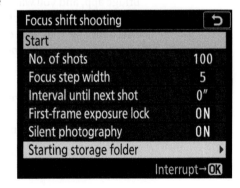

FIGURE 11-22:
This option enables you to change the storage folder or reset numbering.

16. Press the right arrow on the multi selector.

The Starting Storage Folder options appear (see Figure 11-23).

17. To create a new folder, press the right arrow on the multi selector and then press OK.

The options to create a new folder appear. This is similar to what I show you in Chapter 5.

18. To reset numbering, press the down arrow on the multi selector to highlight Reset File Numbers, press the right arrow on the multi selector, and then press OK.

File numbering will be reset.

19. Press the up arrow on the multi selector to highlight Start and press OK.

The camera starts capturing images.

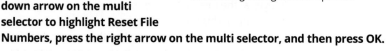

FIGURE 11-23:
The Starting Storage Folder options.

Retouching Images

Photographers should always do their best to get it right in the camera. But there are times when the images you capture need a little help. I recommend you do your retouching in an image-editing program such as Adobe Lightroom or Adobe Photoshop. However, if you're uploading images to your phone using the Snap-Bridge app, and you want to share them with friends and family or on social media immediately, you can retouch the images in camera. When you retouch an image, I recommend that you create a retouched copy of the original image. Doing so leaves the original untouched for editing with an image-editing application on your computer.

Here's how to create a retouched copy of the original image:

1. Press the MENU button.

The camera menus are displayed on your tilting monitor.

2. Press the down arrow on the multi selector to select the Retouch menu (see Figure 11-24), and press the left arrow on the multi selector to highlight the icon.

3. Press the right arrow on the multi selector to place the cursor inside the menu, and then press the down arrow on the multi selector to highlight one of the following commands:

RETOUCH MENU
NEF (RAW) processing
Trim
Resize
D-Lighting
Quick retouch
Red-eye correction
Straighten
Distortion control

FIGURE 11-24:
The Retouch menu.

- *NEF (RAW) Processing:* This command enables you to process an NEF (RAW) image and save a JPEG copy. With this command, you can change image quality, change image size, change white balance, apply exposure compensation, and more.

- *Trim:* This command enables you to crop an image. There are options to size the crop, change the aspect ratio of the image, and position the crop.

- *Resize:* This command gives you the option to resize multiple images.

- *D-Lighting:* This command enables you to brighten shadow areas.

- *Quick Retouch:* This command retouches an image by automatically increasing contrast and enhancing colors. If needed, D-Lighting is used to bring out detail in the shadows.

- *Red-Eye Correction:* This command is for images of people photographed with a flash. Red-eye occurs when the flash reflects on the person's retina, giving the eye a reddish appearance.

- *Straighten:* This command enables you to rotate the image to straighten a tilted horizon or skewed vertical.

- *Distortion Control:* This command enables you to reduce pincushion and barrel distortion on images created with a wide-angle lens.

- *Perspective Control:* This command enables you to correct the perspective of images of buildings when you pointed the camera up.

- *Monochrome:* This command creates a monochrome (black-and-white) copy of the original image. There are also options to create a sepia image or a cyanotype (blue and white) image.

- *Image Overlay:* This command gives you options to combine multiple images into a single image. You can overlay two or more images. When you overlay more than two images, your blending options are Lighten or Darken.

- *Trim Movie:* This command gives you options to trim a movie. Editing movies is covered in detail in the next section of this chapter.

For the purposes of this tutorial, I'll show you how to use the Monochrome command.

4. **Select the desired command and press the right arrow on the multi selector.**

 The options for the selected command are displayed. Figure 11-25 shows the options for the Monochrome command.

5. **Select the desired option, and press the right arrow on the multi selector.**

 The tilting monitor displays images captured on your card (see Figure 11-26).

FIGURE 11-25:
The Monochrome command options.

6. **Use the multi selector arrows to navigate to the image you want to retouch.**

 The image is highlighted with a yellow border.

7. **Press OK to select the image.**

 The tilting monitor displays the selected image and the retouch options. Figure 11-27 shows an image being converted to sepia.

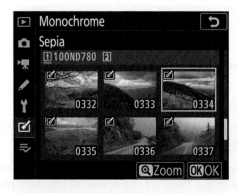

FIGURE 11-26:
Selecting an image to retouch.

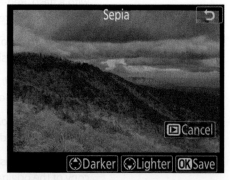

FIGURE 11-27:
Retouching an image.

8. **Retouch the image.**

Depending on the retouch, you'll use the multi selector and perhaps the main command dial and sub-command dial.

9. **Press OK.**

A retouched copy is save to your memory card.

Controlling Light with Flash

Unlike its predecessor, the D750, your D780 does not have a dedicated on-camera flash. However, you can slip a supported flash unit into the accessory shoe and flash your subjects to your heart's content. If you don't have a flash for your D780, and you're considering purchasing one, you can use the following Nikon flashes with your camera: SB300, SB400, SB500, SB600, SB700, SB800, SB900, SB910, or SB5000. Some of these units are no longer available, but you can get a good deal on older units on eBay. The units listed are part of the Nikon Creative Lighting System (CLS). You get the most bang for your buck if you use the SB500 or SB5000.

Using a flash unit

You use a flash unit anytime you need to add more light to a scene. Flash can be used to add light to dimly lit scenes, to create portraits, or to add a splash of light to an otherwise well-lit scene.

To use a flash on your D780, follow these steps:

1. **Insert the batteries in the flash.**

Most Nikon flash units use AA batteries. The correct orientation is stenciled inside the battery chamber.

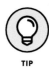

TIP

If you use your flash frequently, consider buying rechargeable batteries.

2. **Mount the flash unit in the camera's accessory shoe.**

It may seem blatantly obvious, but the business end of the flash points toward your subject. You'll know when you have it right. The contacts in the camera accessory shoe align with the contacts on the flash unit. The contacts allow the camera to communicate with the flash.

3. **Lock the unit in place.**

With most units you can easily spot the lock on the back of the unit. Figure 11-28 shows the SB5000 mounted on the D780.

4. **Power on the camera and flash unit.**

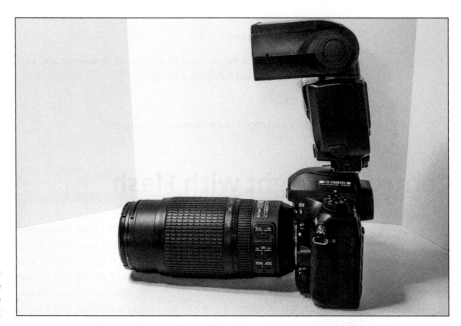

FIGURE 11-28:
Mounting the
flash on the
camera.

5. **Adjust the flash settings.**

 I show you how to adjust flash settings in the "Choosing the flash mode"
 section, later in this chapter.

6. **Take some pictures.**

REMEMBER

Always remove the batteries after using the flash unit. Failure to do so may result
in leakage and ruin your flash.

TIP

The default flash control mode and flash modes are perfect for most photogra-
phy. You can change either using a menu command. However, these options are
beyond the scope of this book.

Choosing the flash mode

Nikon flash units have several different modes. The mode you choose is deter-
mined by your subject matter:

1. **Attach a supported flash unit to the camera.**

 See the preceding section.

2. **Press and hold the flash mode/flash compensation button (see
 Figure 11-29).**

Flash mode/flash exposure compensation button

3. Rotate the main command dial.

As you rotate the dial, the options are displayed (see Figure 11-30), on the tilting monitor, in the viewfinder, and on the control panel. Choose one of the following flash modes:

Red-eye reduction Slow sync + red-eye Flash off

Fill flash Slow sync Rear-curtain sync

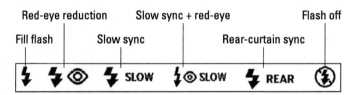

- *Fill Flash:* When you use this mode, the proper flash output is determined based on current lighting conditions. If you're shooting in bright light, the flash adds light to the shadow areas.

- *Red-eye reduction:* When you use this mode, the flash fires just before the photograph is taken, reducing the red-eye effect. Use this mode when shooting portraits.

- *Slow sync:* Use this mode when you shoot with slow shutter speeds to preserve ambient lighting when shooting in dim light or at night.

- *Slow sync + red eye:* Use this mode when shooting portraits at slow shutter speeds in dim lighting conditions. Ambient lighting will be preserved and red-eye will be reduced.

- *Rear curtain sync:* When you use this mode, the flash fires just before the shutter closes. Use this mode when photographing moving objects and a motion trail appears behind the subject, accentuating subject motion.

- *Flash off:* When you use this mode and a flash is attached to the camera's accessory shoe, the flash will not fire under any condition.

4. **Release the flash mode/flash compensation button when you see the desired flash mode.**

Using flash compensation

If you create a photograph with a flash unit attached to a camera, and the resulting image is too bright or too dark, you can employ flash compensation to increase or decrease flash output. Another use for flash compensation would be to decrease flash output if there's glare in the picture. You can also use flash compensation and exposure compensation to brighten the subject and darken the background. You can also use flash compensation creatively in conjunction with a specific subject matter (see Chapter 13).

To alter the flash output with flash compensation, follow these steps:

1. **Attach a supported flash unit to the camera.**

 See the preceding section.

2. **Press and hold the flash mode/flash compensation button (refer to Figure 11-29).**

3. **Rotate the sub-command dial.**

 As you rotate the dial, the amount of compensation is displayed in the viewfinder (see Figure 11-31), on the tilting monitor, and on the control panel.

4. **When you see the desired value, release the sub-command dial.**

 You can alter flash output from –3 EV to +1.0 EV in 0.03-EV increments.

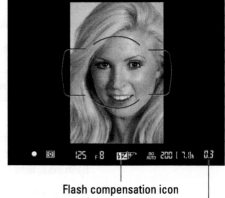

Flash compensation icon

Flash compensation amount

FIGURE 11-31:
Using flash compensation.

Bracketing flash

If you're a stickler for detail, and you love perfectly exposed photographs taken with a flash unit attached, you may consider using flash bracketing. When bracketing flash, you vary the output of the flash. In other words, when you bracket, the camera creates one exposure at the output specified by the camera and bracketed copies where the flash is less powerful and more powerful. But before you can bracket flash output, you need to assign that option to the BKT button. To assign flash bracketing to the BKT button:

1. **Press the MENU button.**

 The menu appears on your tilting monitor.

2. **Press the down arrow on the multi selector to select the Photo Shooting menu, and then press the left arrow on the multi selector.**

 The Photo Shooting menu icon is highlighted.

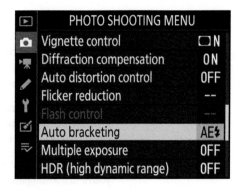

FIGURE 11-32:
The Auto Bracketing command.

3. **Press the right arrow on the multi selector to place the cursor in the menu, and then press the down arrow on the multi selector to highlight Auto Bracketing (see Figure 11-32).**

4. **Press the right arrow on the multi selector.**

 The Auto Bracketing Set options are displayed on your tilting monitor (see Figure 11-33).

5. **Press the right arrow on the multi selector.**

 The Auto Bracketing options are displayed on your tilting monitor (see Figure 11-34).

6. **Press the down arrow on the multi selector to highlight Flash Bracketing and press OK.**

 Flash bracketing is now assigned to the BKT button.

7. **Press the shutter-release button halfway to return to shooting mode.**

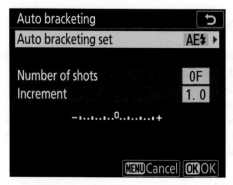

FIGURE 11-33:
The current Auto Bracketing Set options.

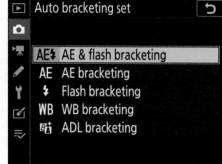

FIGURE 11-34:
The Auto Bracketing options.

Now that you've assigned flash bracketing to the BKT button, you can bracket flash when needed. To bracket flash, follow these steps:

1. **Select the flash mode option as outlined in this section.**

2. **Press the BKT button (see Figure 11-35) located on the left side of the camera as you point it toward your subject and rotate the main command dial.**

 As you rotate the main command dial, the number of frames you're bracketing appears on the control panel.

FIGURE 11-35:
The BKT button.

3. **Determine the number of frames to bracket.**

4. **Rotate the sub-command dial to determine the flash bracketing adjustment.**

 You can bracket flash to increase or decrease output. Rotate the clockwise to increase flash output, or counterclockwise to decrease flash output. Choose an increment of 0.3 (⅓), 0.7 (⅔), 1, 2, or 3 EV for each frame. When you choose a higher value, the difference in flash output between the specified setting increases. In most instances, 0.3 (⅓) or 0.7 (⅔) EV works well.

5. **Compose the image and then press the shutter-release button halfway to achieve focus.**

6. **Press the shutter-release button fully.**

 The camera captures the number of frames specified with flash bracketing applied.

After capturing a set of bracketed images, review the images to make sure that one of them is satisfactory. If you don't get a good image, bracket flash again and choose a different value in Step 4.

3
Applying Your Skills

IN THIS CHAPTER

» **Using the special effect modes**

» **Making a sequence of images**

» **Using Active D-Lighting**

» **Creating HDR images**

» **Creating time-lapse movies**

» **Creating multiple images over a period of time**

Chapter **12**

Creating Special Effects and Other Delights

Creating images can be downright addicting. It's like potato chips — you can't eat just one. The great thing about being addicted to creating lots of images is that you don't end up having to buy a new wardrobe or go on a diet. The great thing about your Nikon D780 is that you can create traditional images, or you can take a walk on the wild side and let your creative inner child run amuck and create images using EFCT mode. In addition to still photography with special effects, you can create time-lapse movies, create high dynamic range (HDR) images, and more.

If you're the kind of person who didn't draw within the lines in school, this chapter will be right up your alley!

Creating Images Using EFCT Mode

You have a tool that enables you to create compelling images. To use this tool, you rotate the mode dial to EFCT. In EFCT mode, you have the following special effects available:

>> **Night vision:** Create monochrome images in dim lighting conditions using a high ISO sensitivity.

>> **Super vivid:** Capture vibrant images with increased contrast and saturation.

>> **Pop:** Create pictures with increased saturation.

>> **Photo illustration:** Create images that look like posters.

>> **Toy camera effect:** Create images that appear to have been created with a toy camera. Objects in images created with this mode have bright outlines and increased saturation.

>> **Miniature effect:** Create images that look like photographs of models of cities and dioramas you see in a museum.

>> **Selective color:** Create a black-and-white image with selective color (for example, a black-and-white photo of a city scene with selective color to show a bright red Ferrari).

>> **Silhouette:** Create images of subjects that are in silhouette against a bright background.

>> **High key:** Create bright images of scenes with blazing light. The resulting images appear to be filled with light.

>> **Low key:** Create a moody image with dark tones and colors.

In the following sections, I show you how to create images with these modes. In some cases, you can adjust the effects when shooting in live view. When this is the case, I show you how to do it. Other EFCT modes cannot be adjusted. When this is the case, I suggest subject matter suitable for that mode. But the fact that you're reading this chapter means you're a creative kind of photographer, so throw caution to the wind and experiment with any type of subject matter that suits your fancy when exploring these modes.

WARNING

When you create images using one of the EFCT modes, you create a JPEG image. If you shoot NEF (RAW) + JPEG, the camera creates a JPEG image only. However, you can capture a NEF (RAW) image of the scene as well. I show you how to do this in the upcoming "Creating an EFCT image and a RAW negative."

Using the EFCT modes

Any of the modes discussed in the following sections have a similar beginning. So I won't bore you with repetitive instructions. In the following sections, I show you specific instructions for selected modes; when the modes can't be adjusted, I suggest subject matter for the mode.

To create an image using one of the EFCT modes, follow these steps:

1. **Press the mode dial release lock, and then rotate the mode dial to EFCT (see Figure 12-1).**

2. **Rotate the main command dial to choose the desired option.**

 The icons for each mode are shown in Figure 12-2.

3. **Compose the scene and take the picture.**

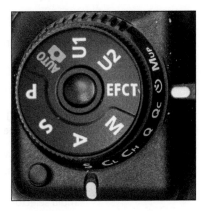

FIGURE 12-1:
The EFCT modes are accessed here.

Some of the EFCT modes have settings you can adjust in live view. Night vison, super vivid, silhouette, high key, low key, and pop are self-explanatory. The only option you have with selective color is three eyedroppers, which you use to determine which colors appear in an otherwise black-and-white image.

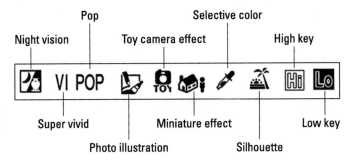

FIGURE 12-2:
Choose the desired EFCT mode.

Experiment with the modes during your picture-taking walkabouts. Some of the effects have adjustable options. I show you which modes you can adjust in the following sections.

Creating a photo illustration

If you're like me, you can create a great image, but you can't draw a straight line. Fear not, intrepid photographer! Your camera enables you to create a photo illustration of your favorite scene. You can adjust the effect when shooting in live view.

To create a photo illustration, follow these steps:

1. **Select photo illustration from the EFCT mode.**

2. **Press the live view button.**

 The tilting monitor refreshes showing the view captured by the lens.

3. **Press OK.**

 The options you can adjust are displayed on the tilting monitor.

4. **If desired, adjust the outline thickness (see Figure 12-3).**

 Press the left arrow on the multi selector to make the outlines thinner or the right arrow on the multi selector to make the outlines thicker.

5. **Press OK.**

 The adjusted effects will be applied to the image.

6. **Compose the image and take the picture.**

FIGURE 12-3:
Adjusting the outline thickness.

Figure 12-4 shows an image created with the photo illustration effect.

Turning your D780 into a toy camera

The toy camera effect is another option for creating a cool image. The resulting image looks similar to images created with some of the early Lensbaby optics (www.lensbaby.com), albeit a tad sharper.

To create an image using the toy camera effect, follow these steps:

1. **Select toy camera from the EFCT mode.**

2. **Press the live view button.**

 The tilting monitor refreshes showing the view captured by the lens.

FIGURE 12-4:
Creating
images with
the photo illus-
tration effect.

3. **Press OK.**

The options you can adjust are
displayed on the tilting monitor
(see Figure 12-5).

4. **If desired, adjust Vividness.**

Press the left arrow on the multi
selector to make the image less
vivid or the right arrow on the multi
selector to make the image more
vivid.

5. **If desired, adjust Vignetting.**

Press the left arrow on the multi
selector to decrease the size of the vignette or the right arrow on the multi
selector to increase the size of the vignette.

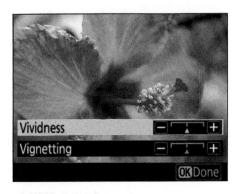

FIGURE 12-5:
Adjusting the options.

6. **Press OK.**

The changes will be applied when you create the image.

7. **Compose the image and take the picture.**

Figure 12-6 shows an image created with the toy camera effect.

FIGURE 12-6:
Creating
images with
the toy camera
effect.

Playing with miniatures

If you photograph cityscapes from a tall building using the miniature effect, cars and people look like toys or models. When you use this effect, you determine which part of the scene is in sharp focus. This is the *slice of focus*. The area surrounding the slice of focus is slightly blurred. The slice of focus can be vertical or horizontal.

To create an image using the miniature effect:

1. **Select miniature from the EFCT mode.**

2. **If desired, press the live view button.**

 The miniature effect has options you can adjust when creating an image with this mode in live view.

3. **Use the multi selector arrows to place the autofocus point.**

4. **Press OK.**

 The miniature effects options are displayed on your tilting monitor.

5. **Use the multi selector arrows to choose the position of the area of the image that will be in focus.**

 This is actually a slice of focus. Press the left arrow on the multi selector or the right arrow on the multi selector to orient the slice of focus vertically or horizontally.

6. **Use the multi selector arrows to specify the size of the slice of focus (see Figure 12-7).**

 Press the up arrow on the multi selector or the down arrow on the multi selector to specify the size of the slice of focus.

7. **Press OK.**

 The orientation and size of the slice of focus are set for this image.

8. **Press the shutter-release button halfway to achieve focus, and then press the shutter-release button fully to take the picture.**

FIGURE 12-7:
Specifying the orientation and size of the slice of focus.

Figure 12-8 shows an image created using the miniature effect.

FIGURE 12-8:
Creating an image with the miniature effect.

Creating an EFCT image and a RAW negative

When you create special effects, there may be times you want to keep a RAW file of the original scene. You can do this when you create images using the following EFCT modes:

>> Night vision

>> Super vivid

>> Pop

>> Photo illustration

>> Toy camera effect

>> Miniature effect

>> Selective color

This is a great option when you use one of the previously listed EFCT modes to create an image of an event that may never happen again.

To create an NEF (RAW) file and a JPEG file of a special effect, follow these steps:

1. **Press the MENU button.**

The camera menus appear on the tilting monitor.

2. **Press the down arrow on the multi selector to highlight the Custom Settings menu, and then press the left arrow on the multi selector to highlight the icon.**

3. **Press the right arrow on the multi selector to place the cursor inside the menu, and then press the down arrow on the multi selector to highlight d8: Save Original (EFFECTS), as shown in Figure 12-9.**

4. **Press the right arrow on the multi selector.**

The Save Original (EFFECTS) options appear on your tilting monitor (see Figure 12-10).

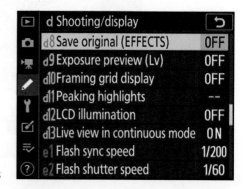

FIGURE 12-9:
The d8: Save Original (EFFECTS) command.

5. Press the up arrow on the multi selector to highlight On and press OK.

When you create an image using the night vision, super vivid, pop, photo illustration, toy camera effect, miniature effect, or selective color effect, the camera saves a JPEG file with the effect applied, and an unprocessed NEF (RAW) file.

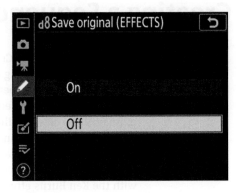

FIGURE 12-10:
The Save Original (EFFECTS) options.

Creating special effects movies

Creating movies using one of the EFCT modes is another way to create compelling entertainment. Your camera is capable of capturing 4K video in a wide variety of frame rates (see Chapter 8). Moviemaking is fun, and if you're an out-of-the-box kind of photographer, you can create interesting and unique movies using the EFCT modes. When you create movies, you do so in live view mode (see Chapter 8). And as I show you in this chapter, you can modify many of the EFCT modes in live view. The possibilities are only limited by your imagination.

If you're creating movies at dusk or creating a video scene of a city, try using the EFCT night vision mode to create your masterpiece. Other options for creating compelling videos of a city are the EFCT super vivid, pop, toy camera effect, or miniature effect modes. Put your camera on a tripod and create a video of a busy intersection using the EFCT miniature effect mode. Another idea is to create a video of people at sunset with their back to the sun using the EFCT silhouette mode. Create a video of a performer in the spotlight using the EFCT high key mode, or create a video of a dark stormy night using the EFCT low key mode.

WARNING

When you create a movie using the EFCT photo illustration mode, it looks more like a slide show.

REMEMBER

Movies created using the EFCT miniature effect mode play back at a high speed. For example, if you record 15 minutes of video using the miniature effect mode, the duration of the processed movie is 1 minute.

Creating a Sequence of Images

If you shoot using the Cʟ (continuous low speed) or Cʜ (continuous high speed) release mode while using one of the EFCT modes, you create a sequence of images. The number of frames per second the camera can capture while using photo illustration or miniature effect will be slower than normal. After creating a sequence of images and downloading them to your computer, you can use third-party software to combine the frames into a single document, and then create a compelling slide show. Some software, such as Adobe Photoshop, enables you to zoom in or out on a frame and move the frame, which, when compiled, creates a slide show with the Ken Burns effect.

Image sequences are effective ways to show change over time. You can record a sequence of images of an athlete in motion, a party in progress, a chef cooking, and so on. If you create an image sequence where a person or object moves, focus is important. If you shoot your special effect image sequence using live view, consider using the AF-C (continuous autofocus) mode and using the Dynamic-area AF mode discussed in Chapter 7. If you use one of the EFCT modes that does not have adjustable options in live view, and you shoot through the viewfinder, use the AF-C autofocus mode and the dynamic-area AF mode with 9 points (see Chapter 10). When creating a movie using the EFCT photo illustration mode, you must focus manually.

If you're photographing a static scene that changes over time, such as traffic moving through a busy intersection, mount the camera on a tripod. You can remotely release the shutter or use the Cʟ or Cʜ release mode to capture multiple images. If you choose Cʟ or Cʜ, you can capture up to 100 images when pressing the shutter-release button. Depending on the amount of movement that occurs when you capture the sequence, you can combine the images to create a movie that looks like a Keystone Cops comedy. Add some interesting background music, and you can create a slide show or movie to entertain friends or clients.

Creating Slow-Motion Movies

You've probably seen movies where slow-motion clips have been added for dramatic effect. A classic use of slow motion is the final scene of *Bonnie and Clyde*. If you're too young to remember that movie, perhaps you've seen *Hard Boiled* (1991) or *Dredd* (2012). When you create a slow-motion movie using one of the frame rates discussed in the following section, the camera records the video at a frame rate four times faster than the frame rate the processed movie is played back at. For example, when you choose the 1920 x 1080; 30p x 4 (slow-motion) option, the

camera records the video at 120 frames per second (fps) and the movie is played back at 30 fps. Plus, with this frame rate, 15 seconds of video produces 60 seconds of footage. At any rate, you can use slow motion for an entire movie, or create a clip that you use for a bigger project you're editing in an application such as Adobe Premiere Pro or Adobe Premiere Elements.

To create a slow-motion movie, follow these steps:

1. **Press the MENU button.**

The menus appear on your tilting monitor.

2. **Press the down arrow on the multi selector to highlight the Movie Shooting menu, and then press the left arrow on the multi selector.**

The Movie Shooting menu icon is highlighted.

3. **Press the right arrow on the multi selector to place the cursor inside the menu, and then press the down arrow on the multi selector to highlight Frame Size/Frame Rate (see Figure 12-11).**

4. **Press the right arrow on the multi selector.**

The video and frame rate options are displayed.

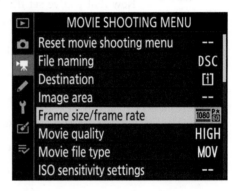

FIGURE 12-11:
Your first step when creating a slow-motion movie.

5. **Press the down arrow on the multi selector and choose one of the following slow-motion frame rates (see Figure 12-12):**

- *1920 x 1080; 30p x 4 (slow-motion):* This option creates a movie with a frame size of 1920 x 1080 (HD) that is recorded at 120 fps (30 fps x 4) and played back at a frame rate of 30 fps. This option is good for most slow-motion movies.

- *1920 x 1080; 25p x 4 (slow-motion):* This option creates a movie with a frame size of 1920 x 1080 (HD) that is recorded at 100 fps (25 fps x 4) and played

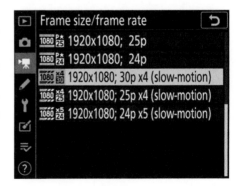

FIGURE 12-12:
Choosing the frame size and frame rate for your slow-motion movie.

back at a frame rate of 25 fps. This option is good for videos that will be used in Europe for countries using the PAL standard.

- *1920 x 1080; 24p x 5 (slow-motion):* This option creates a movie with a frame size of 1920 x 1080 (HD) that is recorded at 120 fps (24 fps x 5) and played back at a frame rate of 24 fps. This option gives you a slow-motion movie with cinematic qualities.

6. **Press OK, and then press the shutter-release button halfway.**

The desired slow-motion frame size and frame rate will be applied to all videos until you visit this menu again and choose a different option.

WARNING

Audio is not recorded when you create a slow-motion movie. You'll have to add the soundtrack using third-party software.

Now that you've set the frame size and frame rate for your slow-motion movie, it's time to record it. To record your slow-motion video, follow these steps:

1. **Press the live view button.**

The view captured by your lens is displayed on the tilting monitor.

2. **Rotate the live view selector to movie live view (see Figure 12-13).**

It's the icon that looks like a movie camera.

3. **Press the movie-record button (see Figure 12-14).**

The camera begins recording your video.

Live view button

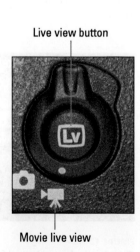

Movie live view

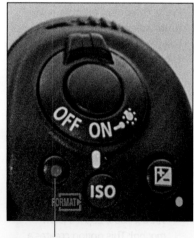

Movie-record button

FIGURE 12-13:
They're gonna put me in a slo-mo movie.

FIGURE 12-14:
Press the movie-record button to begin creating your masterpiece.

4. **Press the movie-record button again.**

The camera stops capturing video.

After you create your slow-motion video, press the play button and review your handiwork (see Chapter 8). But before you view your slow-motion masterpiece, fill a stein with your favorite beverage, grab a bowl of popcorn, and prepare to be amazed!

Creating Dynamic Images with Active D-Lighting

When a scene you're photographing has a wide range of tonal values, from shadows to highlights, the camera isn't capable of recording details in the shadow areas, at least not without a little help from a friend. And that friend is Active D-Lighting. If you create an image and notice it lacks the amount of detail you can see, you can create another image with Active D-Lighting applied. When you use Active D-Lighting, the resulting image has more detail in the highlight and shadow areas. You can use Active D-Lighting with still photography, and when creating movies. Active D-Lighting does not work when you shoot in Auto mode.

Here's how to do it:

1. **Press the MENU button.**

The camera menus appear on the tilting monitor.

2. **Press the down arrow on the multi selector to highlight the Photo Shooting menu if you're shooting stills or Movie Shooting menu if you're shooting a movie, and then press the left arrow on the multi selector.**

The Photo Shooting or Movie Shooting menu icon is highlighted. For the purpose of this tutorial, I show you how to use Active D-Lighting for still photography.

3. **Press the right arrow on the multi selector to place the cursor inside the menu, and then press the down arrow on the multi selector to highlight Active D-Lighting (see Figure 12-15).**

4. **Press the right arrow on the multi selector to view the Active D-Lighting options (see Figure 12-16).**

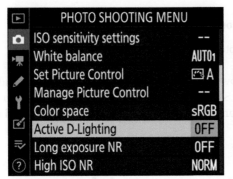

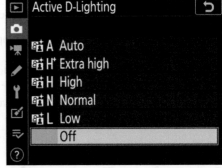

FIGURE 12-15:
The Active D-Lighting command.

FIGURE 12-16:
Choose an Active D-Lighting option.

5. **Choose the desired option.**

TIP

Start with the Auto option. If the resulting image doesn't have enough detail in the shadow and highlight areas, take another picture using the High or Extra High option. If the photo taken with the Auto option looks harsh, take another picture using the Low option.

The image on the top in Figure 12-17 shows an image without Active D-Lighting, and the image on the bottom shows the same scene with Active D-Lighting applied.

TIP

You can also bracket Active D-Lighting. When you bracket Active D-Lighting, you hedge your bets and capture three to five shots. Bracketing Active D-Lighting is useful when you're photographing a place you may never visit again. You can review your images by playing them back on the camera and then deleting the ones you don't like, or as I recommend, download all the bracketed shots to your computer and then delete the duds. It's easier to see the fine details on a large computer screen.

Bracketing Active D-Lighting is a two-step process. The first step is to use a menu command to assign Active D-Lighting bracketing to the BKT button. Then you use the BKT button to specify the number of shots used to bracket Active D-Lighting.

To assign Active D-lighting to the BKT button, follow these steps:

1. **Press the MENU button.**

The menus appears on your tilting monitor.

2. **Press the down arrow on the multi selector to select the Photo Shooting menu, and then press the left arrow on the multi selector.**

The Photo Shooting menu icon is highlighted.

3. Press the right arrow on the multi selector to place the cursor in the menu, and the press the down arrow on the multi selector to highlight Auto Bracketing (see Figure 12-18).

4. Press the right arrow on the multi selector.

The Auto Bracketing options appear on your tilting monitor (see Figure 12-19).

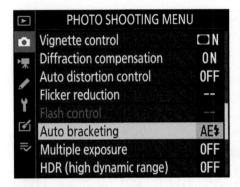

FIGURE 12-18:
The Auto Bracketing command.

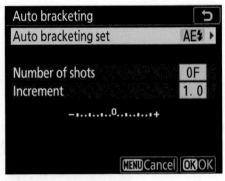

FIGURE 12-19:
The Auto Bracketing Set options.

5. **Press the right arrow on the multi selector.**

 The Auto Bracketing options you can assign to the BKT button appear on your tilting monitor (see Figure 12-20).

6. **Press the down arrow on the multi selector to highlight ADL Bracketing and press OK.**

 Active D-Lighting is now assigned to the BKT button.

FIGURE 12-20:
Assigning Active D-Lighting to the BKT button.

Now that you've assigned Active D-Lighting to the BKT button, you can bracket Active D-Lighting when needed. To bracket Active D-Lighting, follow these steps:

1. **Enable Active D-Lighting as outlined earlier in this section.**

2. **Press the BKT button (see Figure 12-21), located on the left side of the camera as you point it toward your subject, and rotate the main command dial.**

 As you rotate the main command dial, the number of frames you're bracketing appears on the control panel.

3. **Determine the number of frames to bracket.**

 You can bracket two to five frames.

FIGURE 12-21:
The BKT button.

- *When you bracket two frames*, the camera captures one image with Active D-Lighting off, and one image at the value you select. If you choose this option, hold the BKT button and rotate the sub-command dial to choose the setting for the second shot.

- *When you bracket three frames,* the camera captures one image with Active D-Lighting off, one image with Active D-Lighting low, and one image with Active D-Lighting normal.

- *When you bracket four frames,* the camera captures one image with Active D-Lighting off, one image with Active D-Lighting low, one image with Active D-Lighting normal, and one image with Active D-Lighting high.

- *When you bracket five frames,* the camera captures one image with Active D-Lighting off, one image with Active D-Lighting low, one image with Active D-Lighting normal, one image with Active D-Lighting high, and one image with Active D-Lighting extra high.

4. **Compose the image and then press the shutter-release button halfway to achieve focus.**

5. **Press the shutter-release button fully.**

The camera captures the number of frames specified with Active D-Lighting bracketing applied.

Creating High Dynamic Range (HDR) Images

You have another option when confronted with a high-contrast scene with a wide tonal range from shadows to highlights: HDR. HDR stands for *high dynamic range.* Your camera has the option to create a single HDR image by first capturing multiple frames at different exposure levels and then merging them into a single image. Many cameras don't have this option. Without built-in HDR, you have to bracket exposure over several frames and merge them into a single image in an HDR program or an application like Adobe Lightroom.

In the following section, I show you how to create an HDR image and how to save bracketed images as NEF (RAW) files.

Creating an HDR image

When you create an HDR image, you can shoot a single HDR image or a series of HDR images. You can also let the camera automatically determine the HDR strength or choose one of the other options.

To create an HDR image, follow these steps:

1. **Press the MENU button.**

The menus appear on your tilting monitor.

2. **Press the down arrow on the multi selector to select the Photo Shooting menu, and then press the left arrow on the multi selector.**

The Photo Shooting menu icon is highlighted.

3. **Press the right arrow on the multi selector to place the cursor in the menu, and then press the down arrow on the multi selector to highlight HDR (High Dynamic Range), as shown in Figure 12-22.**

4. **Press the right arrow on the multi selector.**

The HDR (High Dynamic Range) options appear on your tilting monitor (see Figure 12-23).

5. **Press the right arrow on the multi selector to see more HDR options (see Figure 12-24).**

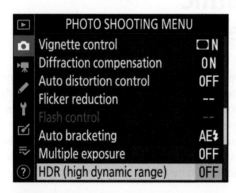

FIGURE 12-22:
The HDR (High Dynamic Range) menu command.

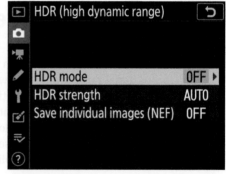

FIGURE 12-23:
The HDR options.

6. **Press the up arrow on the multi selector to highlight one of the following options:**

- *On (series):* The camera captures a series of HDR images until you revisit this menu and choose Off.

- *On:* The camera captures one HDR image.

- *Off:* Choose this option after taking a series of HDR photographs to cancel HDR photography.

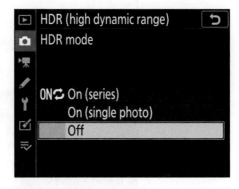

FIGURE 12-24:
Choose how the camera captures HDR images.

7. **Press OK.**

You're returned to the previous menu.

8. **Press the down arrow on the multi selector to highlight HDR Strength and press the right arrow on the multi selector.**

The HDR Strength options are displayed on your LCD monitor (see Figure 12-25).

9. **Choose the desired option.**

The default option is Auto, but after taking a photograph, or capturing a series of photographs, you may decide that the HDR is too strong, or not strong enough. If so, choose one of the other strength options.

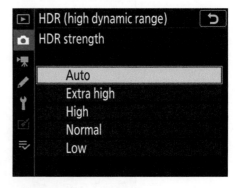

FIGURE 12-25:
Choosing an HDR Strength option.

10. **Press OK, and then press the shutter-release button halfway to return to shooting mode.**

You're now ready to create one HDR image or a series of HDR images. The image on the top of Figure 12-26 needs HDR to bring out the full dynamic range, and the image on the bottom shows the same scene with HDR applied.

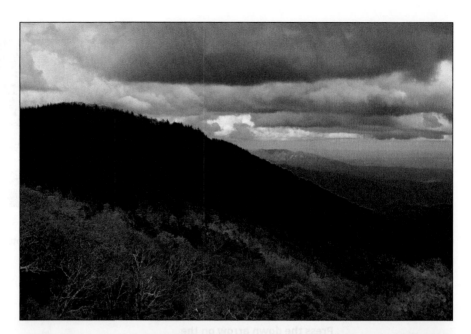

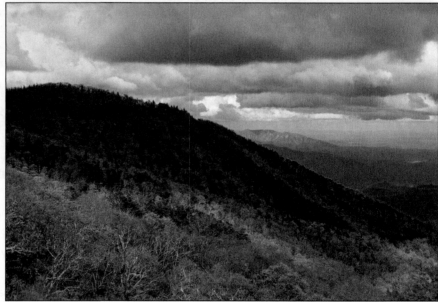

FIGURE 12-26:
Using HDR to
reveal the full
dynamic range
of a scene.

Saving bracketed HDR images as RAW files

If you love the technology your D780 offers, but you still like to tinker with HDR applications or merge bracketed exposures in Adobe Lightroom, you have that

option. You can save the images the camera uses to create your HDR image as NEF (RAW) files and tinker to your heart's content in your favorite image-editing program.

Here's how you do it:

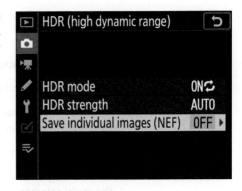

1. **Follow Steps 1 through 7 in the preceding section of this chapter.**

2. **Press the down arrow on the multi selector to highlight Save Individual Images (NEF), as shown in Figure 12-27.**

3. **Press the right arrow on the multi selector.**

 You have two options, On or Off (see Figure 12-28).

4. **Press the up arrow on the multi selector to highlight On, and then press OK.**

 When you create an HDR image, the images used to create the photograph are saved as NEF (RAW) files.

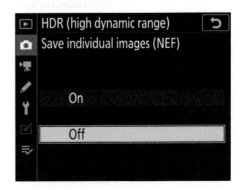

Creating a Time-Lapse Movie

Earlier in this chapter, I discuss creating image sequences. That's a great option if you have the software that can be used to compile the images and, of course, the knowledge. But if you're the kind of photographer who believes time behind the lens is better than time behind the computer, you have other a great option: creating a time-lapse movie.

Creating a time-lapse movie is a great way to record changes that happen over a period of time. You can create a time-lapse movie in any mode except EFCT. I recommend you choose Auto and let the camera make all the decisions. You'll also need to mount your camera on a tripod. After you have those orders of

business out of the way, you're ready to create a time-lapse movie by following these steps:

1. **Press the MENU button.**

 The menus appear on your tilting monitor.

2. **Press the down arrow on the multi selector to select the Photo Shooting menu, and then press the left arrow on the multi selector.**

 The Photo Shooting menu icon is highlighted.

3. **Press the right arrow on the multi selector to place the cursor in the menu, and then press the down arrow on the multi selector to highlight Time-Lapse Movie (see Figure 12-29).**

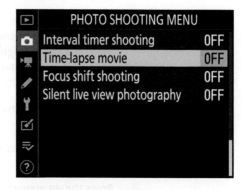

FIGURE 12-29
The first step to creating a time-lapse movie.

4. **Press the right arrow on the multi selector.**

 The Time-Lapse Movie options are displayed (see Figure 12-30). Each option has its own section. You'll need to use the multi selector to move from section to section and specify the duration.

5. **Specify the following parameters:**

 - *Interval:* This is the time between shots. The default is 5 seconds. Accept this option, or press the right arrow on the multi selector and then choose a different duration.

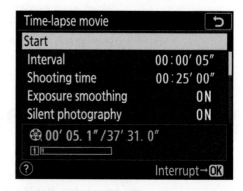

FIGURE 12-30:
Choose the options for your time-lapse movie.

TIP

 Choose an interval faster than the slowest anticipated shutter speed.

 - *Shooting time:* This determines how long the camera captures the frames that make up your movie. You can specify a shooting time of up to 7 hours and 59 minutes.

TECHNICAL STUFF

To determine the duration of the finished movie, divide the duration by the interval. For example, if the shooting time is 30 minutes (1,800 seconds) and the interval is 10 seconds, your time-lapse movie will be 3 minutes long (1,800 ÷ 10 = 180 seconds, or 3 minutes). Elementary, my dear Watson.

- *Exposure smoothing:* The default option is On, which is great, especially when you anticipate the exposure changing over time. This options smooths the images so that viewers won't notice a jarring change when exposure changes. In most instances, you should leave exposure smoothing on, especially if you're creating a time-lapse movie that begins in late afternoon and will end in the evening.

- *Silent photography:* The default option is On. With the default option, the only time you hear the sound of the shutter or mirror rising is at the start and end of the shooting duration.

After specifying the options for your time-lapse movie, you're returned to the first menu (refer to Figure 12-30).

6. **If Start is not highlighted, use the multi selector to highlight it, and then press OK.**

The camera starts capturing the images that will be used to create your time-lapse movie. Now's a good time to break out a picnic lunch or read a good book. When the shooting duration ends, the camera assembles the individual images into a movie.

TIP

Make sure you have a fully charged battery before creating a time-lapse movie. If you're creating a movie with a long shooting time, you may want to consider using a battery pack so your camera doesn't run out of juice while creating the movie.

Interval Shooting

If you like taking matters into your own hands, try interval shooting. With this option, you create multiple images over a period of time, but the camera doesn't combine them into a time-lapse movie. When you use this option, you end up with lots of images that you can then merge into a movie using a third-party application such as Adobe Photoshop. When the camera creates a time-lapse movie, there is no soundtrack, but when you create multiple images, you can add a soundtrack in your favorite image-editing application.

To create a series of images over a period of time, follow these steps:

1. **Press the MENU button.**

The menus appear on your tilting monitor.

Do not attempt interval shooting when using Timer or M_{UP} for the release mode.

WARNING

2. **Press the down arrow on the multi selector to select the Photo Shooting menu, and then press the left arrow on the multi selector.**

The Photo Shooting menu icon is highlighted.

3. **Press the right arrow on the multi selector to place the cursor in the menu, and then press the down arrow on the multi selector to highlight Interval Timer Shooting (see Figure 12-31).**

4. **Press the right arrow on the multi selector.**

The interval timer shooting options are displayed on your tilting monitor (see Figure 12-32).

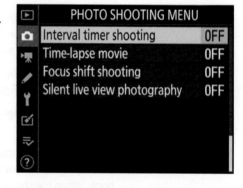

FIGURE 12-31:
Go here to enable interval timer shooting.

5. **Choose the following options:**

- *Choose start day/time:* Press the right arrow on the multi selector to display a menu from which you can specify the day and time the shooting will start. The default option is Now, or you can use the multi selector to specify the day and time. After choosing the day and time, press OK to return to the previous menu and choose the next option.

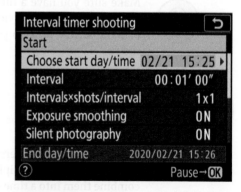

FIGURE 12-32:
The options for interval timer shooting.

- *Interval:* The default interval is 1 minute between shots. To choose a different interval, press the right arrow on the multi selector to display a menu from which you choose the interval between shots. After specifying the interval, press OK to return to the previous menu and choose the next option.

- *Intervals x shots/interval:* The default option is 1 shot per interval. Press the right arrow on the multi selector to display a menu from which you can specify more shots per interval. After specifying this option, press OK to return to the previous menu and choose the next option.

- *Exposure smoothing:* The default option is On, which is great, especially when you anticipate the exposure changing over time. This option smooths the images so that viewers won't notice a jarring change when exposure changes. In most instances, you should leave exposure smoothing on, especially if you're shooting a series of images that begin in late afternoon and end in the evening.

- *Silent photography:* The default option is On. With the default option, the only time you hear the sound of the shutter or mirror rising is at the start and end of the shooting duration.

After specifying these options, the ending day and amount of time are displayed at the bottom of the Interval Timer Shooting menu.

6. **Highlight Start and press OK.**

If you chose Now for the starting time, the mirror will lock up and the camera will start capturing images in 3 seconds. If you specified a day and time, the camera starts capturing images at the specified day and time. The camera continues writing images to the memory card until all the photos have been created.

TIP

Make sure you have a fully charged battery before shooting intervals. If you're capturing images over a long period of time, with a short duration between intervals, you may want to consider using a battery pack so your camera doesn't run out of juice while creating the movie.

TIP

Make sure the memory card(s) you have in the camera have enough room to capture all the images that the camera will capture during the specified duration.

IN THIS CHAPTER

» **Photographing events**

» **Shooting landscapes**

» **Photographing portraits**

» **Photographing sports**

» **Photographing wildlife**

» **Doing macro photography**

Chapter **13**

Honing Your Skills

I f you've read every chapter of this book in order, you know the Nikon D780 like the back of your hand. Or maybe you fast-forwarded to this chapter for specific information about your favorite type of photography. Regardless, your D780 is ideally suited for just about every genre of photography that exists.

But shooting different genres requires different skill sets and different camera settings. As a professional photographer, I've shot many different genres of photography over the years. In this chapter, I share some of my knowledge and show you what settings to use and how to photograph many scenarios.

Shooting Special Events: Birthdays, Weddings, and More

Photographing special events like birthdays, weddings, and social gatherings can be fun and profitable. Events can also be stressful, especially when the event is a once-in-a-lifetime occurrence, like a wedding. Photographs from special events can be formal (the bride and the groom at the alter) or casual (candid photographs of family and friends during and after the event).

When you photograph a special event, make sure that photography is permitted. Contact the organizer of the event. Doing so may grant you special access to areas not normally available to event guests.

When you photograph an event, you capture the traditional photos requested by the person who asked or hired you to photograph the event. But that doesn't mean your photos have to be rigid. Create the traditional images first, and then branch out to capture candid photos of event participants and guests. If you're creating pictures for yourself, the rules go right out the window. Shoot the images that will help you remember the event in years to come and inject a bit of your personal style.

Before photographing an event, search the web for the type of event you're photographing, and look at lots of images or get some ideas from a magazine.

Setting the camera

When you photograph an event, you take a time-honored series of pictures. Whenever people are your subject, you need to control depth of field, so use aperture-priority auto (A) mode. When you need to zoom in tight on the action, use a large aperture, which gives you a shallow depth of field and draws the viewer's attention to the subject. When you photograph a group of people, use an aperture of f/5.6 or f/8.0 to capture a larger depth of field, which gives you a photo that has everyone in the picture in focus.

A wide-angle lens is useful when you need to create images that show the magnitude of a large outdoor event. A zoom lens with a focal range from wide-angle to midrange telephoto makes it possible for you to quickly zoom in or out as needed.

A single auto-focus point lets you pinpoint the person you want to make the center of attention. Using AF-A (autofocus automatic) enables the camera to quickly and accurately focus on stationary subjects or moving subjects. This option makes it possible for the camera to continuously focus on the bride and groom as they walk down the aisle, or to focus on a speaker who is stationary at the dais.

An ISO range of 100 to 800 allows you to photograph a bright outdoor event (ISO 100) or a wedding in a dimly lit church (ISO 800).

If you're photographing a large group of people, arrange them in rows. Ask the tallest people to stand at the back of the group, and then create rows of shorter people. If young children are part of the group, place them in front of the adults. If you feel creative, shoot from a low vantage point and have a couple of members of the group kneel or lie on the ground.

CAMERA SETTINGS: SPECIAL EVENTS

These are the settings I recommend for shooting special events:

- **Metering mode:** Matrix

- **Release mode:** Single frame

- **Shooting mode:** Aperture-priority auto (A) mode

- **Aperture:** f/5.6 to f/8.0

- **ISO:** 100 to 800, with auto ISO mode enabled in case the light is too dim to capture a blur-free image at the desired setting

- **Focus mode:** AF-A (autofocus automatic)

- **Autofocus point:** Single-point AF

- **Focal length:** 35mm to 100mm or a zoom lens such as the Nikkor 24–120mm f/4.0

- **Image stabilization:** On, unless using a tripod

Photographing the event

If you're photographing an event for a person, talk with him well before the event and ask him which shots are important to him. Do the same if you're photographing a once-in-a-lifetime event like a wedding. When photographing a wedding, chat with the couple well in advance of the ceremony and ask them which shots are important to them and which relatives need to be in the photos. When you need to move frequently to capture the required images, make sure everyone associated with the event knows so they won't be startled when you move quickly to capture an image.

TIP

Arrive early at the venue where the event is being held and get your gear ready. When you're cleaning your lenses, look for an ideal vantage point from which to photograph the procession. (You can better prepare yourself if you know what's going to happen. Attend the rehearsal if at all possible.)

If you're photographing the event with additional photographers, coordinate tasks and priorities. If you're photographing an event like a wedding with multiple photographers, each photographer should be responsible for a key player (the bride, the groom, and the parents), and one photographer should be responsible for capturing candid photos and images of the entire group.

Photograph the key moments in the event. If you're photographing an event with speakers, capture images of the handshake of the moderator and the keynote speaker. If you're photographing a wedding, zoom in to capture a single shot of the groom and his mother walking down the aisle, and another shot of the bride and her father walking down the aisle. Get a photograph of the couple's first kiss and the wedding party celebrating.

Figure 13-1 shows a photograph of the happy couple relaxing just before the reception.

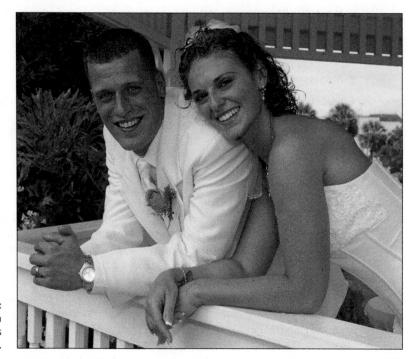

FIGURE 13-1:
Photograph key moments of the event.

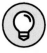
When photographing a wedding, after the event is over, photograph the wedding procession as they leave. You have to be quick on your feet and get to the end of the aisle right after you photograph the couple's first kiss. The bride and groom are the first to leave, and they get a lot of attention from the guests attending the ceremony. Don't forget to photograph the other members of the wedding party, too.

If you're photographing an event with multiple photographers, have one of the photographers create some time-lapse movies of the event. I show you how to create time-lapse movies with your D780 in Chapter 12.

COMMON PROBLEMS AT SPECIAL EVENTS

When photographing a special event, you may run into problems. The following is a list of problems I've encountered while photographing events and their solutions:

- **You're photographing an outdoor event and the sky is too bright.** You need to make your exposure spot-on when shooting an outdoor event. If you're photographing an outdoor wedding, make sure your camera properly exposes the bride's gown. If the camera blows out a detail on the gown to pure white, you may have a hard time recovering the detail in your image-editing program, and the bride won't be a happy camper when you present her with the photos. You can leave the camera settings so that the sky is too bright in the photos, as long as the people attending the event are properly exposed.

- **People's faces include areas of bright light.** You have to deal with this problem when you shoot an outdoor event. Use exposure compensation to reduce the overall exposure by 1/3 EV. The resulting images will still include areas of bright light, but those areas won't be as noticeable.

- **The event is in mixed lighting conditions, such as bright light and shade.** When you're faced with this dilemma, make sure the key players are properly exposed. For example, if the event is a wedding, make sure the images of the bride and groom are exposed correctly. In a situation like this, it's okay if the event moderator is slightly underexposed. Another solution is to shoot some of the formal images in shade.

Many image-editing applications have controls that enable you to recover details in shadow areas, but getting it right in the camera is best.

TIP

You can augment lighting with fill flash. This is useful when photographing subjects that are backlit. For more information about flash photography, see Chapter 11.

Photographing the Landscape

No matter where you live, you can find lovely landscapes, maybe within a few miles of your home. Landscape photography done right is stunning. It captures the mystery and grandeur of the place where you took the picture. When you photograph a landscape, your vantage point and the way you compose the photograph go a long way toward creating an image that's a work of art and not just a snapshot. You want to draw viewers into the picture so that they take more than just a casual glance.

When you photograph a landscape, you photograph the big picture — a wide sweeping brushstroke that captures the beauty of the area. So, you want every subtle detail to be in focus, which means you want a huge depth of field (see Figure 13-2). In addition to a large depth of field , composition also plays a key role when you photograph a landscape.

FIGURE 13-2: Photographing a landscape.

Setting the camera

When you photograph a beautiful landscape, you want to see every detail, which is why you use aperture-priority auto (A) mode and a small aperture to ensure a large depth of field. A wide-angle lens lets you capture the majesty of the land-scape in your photograph, and a low ISO gives you a noise-free image. However, if you're photographing landscapes on overcast days, you may have to increase the ISO to maintain a shutter speed of 1/30 second. If you don't want to increase the ISO setting, use image stabilization (if your lens has this feature) or mount your camera on a tripod.

CAMERA SETTINGS: LANDSCAPES

These are the settings I recommend for shooting landscapes:

- **Metering mode:** Matrix

- **Release mode:** Single frame

- **Shooting mode:** Aperture-priority auto (A) mode

- **Aperture:** f/11 to f/16

- **ISO:** 100 to 200, with auto ISO mode enabled in case the light is too dim to capture a blur-free image at the desired setting

- **Focus mode:** AF-S (single autofocus)

- **Autofocus Point:** Single-point AF

- **Focal length:** 24mm to 35mm

- **Image stabilization:** On, especially if the shutter speed dips below 1/30 second; off when using a tripod

Turning your lens on the landscape

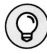

TIP

Being a great landscape photographer requires practice and a bit of study. Shoot landscapes whenever you have the chance and study the work of master landscape photographers, such as Ansel Adams, Clyde Butcher, David Muench, and David's son Marc Muench. Studying the work of the masters can help give you an eye for landscape photography and, after much practice, develop your own unique style. Search the web for these photographers to see samples of their eye-popping work.

You can photograph a landscape whenever you see one that strikes your fancy. However, whether you're photographing landscapes on vacation or at home, try to set aside a block of time in which to photograph landscapes. Travel to your favorite area, or spice things up and travel to a place you've never visited before. Then embark on your quest to capture the perfect photograph of the area you're in.

TIP

When you find an area that you want to photograph, find the ideal vantage point. Don't place the horizon line in the middle of the picture. Place the horizon line in the upper third of the image when the most important part of the landscape you're photographing dominates the bottom of the scene, such as when you're photographing sand dunes in the desert. Place the horizon line in the lower third of the image when the most important part of the landscape dominates the upper part of the scene you're photographing, such as when you're photographing a mountain range, or a landscape with billowing clouds.

When you find an interesting element in the landscape, such as a photogenic rock or dead branch, move close to the object, zoom in, and then move around it until you see an interesting composition in your viewfinder (see Figure 13-3).

Many landscape photographers have tunnel vision and look straight ahead. Notice what's both above and below you. You may find an interesting photograph hiding there.

Before taking your picture, take a good look at the area you've framed in the viewfinder to make sure there isn't any litter, such as empty soda cans or candy wrappers that can ruin an otherwise great image.

The best time to take photographs of beautiful landscapes is early in the morning, just after the sun rises, or late in the afternoon, when the light is pleasing. The first hour and the last hour of daylight are known as the *golden hours,* times when you have great light for photographing landscapes, because the light accentuates forms such as rocks and trees, and the shadows cast by these objects are pleasing.

Barren landscapes can be saved with dramatic clouds. If you live near a place that's beautiful but stark, visit it when there are some moody clouds or thunderheads in the distance. Make this the focal point of your photograph by placing the horizon line in the lower part of the image.

COMMON PROBLEMS IN LANDSCAPE PHOTOGRAPHY

Landscape photography is very rewarding. You get to commune with nature and breathe fresh air. But no form of photography is without problems. Here are a few issues you may encounter and some solutions you can try:

- **The foreground is too busy.** If the picture has details such as twigs, vines, or branches that detract from the overall picture, move to a slightly different vantage point to remove the offending details from the image.

- **The background doesn't seem sharp.** When you're photographing a huge landscape that goes on for miles and miles, atmospheric haze can cause distant details to look soft. If you encounter this problem, consider purchasing a UV filter for your lens. If you don't have a UV filter, take the picture anyway. Some image-editing applications have an option to remove haze from an image.

 If your lenses have different accessory thread sizes, purchase filters for the largest-diameter lens you own, and then purchase a step-up ring for the smaller-diameter lenses. For example, if your biggest lens accepts 77mm filters and you also own a lens that accepts 58mm filters, buy a 58–77mm step-up ring, which is much cheaper than the cost of another filter.

- **There are telephone lines and houses in the picture.** Sometimes, you can't avoid getting a bit of civilization in your nature photos, but other times you can change your vantage point slightly to remove the offending elements from the picture. Alternatively, change your vantage point until a tree or other landscape element hides the objects. If the suggested solutions prevent you from getting the image you want, take the picture and remove the unwanted elements in your image-editing application.

- **The sky is boring.** If the scene you're photographing would benefit from a few clouds, patiently wait a few minutes for some clouds to drift into the scene. Alternatively, you can come back to the area on a different day or at a different time, when atmospheric conditions are more conducive to a picture-perfect sky. Try photographing the landscape at night, and use your camera's long exposure option to capture images with star trails.

TIP

Photograph waterfalls using a shutter speed of 1/15 second or less with the camera on a tripod. This setting gives the water a silky-smooth look. If you're shooting a waterfall in bright conditions, set the camera to the lowest ISO possible. If the shutter speed is still too fast, use a neutral density (ND) filter to reduce the amount of light reaching the sensor. ND filters are available from your favorite camera retailer. ND filters come in varying strengths. However, you can purchase

a variable neutral density filter that has a dial you rotate to vary the strength of the filter.

When using a tripod to create a photograph, make sure you disable image stabilization, which may induce movement due to the fact that the lens is trying to compensate for movement that isn't there.

When hiking to photograph the landscape, stop frequently and look at where you've been. You may discover the raw material for a great photograph. Look down as well. You may see interesting details like fallen leaves that can be used to create interesting images.

Creating Portraits

Most adults spend a lot of time earning money to support their lifestyle. Some people love what they do, but other people think their 9-to-5 routine is torture. If you have a friend who fits in the former category and needs a picture of herself for business cards or passports, grab your camera and use the settings in this section.

Setting the camera

When you create a portrait for someone, you want to make him the center of attention, so you photograph the scene in aperture-priority auto (A) mode and use a large aperture (a small f/stop number) to create a shallow depth of field that draws the viewer's attention to your subject. The suggested ISO of 100 is perfect for shooting in a bright room or outside. If you photograph the person in overcast conditions, use an ISO of 400. The medium telephoto focal length suggested renders a pleasing portrait without distorting your subject's features. Use image stabilization if available because the slightest operator movement results in a photo that's less than tack sharp.

Creating a portrait

You photograph the typical formal portrait against a solid-colored background, although some professional photographers use a painted muslin background. You can get good results if you photograph your subject against a solid-colored wall. Just make sure your subject is a few feet in front of the wall; otherwise, any texture in the wall will be captured with the image and will distract the viewer's attention.

CAMERA SETTINGS: PORTRAITS

These are the settings I recommend for shooting portraits:

- **Metering mode:** Matrix

- **Release mode:** Single frame

- **Shooting mode:** Aperture-priority auto (A) mode

- **Aperture:** f/4.0 or larger (which means smaller f-stop numbers, like f/2.8 or f/1.2)

- **ISO:** 100 to 400

- **Focus mode:** AF-S (single autofocus)

- **Autofocus point:** Single-point AF

- **Focal length:** 80mm to 100mm

- **Image stabilization:** On

TIP

Turn off any unnecessary lights. Over-head lights are fine. If you're photo-graphing a subject in his office, and you turn on the light on your subject's desk, you run the risk of throwing the camera white balance off and adding hotspots to your subject's face.

Position your subject a few feet in front of your backdrop, and tell her how you want her to pose. Posing is beyond the scope of this book. But a good generic pose involves having your subject turn her head to one side and tilt her chin up (see Figure 13-4).

When you compose the picture, use natural elements to draw the viewer into the picture. In Figure 13-4, the subject's right shoulder draws the viewer into the image. Her left eye is on a rule-of-thirds power point. (See Chapter 15 for some tips on composing your images.)

FIGURE 13-4:
Tell your subject how you want her to pose.

COMMON PROBLEMS WITH PORTRAITS

When you create a portrait and review the image on your tilting monitor and you don't like what you see, the first thing to do is make sure your subject is relaxed. You may notice one of these other problems as well:

- **The image is dull and lifeless.** The lighting you have available usually causes this problem. Portrait photographers illuminate their subjects with multiple light sources. Working with multiple light sources is a subject for an entire book. But you can add some life to your portraits by illuminating your subjects with a diffused flash. You can purchase snap-on diffusers for your flash at your favorite camera retailer. Stoffen makes diffusers that fit most popular flash units.

- **The backdrop is dark gray.** Even a white background looks gray if you don't use illumination. Some Nikon flash units can function as a commander and trigger external flash units. Your flash unit may also have a swivel head, which enables you to bounce the flash off a white ceiling, which creates soft diffuse light. If your flash doesn't have either option, you can use an image-editing application to create a careful selection around your subject and then replace or brighten the background.

TIP

If you're photographing a model or an aspiring actress, use some props to draw the viewer into the image.

TIP

When focusing on your subject, place the autofocus point over the subject's eye, or use the camera's face and eye detection. This ensures that the eyes — the windows to your subject's soul — are in sharp focus.

After you take the picture, review it on your tilting monitor. Make sure the image is properly exposed and your subject looks relaxed. In a typical portrait session, you have to take several pictures before the subject relaxes and you get some good images.

Capturing Sporting Events

Photography is a wonderful pastime. You can use your camera to capture memories of the things that interest you. If you're a sports fan, you can photograph your favorite sport. You can photograph individual athletes, but sports have more to them than just the athletes. Whether your favorite sport is football or auto racing, each one has its own rituals. And every sport includes a supporting cast. When you photograph a sporting event, you photograph each chapter of the event, from

the pre-games festivities to the opening kickoff to the winning touchdown. Your creative mind, your knowledge of the sport, and the settings in this section give you all the tools you need to tell a story. Begin at the beginning, before the athletes flex their muscles or the drivers start their engines.

Setting the camera

This section gives you a couple of different shooting scenarios. When you're photographing the pre-event festivities, shoot in aperture-priority auto (A) mode. When your goal is to photograph an athlete preparing for the event, you want a shallow depth of field, so use a large aperture (a small f/stop number). When you want to photograph the crowd, or a group of athletes practicing, use a small aperture (a large f/stop number) to ensure a large depth of field. When your goal is to stop action, shoot in shutter-priority auto (S) mode at a speed fast enough to freeze the action. For an athlete, you can freeze motion with a shutter speed as slow as 1/125 second. To stop a racecar dead in its tracks, you need a fast shutter speed of 1/2,000 second. To capture the beauty of a speeding race car with a motion blur, you pan the camera and shoot with a shutter speed of 1/125 second. The focal length you use varies depending on how close you can get to the action. If you're photographing a large crowd before the event, use a wide-angle focal length of 28mm to 35mm. If you're photographing individual athletes, zoom in.

CAMERA SETTINGS: SPORTING EVENTS

These are the settings I recommend for shooting sporting events:

- **Metering mode:** Matrix

 Release mode: Single frame, C$_L$ (continuous low speed), or C$_H$ (continuous high speed)

- **Shooting mode:** Shutter-priority auto (S) mode or aperture-priority auto (A) mode

- **Shutter speed:** 1/250 second or faster

- **Aperture:** Varies

- **ISO:** The lowest possible ISO setting for the lighting conditions

- **Focus mode:** AF-C (continuous autofocus)

- **Autofocus point:** Single-point AF

- **Focal length:** Varies

- **Image stabilization:** On, unless using a tripod

Capturing the event

When you photograph a sporting event, you have to be in the moment. Before the event starts, you can capture interesting pictures of the crowd, the athletes performing their pre-event rituals, and the athletes warming up. When the event starts, you can capture the frenetic action. When the event is well and truly underway, keep alert for any interesting situations that may arise and, of course, any team player who scores. If you're photographing a car race, be sure to include pictures of pit stops and other associated activities such as a driver change during an endurance race. And you probably want a picture or two of the winning driver spraying the champagne.

TIP

Arrive at the event early and take pictures of anything that piques your curiosity. Remember to change settings based on what you're photographing.

Photograph the pre-event activities, such as the introduction of the players, athletes going through pre-event rituals, the coach meeting with her team on the sidelines, or pictures of the drivers getting ready. You can get creative with your composition when you photograph the pre-race events. Don't be afraid to turn the camera diagonally or venture to an interesting vantage point. Let your inner child run amuck and capture some unusual pictures.

The action can get a little crazy when an event begins. Each team is trying to gain an advantage over the other. If you're photographing a race, drivers may battle fiercely to achieve the lead by the first corner. You never know what may happen. Stay alert for any possibility. Hold the camera and be ready to compose an image when you anticipate something interesting about to happen. Be proactive: Have the camera to your eye a split second before the crucial moment.

The middle of any event is a great time for photographers. If you're photographing an event such as a basketball or football game, you can get some shots of substitutions. You can also photograph the fans to capture their reactions to a winning score and so on. If you're photographing an auto race, the cars are now a little battle weary, with tire marks, racer's tape, and other chinks in their armor (see Figure 13-5).

TIP

Be on your toes, especially if the score is close. In the final minutes or final laps, it's do or die. Athletes give their all to win the event, which gives you opportunities for some great pictures.

Take photographs of the winning team celebrating and capture the glum looks of the losers. Take photographs of any awards ceremonies. Tell the complete story of the event.

Photographing Nature and Wildlife

If you live near a state park or wilderness area, you can capture some wonderful photographs of animals such as deer, raccoons, and otters in their natural surroundings.

REMEMBER

You can easily spook these kinds of wild animals because they're relatively low in the food chain. They have a natural fear of humans, which means you have to be somewhat stealthy to photograph them. Patience is a virtue. If you're patient and don't do anything startling, you can capture great images of animals such as deer.

If you live near a state park, go there often to find out which areas of the park you're likely to find your subjects and to get to know the habits of the animals who live there, including their feeding habits. After you know the habits of the animals you want to photograph and get familiar with the lay of the land, you can capture some wonderful wildlife images by using the following settings.

Setting the camera

The goal of this type of photography is to capture a photograph of an animal in the wild. You use aperture-priority auto (A) mode for this type of photography to control depth of field. The animal is the subject of your picture, so you use a large aperture to create a shallow depth of field and draw your viewer's attention

to your subject. Use a smaller aperture when photographing a group of animals. AF-C (continuous autofocus) enables the camera to update focus while the animal moves. You also use the C∟ (continuous low speed) or Cн (continuous high speed) release mode to capture a sequence of images of the animal as it moves through the area. The focal length you use depends on how close you can safely approach the animal. Use image stabilization if you have to shoot at a slow shutter speed.

TIP

The slowest shutter speed you should use when handholding your camera is the inverse of the focal length. For example, if you're using a 50mm FX lens on your D780, the slowest shutter speed you should use when holding the camera by hand is 1/60 second.

Capturing compelling images of nature and wildlife

When you're taking pictures of animals in their natural habitat, you have to stay out of the open so that you don't frighten the animal. I also recommend wearing clothing that helps you blend in with the surroundings.

CAMERA SETTINGS: NATURE AND WILDLIFE

These are the settings I recommend for shooting nature and wildlife:

- **Metering mode:** Matrix
- **Release mode:** C∟ (continuous low speed) or Cн (continuous high speed)
- **Shooting mode:** Aperture-priority auto (A) mode
- **Aperture:** f/3.5 (which gives you a shallow depth of field) when photographing a solitary animal or a bird; a smaller aperture (larger f/stop number) when photographing a group of animals
- **ISO:** The lowest ISO setting for available light conditions that gives you a shutter speed fast enough that you can handhold the camera with the focal length you're using
- **Focus mode:** AF-C (continuous AF)
- **Autofocus point:** Single-point AF
- **Focal length:** A long focal length so that you can take the photograph from a safe distance without endangering the animal or yourself
- **Image stabilization:** Optional

The one exception to this suggestion is if you photograph in an area where hunting is permitted. Do not try to photograph wildlife in an area where hunting is permitted during hunting season.

Go to a place where you've previously sighted the species you want to photograph, hide behind some natural cover, and wait. Photograph during the early morning or late afternoon when the light is better and animals are out foraging for food.

When you see an animal, zoom in until the animal fills the frame, and then zoom out slightly. When you see an animal you want to photograph, and need to get closer, don't make eye contact with the animal. Walk slightly to the side of the shortest distance to the animal. Change course once or twice, and when you get close enough, compose the image and take the picture. Your goal is to make the animal think it's not in danger.

Position the autofocus point over the animal's eye. Zoom in tight on the animal to capture an intimate portrait and compose the image according to the rule of thirds. This kind of photo is as close as you'll get to shooting a portrait of a wild animal (see Figure 13-6).

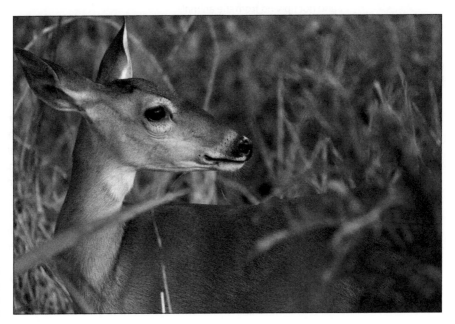

FIGURE 13-6:
Zoom in close for an intimate animal portrait.

COMMON PROBLEMS WITH NATURE AND WILDLIFE PHOTOGRAPHY

Wildlife photography is exciting, but you may also find it challenging. Here are some problems you may encounter, as well as their solutions:

- **The image isn't sharp.** Make sure you're shooting with an ISO that's high enough to enable a relatively fast shutter speed, and use image stabilization if your lens has this feature. If you don't have the image stabilization feature, mount your camera on a tripod or monopod. Don't use image stabilization if the camera is mounted on a tripod, though — you may get undesirable results because the lens will try to compensate for operator motion when the camera is, in fact, rock steady.

- **The animal blends into the background.** The coloring of some animals causes those animals to blend into the background. Try shooting from a different angle. You can also use the largest aperture to blur the background as much as possible. If you use a large aperture, make sure you get the animal's eyes in focus. If you don't, the entire picture will appears to be out of focus.

- **The animal disappears before you take the picture.** Make sure you're well hidden and not upwind from the animal.

Shooting Macro Photography

If you have lush flowers or small critters in your yard or live near a botanical garden, you have a rich resource for wonderful close-up photographs. You can take a nice photograph of a flowerbed or create something really special by photographing a flower up close and personal. A close-up of a flower or a small animal like a lizard reveals the beautiful architecture of the flower, or the symmetry and unique appendages of the animal.

When you see a compelling photograph of a flower, you can almost smell that flower. To create a great macro photograph of flowers, you need great-looking flowers, the right light, and a good eye for composition. Add the settings and techniques discussed in this section, and you're well on your way to creating great photographs of flowers or other small things.

Setting the camera

When you photograph a close-up of a flower, small animal, or insect, you take the picture almost like you're shooting a portrait of a person. In both cases, you carefully compose the image and choose the proper camera settings to get a great photograph. When you shoot in aperture-priority auto (A) mode and use a large aperture (a small f/stop number), you get a shallow depth of field that draws the viewer's attention to the subject. With a single autofocus point, you can lock focus on any part of the subject so that you draw attention to the stamen, a flower petal, or an insect on the flower. A low ISO gives you a crisp image that has little or no digital noise. A focal length of 90mm or longer lets you get close to your subject. However, you can get your best results if you have a macro lens. If your lens has image stabilization, enable the feature. When you capture close-ups of any subject, the slightest bit of operator movement can result in an image that doesn't look sharp.

TIP

Many lenses come equipped with a macro mode, which lets you get really close to your subject and still keep it in focus. If you don't have a macro lens, consider buying one if you enjoy photographing close-ups of objects such as flowers. You can also buy an extension tube for close-up photography.

REMEMBER

Don't use image stabilization if you mount your camera on a tripod.

CAMERA SETTINGS: MACRO PHOTOGRAPHY

These are the settings I recommend for macro photography:

- **Metering mode:** Matrix

- **Release mode:** C_L (continuous low speed) or C_H (continuous high speed)

- **Shooting mode:** Aperture-priority auto (A) mode

- **Aperture:** f/3.5 to f/5.6

- **ISO:** 100, 200, or the lowest setting that gives you a shutter speed that's the reciprocal of the focal length you're using to photograph the flower

- **Focus mode:** AF-S (single AF)

- **Autofocus point:** Single-point AF

- **Focal length:** 90mm or longer macro lens

- **Image stabilization:** On, unless using a tripod

Taking the picture

You get your best images if you photograph your subject in flattering light. Harsh overhead light is not flattering. If you're faced with those conditions, use a small diffuser to soften the light. You can photograph flowers indoors or outdoors. If you photograph flowers outdoors, take your photos early in the morning or late in the afternoon because that's when the light is most flattering. The same rule applies when photographing small insects or animals. Also, cloudy overcast conditions offer soft, diffuse lighting that can be great for this type of photograph.

When photographing flowers, photograph a light-colored flower against a dark background and photograph a dark-colored flower against a light background.

If you're shooting indoors, try placing the subject near a window that's not receiving direct sunlight so that you can get soft, diffuse light, which is perfect for photographing small objects such as flowers.

If you're taking a picture of the entire object, make sure you leave a bit of breathing room around the subject.

Use your flash to add a kiss of light to the image. This extra light warms the image and adds light to the shadows. If your camera has flash exposure compensation, use it to determine how much light the flash adds to the image.

If you want to create a photograph of a flower dappled with pearls of dew, but the flower doesn't have any dew on it, carry a small spray bottle with you and mist the flower prior to photographing it. But don't mist flowers in the heat of the day, when the afternoon sun can quickly heat the water and hurt the flower.

You can create a very intimate flower portrait if you zoom in tight and capture fine details of the flower (see Figure 13-7). When you zoom in this closely, make sure you compose the scene in your viewfinder to create an aesthetically pleasing picture.

4
The Part of Tens

Get your hands on ten tips and tricks for using your Nikon D780.

Find ten ways to create perfect images.

IN THIS CHAPTER

» **Customizing your camera**

» **Restoring default settings**

» **Creating your own menu**

» **Editing your images in Adobe Lightroom**

» **Downloading Nikon software**

Chapter **14**

Ten Tips and Tricks

When you start exploring the possibilities of your camera, it's like chipping away at the tip of an iceberg. There's so much you can do with your Nikon D780, it boggles the mind. You can customize your camera to suit your working preferences, making life easier when you're busy creating images. You can also create a custom menu to quickly access your frequently used menu commands. Speaking of menus, they can be a little confusing at times. Not to worry, say the Nikon camera gurus, we've added help to the camera so you don't have to carry the manual with you. How cool is that?

In this chapter, I show you how to customize your camera, create your own menu, add copyright information to your images, and more. I also introduce you to Adobe Lightroom, which in my opinion, is the most powerful image-editing software on the planet. And just in case you make changes to the camera you don't like, I show you how to restore the camera to its default settings.

Creating Custom User Settings

You have two buttons on the mode dial that are fully customizable: U1 and U2. (The latter will *not* play music from the rock band of the same name.) To create custom user settings, follow these steps:

1. Make the desired changes to your camera's settings.

You can save some settings from the photo shooting menu, the movie shooting menu, shooting mode, white balance, and so on. An example of custom settings would be to customize mode U1 for sunsets with the following settings: aperture-priority auto (A) mode on the mode dial, the white balance set to cloudy, the ISO sensitivity set to 100, and the focusing set to AF-S autofocus mode.

2. Press the MENU button.

All the Nikon menus are displayed on your tilting monitor.

3. Press the down arrow on the multi selector to highlight the setup menu, and then press the left arrow on the multi selector.

The setup menu icon is highlighted.

4. Press the down arrow on the multi selector to highlight Save User Settings (see Figure 14-1).

5. Press the right arrow on the multi selector.

The Save User Settings options appear on your tilting monitor (see Figure 14-2).

6. Use the multi selector to highlight Save to U1 or Save to U2 and then press the right arrow on the multi selector.

FIGURE 14-1:
The Save User Settings command.

The Save User Settings menu resets, and you have two options: Save to U1/U2 (the number depends on the option you choose in Step 6) and Cancel.

7. Highlight Save Settings.

The settings are assigned to the specified button.

8. **Press the shutter-release button halfway to return to shooting mode.**

To access the custom settings, rotate the mode dial to the button to which you assigned the settings (U1 or U2).

If after using the customs settings, you decide you need to reset the button, you can easily do so by following these steps:

1. **Press the MENU button.**

All the Nikon menus are displayed on your tilting monitor.

2. **Press the down arrow on the multi selector to highlight the setup menu, and then press the left arrow on the multi selector.**

The setup menu icon is highlighted.

3. **Press the down arrow on the multi selector to highlight Reset User Settings (see Figure 14-3).**

4. **Press the right arrow on the multi selector.**

The options appear on your tilting monitor (see Figure 14-4).

5. **Select Reset U1 or Reset U2 and press the right arrow on the multi selector.**

The reset command refreshes, and you have two options: Reset U1/U2 (the number depends on the option you choose in Step 4) and Cancel.

FIGURE 14-2:
Saving user settings to mode U1 or U2.

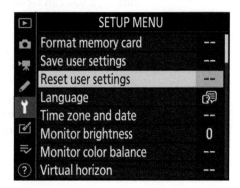

FIGURE 14-3:
Resetting user settings.

FIGURE 14-4:
Choose the mode to reset.

6. **Highlight Reset and then press OK.**

 The custom settings for the mode specified are reset.

7. **Press the shutter-release button halfway to return to shooting mode.**

 You can now choose new settings to assign to the mode you just reset.

Resetting Default User Settings

If you're like me, sometimes you go over the top and change so many settings, the camera doesn't work the way you want it to. No problem, you say, just undo the command that changed the camera for the worse. Yes, dear reader, that's fine . . . if you can remember which command that was. But in case you can't, you can restore the camera to the default settings by performing a two-button restore.

To reset the camera to default settings, press and hold the zoom out/metering button (see the left side of Figure 14-5), which is located on the lower-left side of the camera when pointed toward your subject, and the exposure compensation button, which is located near the shutter-release button (see the right side of Figure 14-5). Each of these buttons has a green dot alongside it. Hold both buttons for 2 seconds and — poof! — the default settings are restored.

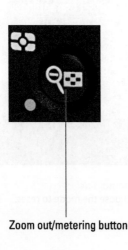

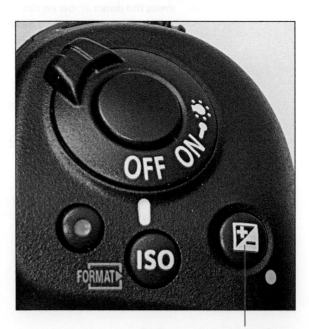

FIGURE 14-5:
The two-button
restore. Zoom out/metering button Exposure compensation button

Creating a Custom Menu

The one thing that drives me crazy with the Nikon D780, and every other camera really, is fiddling around in the menu to find the command I need and missing a shot in the process. But that doesn't have to be the case. You can make a custom menu with the commands you frequently use. With a custom menu, you can quickly cut to the chase, make the change you need to make, and grab the shot. For example, if you frequently use Active D-Lighting or use the HDR option to create images with an increased dynamic range, you can add these commands to your custom menu.

To create a custom menu, follow these steps:

1. **Press the MENU button.**

All the Nikon menus are displayed on your tilting monitor.

2. **Press the down arrow on the multi selector to highlight My Menu and press the left arrow on the multi selector.**

The My Menu icon is highlighted.

3. **Press the right arrow on the multi selector to place the cursor inside the menu, and press the down arrow on the multi selector to highlight Add Items.**

4. **Press the right arrow on the multi selector.**

The menus are displayed.

5. **Highlight the menu from which you want to add an item, and then press the right arrow on the multi selector.**

For example, if you want to add items for the movie shooting menu, highlight it and press the right arrow on the multi selector to display the menu items. Figure 14-6 shows the movie shooting menu.

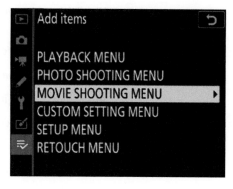

6. **Highlight the desired menu item (see Figure 14-7), and then press OK.**

FIGURE 14-6:
Adding items to the custom menu.

The item is added to your custom menu.

7. **Press the up arrow or down arrow on the multi selector to position the item in your menu.**

8. **Repeat Steps 3 through 7 to add additional items to the menu.**

9. **Press the shutter-release button halfway to exit the menus and return to shooting mode.**

 The next time you need a command from your custom menu, press the MENU button to open the menus, and then open My Menu to choose the desired command.

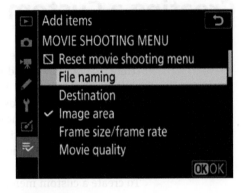

FIGURE 14-7:
Choosing items to add to the menu.

After you use your custom menu for a while, you may decide that you need to remove some items from the menu. To remove items from your custom menu, follow these steps:

1. **Open My Menu.**

2. **Highlight Remove Items and then press the right arrow on the multi selector.**

 The items on your custom menu are displayed.

3. **Highlight an item you want to remove, and press the right arrow on the multi selector.**

 The item is marked for deletion.

4. **Repeat Step 3 to mark other items for deletion.**

5. **After selecting the items you want to remove, press OK.**

 A dialog appears asking you to confirm deletion.

6. **Press OK.**

 The items are removed from your custom menu.

Customizing Your Camera

Many of the buttons on your camera are customizable. If the task a specific button accomplishes is something you don't do frequently, you may be able to customize the button. To customize the buttons on your camera, follow these steps:

1. **Press the MENU button.**

 The camera menus appear on the tilting monitor.

2. **Press the down arrow on the multi selector to highlight the Custom Settings menu, and then press the left arrow on the multi selector.**

 The Custom Settings menu icon is highlighted.

3. **Press the right arrow on the multi selector to place the cursor inside the menu, then press the down arrow on the multi selector to highlight f3: Custom Controls, and press the right arrow on the multi selector.**

 An illustration of the camera appears on the tilting monitor.

4. **Use the multi selector to highlight the button you want to customize and press the right arrow on the multi selector.**

 For the purposes of this tutorial, I show you how to customize the Pv button, which is selected in Figure 14-8. You can customize the following buttons:

 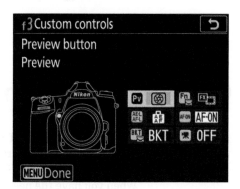

 FIGURE 14-8:
 Customizing a button.

 ● *Pv:* The default function of this button is to stop down the lens to the current aperture to preview depth of field.

 ● *Fn:* This button is used for quick access to frequently used settings.

 ● *AE-L/AF-L:* The default function of this button is to lock exposure and focus to a specific part of the frame.

 ● *AF-On:* This button can be used to lock focus in autofocus mode.

 ● *BKT:* This button is used for bracketing exposure, flash, white balance, and Active D-Lighting (ADL).

 ● *Movie Record:* This button is used to start and stop movie recording.

5. **After selecting a button, press the right arrow on the multi selector.**

 The functions you can assign to the button are displayed (see Figure 14-9).

6. **Press the down arrow on the multi selector to highlight the function you want to assign to the button.**

 For example, if you frequently photograph scenes that require center-weighted metering, you can assign that function to the Pv button.

7. **After choosing a function for the button, press OK.**

 The function is assigned to the button and you're returned to the previous menu.

8. **Repeat Steps 4 through 7 to customize other buttons.**

9. **After customizing your camera, press the shutter-release button halfway.**

 You're returned to shooting mode, and you can test the buttons.

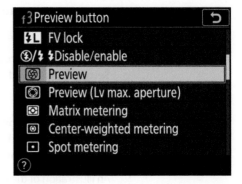

FIGURE 14-9:
Choosing an option to assign to a button.

Creating a Makeshift Tripod

Tripods take up a lot of room. When packing for a trip, you may decide to leave your tripod at home to free up some space in your luggage. Or you may leave home for a photo shoot thinking you won't need a tripod, then find out you need one. When you have the need for a tripod, but you don't have one with you, creating a makeshift tripod will save the day.

TIP

Here are some suggestions for crafting a makeshift tripod:

» **Switch to live view mode and place the camera near the edge of a table.** If you can see the tabletop in the viewfinder or tilting monitor, move the camera closer to the edge.

» **Use a wall to steady the camera.** This option is handy if you're shooting in portrait orientation (rotating the camera 90 degrees to create an image that is taller than it is wide). Hold the camera tightly against the wall and take the picture.

» **Use a small beanbag to steady the camera.** You can just toss the beanbag in your camera bag; it doesn't take up much space. Place your camera on the beanbag and move it to achieve the desired composition. You can purchase beanbags at your local camera store.

 As an alternative to the beanbag, you can carry a resealable plastic bag filled with uncooked rice (cooked rice is messy and will spoil) in your camera bag. Place your camera on the bag and move it until you achieve the desired composition.

- » **Use a crumpled t-shirt to steady your camera.** Place a crumpled t-shirt on a flat surface, place your camera on it, and take the picture.

- » **Become a human tripod.** Stand with your feet spread apart, press your elbows into your ribs, bring the camera to your eye, and take the picture.

- » **Use a monopod to steady your camera.** You can purchase a monopod at your favorite camera store. Many monopods have retractable feet in the base that, when extracted, stabilize the monopod. It's not a tripod, but it may fit the bill.

In addition to using one of these techniques, use the self-timer to delay the release of the shutter. This gives the camera a chance to stabilize from any vibration that occurs when you press the shutter-release button.

Working with Adobe Lightroom Classic

If you're serious about your photography, and you capture your images using your camera's NEF (RAW) mode, you may want to consider getting a subscription to Adobe Lightroom. The software has everything you need to organize a huge collection of photographs. In addition, you use the software to process your images, export your images, create slideshows, and more. In fact, you can even use the application to create a gallery of your photos and upload the gallery to your website. As of this writing, Adobe has a Photography subscription for $9.99 per month that includes Lightroom and Photoshop. With a subscription, you get free updates to both applications when Adobe releases them.

Lightroom is divided into seven modules. The modular workflow is much better than an all-in-one application of this magnitude. Each module is dedicated to the task at hand. The application is divided into the following modules:

- » **Library:** You organize your images in the Library module. You have options to create folders and transfer images between folders in this module, which is a great way to stay organized. After all, who wants to search for a needle in a haystack (which is exactly what you do if you store all your images in one folder)? You can also rename images in the Library module, assign keywords to images, rate images, search for images, and export them. In addition, you can create multiple export presets. For example, if you upload images to your website or to social media, you can create a preset with the image size, file format, and quality. You can also create a watermark preset. Watermarks can be used to protect your images from theft when you post them on the Internet, which is still like the Wild West.

>> **Develop:** In the Develop module (shown in Figure 14-10), you process your images to pixel perfection. The module is logically organized into several sections. In one section, you apply basic processing to the image, such as adjusting the exposure, setting white balance, setting the black point and white point, applying noise reduction to the image, sharpening the image, and much more. You can also crop images in the Develop module, correct perspective, and correct lens anomalies such as pincushion and barrel distortion. Adobe has a huge database of popular lenses in the application; the application may be able to detect the lens you shot the picture with, which enables you to instantly correct any problems associated with the lens. In addition, you can use the Develop module to apply special effects to the image such as split toning, adding a vignette, simulating film grain, and so on. And if you have some settings you use over and over again, you can create a preset to apply the settings in one fell swoop.

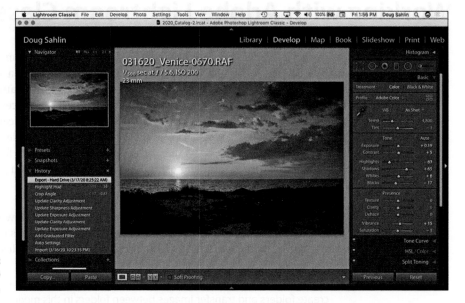

FIGURE 14-10:
The Develop module.

>> **Map:** If you attach a GPS receiver to your camera when shooting, the longitude and latitude are saved as metadata. After you import images with this data, you open the Map module and the images are placed on a map in the exact location from which you shot them. This is a great way to find images that were shot in a certain location. If you don't use a GPS receiver, you can manually place images on a map in this module.

>> **Book:** In this module, you can create a book with selected images. After creating the book, you can upload it to Blurb (www.blurb.com) from the

module to get a printed copy of the book to share with friends and family. I've used Blurb to create books for wedding clients. The book Blurb offers is high quality. You can order a hardcover book or a soft cover one.

>> **Slideshow:** In this module, you can create a slideshow. You can create a slideshow with music for viewing on your computer or export the images as a PDF for sharing with other photographers and friends. You can also export a video slideshow.

>> **Print:** As the name implies, you use this module to print your images. You can print a single image or multiple images on a sheet. You can even create a *contact sheet* (which contains thumbnail-size images) of several images.

>> **Web:** In this module, you can create a web gallery of images you select in the Library module. There are several web templates from which to choose. You can even customize a template and save it for future use. After creating the gallery, you can upload it from the module to your website.

There is a logical workflow to Adobe Lightroom from import to export. To learn more about the possibilities of this application, pick up a copy of *Adobe Photoshop Lightroom Classic For Dummies*, 2nd Edition, by Rob Sylvan (Wiley).

TECHNICAL STUFF

Another option is Adobe Lightroom CC, which you can use on your smartphone or tablet. The editing process is different, but the application does allow you to upload photos from the desktop version of Lightroom (discussed here) to the cloud and display them on your tablet or phone, which is a great way to show your work to clients or friends.

Compiling Focus Shift Images in Adobe Photoshop

In Chapter 11, I show you how to use your camera's focus shift settings to vary the focus of a scene over a series of images. Focus shifting (also known as focus stacking) is a great way to create a image that is in sharp focus from front to back. However, the camera does not compile the images with shifted focus into a single image. You have to do that in a third-party application like Adobe Photoshop, which is available by subscription. If you have the Adobe Photography subscription, you can use Lightroom in conjunction with Photoshop to combine the focus-shifted images into a single photograph.

Here's how to combine focus-shifted images:

1. **Import the images into Lightroom.**

2. **Select the focus-shifted images in the Library module, right-click, and choose Edit In ⇨ Open As Layers in Photoshop.**

 Lightroom processes the images for export, Photoshop launches, and a single document is created with a layer for each photo you selected in Lightroom.

WARNING

 If you specified lots of images for your focus shift, it may take a long time for Photoshop to launch and distribute the photos to layers.

3. **In Photoshop, open the Layers panel, select all the layers, and then choose Edit ⇨ Auto-Blend Layers.**

 A dialog appears with two options: Panorama and Stack Images (see Figure 14-11).

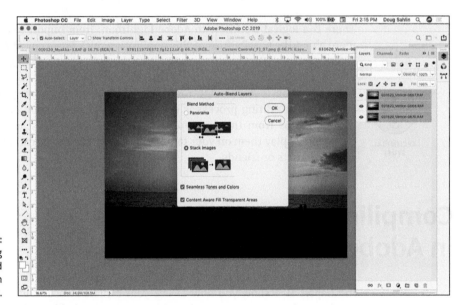

FIGURE 14-11:
Stacking focus-shifted images in Photoshop.

4. **Accept the default options and click OK.**

 Photoshop merges the layers into a single image. This may take some time if there many layers of focus-shifted images.

5. **In the Layers panel, select all the layers and then choose Layers ⇨ Merge.**

 Photoshop merges the layers to a single image.

6. **Choose File ⇨ Save As.**

 Choose the file format and destination for the image.

Photoshop offers a wide variety of export formats. You can also resize the image before saving it. Unfortunately, that's beyond the scope of this book. If you want to learn more about Photoshop, check out *Adobe Photoshop CC For Dummies*, 2nd Edition, by Peter Bauer (Wiley).

Adding Copyright Information and Author Name to the Camera

Protecting images is very important to every photographer. You can add your copyright information and name to every image you create. The information is saved as metadata. Nikon Capture NX-D and many other image-editing applications recognize the metadata you add in camera. This approach isn't foolproof, but it's better than no protection at all.

To add your name and copyright information to the camera, follow these steps:

1. **Press the MENU button.**

 The camera menus appear on the tilting monitor.

2. **Press the down arrow on the multi selector to highlight the setup menu, and press the left arrow on the multi selector.**

 The setup menu icon is highlighted.

3. **Press the right arrow on the multi selector to place the cursor inside the menu, and then press the down arrow to highlight Copyright Information (see Figure 14-12).**

4. **Press the right arrow on the multi selector.**

 The Copyright options are displayed on your tilting monitor (see Figure 14-13). Artist is selected by default.

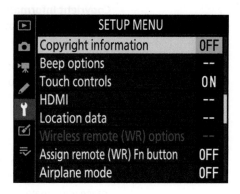

FIGURE 14-12:
Adding copyright information to the camera.

5. **Press the right arrow to add artist information to the camera.**

 The camera keyboard appears.

6. Enter your name.

For more information on the camera keyboard, see Chapter 4.

7. Press the zoom in/QUAL button.

Your name is recorded and you're returned to the previous menu.

8. Press the down arrow to the multi selector to highlight Copyright, and then press the right arrow on the multi selector.

The keyboard appears.

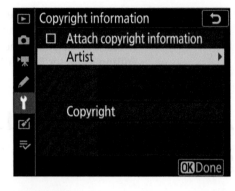

FIGURE 14-13:
Copyright options.

9. Enter your copyright information.

I'm not a lawyer, but I've heard the proper way to write a copyright is the copyright symbol, followed by the year, followed by your name (for example, © 2020 Doug Sahlin).

10. Press the Zoom in/QUAL button.

Your copyright information is recorded and you're returned to the previous menu.

11. Press the up arrow on the multi selector to highlight Attach Copyright Information, and then press the right arrow on the multi selector.

A check mark appears in the Attach Copyright Information check box (see Figure 14-14).

12. Press OK.

The copyright and artist data are saved to the camera and will be written to the metadata of each image you create.

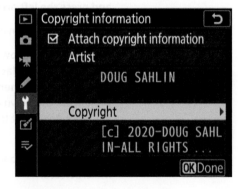

FIGURE 14-14:
Attaching your copyright information.

REMEMBER

Make a note to change the copyright information to the new year on January 1.

Using the Nikon Download Center

When you need manuals, software, or firmware for your Nikon D780, you can find it at the Nikon Download Center. Simply launch your favorite web browser and navigate to https://downloadcenter.nikonimglib.com/en/index.html.

Getting Help

Your camera has a built-in help menu. Whenever you see a menu command and you're not sure what it does, you may be able get help by pressing the help/protect/WB button (see Figure 14-15). Figure 14-16 shows help for the pixel mapping command in the setup menu. If the help dialog extends below the screen, press the up and down arrows on the multi selector to scroll. After reading the help, press the help/protect/WB button again to return to the menus.

FIGURE 14-15:
Click this button to get help.

FIGURE 14-16:
Help me!

IN THIS CHAPTER

» Becoming a more creative
photographer

» Composing images

» Waiting for the perfect light

» Finding the perfect vantage point

» Looking at the *i* menu

Chapter **15**

Ten Ways to Create Pixel-Perfect Images

A t some point in time, you have to transcend technology and add craft to your photography equation. When you transcend technology, you know instinctively which buttons, dials, and settings you need to capture a specific image. After mastering that part of the equation, you add creativity into the mix.

That's what this chapter is all about: enhancing your creativity and learning some techniques you use to put a stamp of originality on every image you create.

Enhancing Your Creativity

Great photographs are made by creative photographers who stretch the envelope. You can enhance your creativity by trying new things. Schedule a time each week when you experiment with new techniques or new equipment. Julia Cameron, author of *The Artist's Way,* calls this an "Artist's Date." When I do this, I limit myself to one or two lenses, and I often visit familiar territory. When you photograph a familiar place and the goal is to enhance your creativity, do things differently. Shoot from a different vantage point and use a different lens than you'd normally use for the subject.

When I was out on a recent "Artist's Date," I spotted this colorful mask while visiting the Ringling Museum. Normally I'd photograph something like this with a 50mm lens. Instead I put my Lensbaby Composer with the Double Glass Optic on the camera with and composed the scene through the camera viewfinder (see Figure 15-1).

Great photos always inspire me to get out the camera and take some pictures. Great photos can also help you become more creative. When you see a really great photo, dissect the image and try to figure out what the photographer did to make it so compelling. Was it a camera technique, or did the photographer do some editing after the fact to make the image pop?

You can find great photos on the Internet in lots of places. One of my favorite places is Photo.net (http://photo.net). Here, you'll find many types of inspirational photographs —

FIGURE 15-1:
Look at things in a new way to enhance your creativity.

from portraits to drop-dead gorgeous landscapes. You can even join Photo.net and upload your own images. Next time you need something to spark your creativity, look at some great photographs!

TIP

You can enhance your creativity while you're taking pictures. Stretching the envelope is a wonderful way to create interesting photographs. The following points can help you stretch your creativity:

>> **Simplify the scene to its lowest common denominator.** A great way to do this is to use a large aperture (small f-stop value) and focus your camera on the most important part of the scene. Or you can compose your picture so the viewer's eye is drawn to a single element in the image.

>> **Look for patterns.** Patterns are everywhere. For instance, migrating birds in flight create a unique pattern; scattered leaves in the gutter create interesting random patterns; and flower petals create compelling symmetrical patterns. Of course nothing says you have to compose an image symmetrically.

>> **Don't fall in love with your first shot.** Before moving on, think of other ways you can capture the scene. Perhaps you can move to a different vantage point, switch lenses, or select a different aperture. Milk a scene for all it's worth and remember to look down. An interesting photograph may be beneath your feet.

>> **Explore your favorite subject and create a theme of photographs.** For example, if you're a cat lover, photograph your cat and then photograph the neighborhood cats. When you photograph the same subjects or places frequently, you think of new ways to create interesting pictures. Your creative juices start flowing and before you know it, you see your favorite subject in a different way. Photographing your favorite subjects and photographing them often helps you master your camera.

My favorite subject happens to be landscapes. I live near the ocean and not very far from a picturesque river, so lately this has been my theme.

Composing Your Images

A photographer's job is to create a compelling image, an image that makes the viewer take more than a casual glance. When you compose an image properly, you draw your viewer into the image. Lots of rules exist for composing a photo; I mention many of them in this section. Your job as a photographer is to figure out which rule best suits your subject. This section is designed to make you think about composition when you look through the viewfinder of your Nikon D780. You can use the camera viewfinder grid or the live view framing grid as a visual reference.

When you compose an image, look for naturally occurring curves that you can use to draw your viewer into the photograph. Curves are everywhere in nature: Birds have curved necks, and roads and paths have curves. The trunk of a tree curves to cope with Mother Nature like the trees in the tundra regions of Rocky Mountain National Park. Look for naturally occurring curves and compose your image so that the curve draws the viewer's eye into the picture.

Many photographers take pictures in *landscape* orientation (where the image is wider than it is tall). When you're photographing a scene like a waterfall, a person, or anything that's taller than it is wide, rotate the camera 90 degrees. This is known as *portrait* orientation. My photograph of a brown pelican on a post (see Figure 15-2) is an example of shooting in portrait format. Other compositional elements are in this picture: The curve of the bird's body draws you to the bird's eye.

Many photographers place the horizon line smack-dab in the middle of the picture. Boring! When you're photographing a landscape, take a deep breath and look at the scene. Where is the most important part of the scene? That part of the scene should occupy roughly two-thirds of the image. For example, if you're photographing a mountain, the mountain base should be in the lower third of the image. When you're photographing a sunset, place the horizon line in the lower third of the image to draw your viewer's attention to the sky. In Figure 15-3, I wanted to draw the viewer's eye to the majestic peaks from Tunnel View in Yosemite National Park, so I placed the horizon line in the lower third of the image, and the majestic mountains dominate the image.

FIGURE 15-2:
Using curves as part of your composition.

FIGURE 15-3:
Placing the horizon line.

When you're composing an image, you want to draw the viewer's eye to a center of interest in your photo. In a composition rule known as the *Rule of Thirds,* imagine your scene is divided into thirds vertically and horizontally, creating a grid, as shown in Figure 15-4. Compose your picture so a center of interest intersects two gridlines. The grid you can enable in the viewfinder doesn't quite get the job done, but it does give you a point of reference. Figure 15-4 shows a grid overlay on an image I photographed at Sanibel Island. Notice where the boy is placed in the sunset image. The middle of his body intersects two gridlines. This image, therefore, is composed according to the Rule of Thirds.

FIGURE 15-4: Aligning an image according to the Rule of Thirds.

VISUALIZING YOUR IMAGES

Anybody can point a camera at something or somebody, press the shutter button, and create a photograph. The resulting photograph may or may not be good, but that's not really photography. True photography is studying your subject and then visualizing the resulting photograph in your mind's eye. When you visualize the photograph, you know the focal length needed to capture your vision, the camera settings to use, and the vantage point from which to shoot your image.

Being in the Moment

If you're going to become a good photographer, you must learn to see photo opportunities. And when you see them, you need to make the best of that "Kodak moment" and capture some keeper photos on your memory card. To recognize subject matter that contains the raw material to create a good or perhaps great photograph, you must be observant, or as they say, "in the moment."

TIP

When you create images, don't think about what you need to do this afternoon or tomorrow, and don't put a time limit on your photo shoot. Observe what's around you, imagine the type of images you can create with the subject matter before you, and create lots of images.

Just taking a quick glance into the viewfinder and then pressing the shutter-release button is not being observant. So many people go through life with blinders on. They drive to and from work without observing the beauty around them and the changes in their own neighborhoods or hometowns, and they always take the same routes whenever they go somewhere. Armed with your Nikon D780, a creative spirit, and the ability to see photo opportunities, you can capture some wonderful photographs of the town in which you live or any place you visit.

Practicing 'til Your Images Are Pixel-Perfect

If you use your camera only once in a blue moon, your pictures will show it. Letting your gear gather dust in the closet won't help you become a better photographer. Instead, use your camera every chance you get. Consider joining a local camera club — networking with other photographers is a wonderful way to get new information! You may also find a mentor there. Simply strike up a friendship with an experienced photographer and tell her you want to tag along the next time she does a photo shoot.

The best way to practice photography is to take pictures of people, places, and things that interest you every chance you get. Practice your photography when you see something that inspires you, such as a compelling image in a magazine or a picture on the web. With that inspiration fresh in your mind, grab your camera and take lots of pictures of similar subjects.

I often do a photo walkabout. I grab one or two lenses, my trusty camera, and my imagination and then drive to a part of town I haven't photographed before. Then

I park the car and start exploring. This photo walkabout gives me a chance to learn how to use a new piece of gear or experiment with a new technique, which enhances my creativity. Figure 15-5 shows an image I created with a 85mm macro lens shortly after I received it.

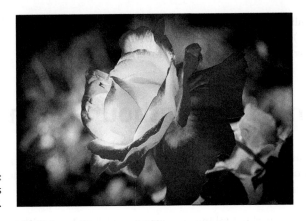

FIGURE 15-5:
Practice makes
perfect.

Becoming a Student of Photography

When you decide to seriously pursue photography, you can find a lot of resources. Great portrait photography is all around you. For instance, you'll find portraits of everyone from celebrities to politicians to scientists in publications like *The New York Times* or *The New Yorker*, or you can find great pictures of places in magazines like *Outdoor Photographer, National Geographic*, or *Travel+Leisure*. You can find great pictures of things in magazine advertisements. Your local newspapers and magazines are also great resources for compelling images.

When you see an interesting image in a magazine or newspaper, study it carefully. Try to determine the type of lens the photographer used. See if you can tell whether the photographer used a fast or slow shutter speed or a large or small aperture. Also try to determine how the photographer illuminated the subject. Did he use available light, camera flash, or fill flash? If you study great images carefully, you can get a rough idea of the settings the photographer used to take the picture.

Another great way to understand portrait photography is to study the masters. Here are just a few examples to get you started, depending on what kind of work you're interested in:

>> **Portrait photography:** Annie Leibovitz, Greg Gorman, Richard Avedon, or Arnold Newman

- >> **Street photography:** Henri Cartier-Bresson, Garry Winogrand, Joel Meyerowitz, or Helen Levitt

- >> **Landscape photography:** Ansel Adams or Clyde Butcher (affectionately known as the "Ansel Adams of the Everglades")

TIP

You can also find lots of examples of great photography at Photo.net (www. photo.net). Other photography sites such as Flickr (www.flickr.com) and 500px (www.500px.com) can be sources for inspirational photography.

Never Leaving Home without a Camera

You can't ask a photo opportunity to wait while you go home to get your camera. Photo opportunities happen when you least expect them. So, never leave home without a camera!

If you're nervous about taking your expensive Nikon D780 with you wherever you go, I don't blame you, and I actually feel the same way. That's why I bought a relatively inexpensive point-and-shoot camera that I carry with me everywhere I go. When I see something I want to photograph, I reach in the glove box of my car, grab my trusty point-and-shoot camera, and snap the picture.

Nikon makes the CoolPix A1000, a wonderful point-and-shoot camera with professional features; it's a great camera to augment your D780. The A1000 won't fit in your shirt pocket, but it will fit in your pants pocket, coat pocket, or glove box.

If you've got an old cellphone, it's hard to get good images. However, if you have a relatively new smartphone, you may have a very good camera. If your portable device doesn't have a great camera, you can still use it to create a digital sketch of a scene you want to photograph at a later date with your D780. As photographer Chase Jarvis is fond of saying, "The best camera is the one that's with you."

Waiting for the Light

If you don't have the right light for your photograph, wait. The quality and quantity of light can change quickly, especially in the early morning or late afternoon. Light can make the difference between a mediocre photo and a *WOW!* photo of a scene. If you're photographing in the middle of the day when the light is harsh, but there are clouds in the sky, wait a few minutes until a cloud eclipses the sun. If it's a thick cloud, you'll have very nice lighting. If it's a thin cloud, the harsh light will be diffused to an extent, and you'll get a better photograph than you would have without

the cloud cover. In addition to buffering the light, a cloud drifting by can add interest to a photo. Clouds can be used as compositional elements, as well as light modifiers. Wait patiently until the cloud is in the right position to add interest to your photograph. The next time you arrive at a great scene but don't have the right light, wait.

TIP

Also, wait when you're shooting candid pictures of people. Minutes may pass with nothing exciting happening, but don't put away the camera yet. If you wait patiently, something will happen that piques your interest and compels you to press the shutter-release button.

Defining Your Goals

Before you press the shutter-release button, get a clear idea of what the final image will look like. If you don't have a goal for the picture or the photo shoot, you're wasting your time, and if you're photographing a person, you're wasting your time and your subject's time. Of course, the goal doesn't have to be a great image. You can go on a photo shoot to experiment with new ideas, master a new technique, or experiment with a new lens. After all, practice makes perfect.

When you know why you're taking the picture, you'll know what settings to use, how to light the photo, which lens to use, and so on. If you're creating an image for a friend or a client, adhere to the standard rules of composition, but also take a couple of pictures using a unique vantage point or a slightly different composition than you'd normally use; you may end up with some interesting pictures your client will like. On the other hand, if you're creating photographs for yourself, the sky's the limit and you can get as creative as you want. You can shoot from different and unique vantage points, tilt the camera, break the composition rules, use an unorthodox lens, and so on.

Finding Your Center of Interest

When you create a picture of a person or place, decide what the main point of interest is and how you'll draw the viewer's eye there. For some photos, the point of interest may be a person's face or a landmark, such as the Lincoln Memorial. If you're creating a portrait of a pianist, a picture of him playing the piano would be appropriate and your center of interest could be his hands on the keys.

Sometimes, you have more than one center of interest. When this occurs, you can compose the photo in such a manner that one center of interest leads the viewer's eye to the other center of interest. For example, if you're photographing

a cellist on a beach near San Francisco's Golden Gate Bridge, you have two centers of interest — the musician and the bridge. Your job is to marry these two centers of interest to create a compelling image and guide your viewer's eye through the photo. You also need to compose the photo so that one center of interest doesn't dominate the other.

Locating the Best Vantage Point

The decision you make on your best vantage point depends on what you're photographing. In most instances, you want to be eye to eye when photographing a person. The only exception to this rule is when you photograph a short adult. Take one picture at eye level, and then drop to one knee and point the camera up. If you're photographing a landscape and the sky or a mountain is the dominant feature, choose a vantage point that causes the sky or mountain to dominate the upper two-thirds of the image. If you're photographing a scene in which a lake or the ocean is the dominant feature, lie on your belly and compose the photo so that the water feature occupies the bottom two-thirds of the image. If the subject is a towering mountain range, position the camera so that the mountain and sky occupy the upper third of the image (see Figure 15-6). Yup, the old Rule of Thirds is at work.

FIGURE 15-6: Using a unique vantage point to add interest to an image.

Thinking about What Else Is in the Picture

A good photograph doesn't come easy. To create good photographs, photograph what you love, condense the three-dimensional objects before you into a compelling two-dimensional image, and then arrange the elements in the frame to tell your story and show your viewers why you took the picture. Some photographers make the mistake of including too much information in their photographs. When you create an image, take time to see everything in the frame and ask the following questions:

>> **Are the elements arranged in a manner that will convey my message?** If not, move until the composition pleases you and does tell your story.

>> **Does everything need to be in the frame?** If not, walk closer to your subject (also known as "foot zoom") or move until the distracting elements are no longer in your picture.

>> **Are the elements on the left and right sides of the frame balanced?** The balance can be light to dark, or it can be about the number of elements in each side of the frame. An unbalanced frame can also be useful. If you do create an image with an unbalanced frame, make sure the side with the heaviest visual impact is where you want to draw the viewer's attention.

>> **Are there any distracting elements at the edge of the frame?** Many photographers only pay attention to the center of the frame. Pay attention to everything in the frame, including the edges, and get rid of the distracting elements to create better pictures.

Getting the right amount of elements in your images comes instinctively when you take lots of pictures, and take the time to monitor what's in the frame of each image you create.

REMEMBER

Don't just look at your viewfinder and snap the picture. Take a bit of time to see what's in the frame and make sure the information you want to include in your photograph is in the frame and nothing more. You can always move to the left or right, crouch down, or move to a higher vantage point to get the image you envision and take care of any potential problems at the same time. Do this and you'll create a much better image.

Index

O

Off option, 204

OK button
location of, 11
overview, 56

On (series) option
High Dynamic Range (HDR), 239
multiple-exposure image, 204

On/Off option
file number sequence, 94
High Dynamic Range (HDR), 239

Overflow option, 146

Overlay Shooting option, 206

Overview option, 102

P

P mode. *See* programmed auto (P) mode

PAL format, 137

panning, 144

Pelican website, 51

Perspective Control command, 211

photo illustration effect
capturing with, 224
overview, 222

photo shooting menu, 59

photography
center of interest and, 295–296
composition and
questions about, 297
resources, 293–294
Rule of Thirds, 289–291
landscape
camera settings, 252–253
composition, 253–256
overview, 251–252
lighting and, 294–295
macro, camera settings, 265
nature and wildlife
camera settings, 261–262
composition, 262–264
overview, 261
portraits
camera settings, 256
composition, 256–258

practicing, 292–293

special events
camera settings, 248–249
composition, 249–251
overview, 247–248
recommendations, 92

sporting events
camera settings, 259
composition, 260–261

vantage point and, 296

Photo.net, 288

Photoshop, 281–283

Picture Controls. *See also* EFCT mode
applied to JPEG files, 64
capturing photos with, 65–66
custom
creating, 68–70
saving and sharing, 70–72
modifying, 66–68
not applied to NEF files, 64
not applied to RAW files, 64
not recorded on metadata, 64
overview, 63–65
video and, 141–142

picture display options, 101–102

picture review options, 104–105

pictures. *See also* capturing; videos
adding author name to, 283–284
adding copyright information to, 283–284
backing up, 91
blurry, 74
deleting, 112
HDR and, 238–240
navigating in zoomed, 105
protecting, 112–113
quality of
overview, 80
specifying, 81–85
rating, 105–106
retouching, 210–213
reviewing, 99–100
rotating, 103–104
sharpness of, 74
shooting multi-exposure, 203–206

S

About the Author

Doug Sahlin is an author and photographer living in Venice, Florida. He has written books about computer applications such as Adobe Flash and Adobe Acrobat. He has also written books about digital photography and co-authored 13 books on topics such as Adobe Photoshop and Adobe Photoshop Elements. Recent titles include *Digital Landscape & Nature Photography For Dummies, Digital SLR Settings & Shortcuts For Dummies, Canon EOS 7D For Dummies, Canon EOS 6D For Dummies, Canon EOS Rebel SL1/100D For Dummies,* and *Canon EOS 7D Mark II For Dummies* (all published by Wiley). Many of his books have been bestsellers on Amazon.

Doug teaches Adobe Acrobat to local businesses and government institutions. He also teaches Adobe Photoshop and Adobe Photoshop Lightroom at local photography stores. In addition, Doug is a photography tutor.

Dedication

Dedicated to the Pretty Ballerina René, my sweetheart, coach, mentor, and the best support team any author could ask for.

Author's Acknowledgments

Thanks to Executive Editor Steve Hayes for making this book a possibility. Special thanks to Elizabeth Kuball for making sure my text is squeaky clean with no grammatical errors. Thanks to Mark Hemmings for making sure the book is technically accurate. Many thanks to the other members of the Wiley team for taking the book from concept to fruition.

Thanks to agent extraordinaire Margot Hutchison for ironing out the contractual details. Many thanks to Nikon for creating some of the greatest cameras on the planet. Special thanks to my friends and family. Kudos to René for being so understanding and supportive. And thanks to the furry kids, Kiki and Micah, for their love, affection, and comic relief.

Publisher's Acknowledgments

Executive Editor: Steven Hayes

Project Editor: Elizabeth Kuball

Copy Editor: Elizabeth Kuball

Technical Editor: Mark Hemmings

Proofreader: Debbye Butler

Production Editor: Siddique Shaik

Cover Image: © Courtesy of Doug Sahlin

Leverage the power

Dummies is the global leader in the reference category and one of the most trusted and highly regarded brands in the world. No longer just focused on books, customers now have access to the dummies content they need in the format they want. Together we'll craft a solution that engages your customers, stands out from the competition, and helps you meet your goals.

Advertising & Sponsorships

Connect with an engaged audience on a powerful multimedia site, and position your message alongside expert how-to content. Dummies.com is a one-stop shop for free, online information and know-how curated by a team of experts.

- Targeted ads
- Video
- Email Marketing

- Microsites
- Sweepstakes sponsorship

20 MILLION PAGE VIEWS
EVERY SINGLE MONTH

15 MILLION UNIQUE
VISITORS PER MONTH

43% OF ALL VISITORS ACCESS THE SITE VIA THEIR MOBILE DEVICES

700,000 NEWSLETTER SUBSCRIPTIONS
TO THE INBOXES OF
300,000 UNIQUE INDIVIDUALS EVERY WEEK

of dummies

Custom Publishing

Reach a global audience in any language by creating a solution that will differentiate you from competitors, amplify your message, and encourage customers to make a buying decision.

- Apps
- Books
- eBooks
- Video
- Audio
- Webinars

Brand Licensing & Content

Leverage the strength of the world's most popular reference brand to reach new audiences and channels of distribution.

For more information, visit dummies.com/biz

PERSONAL ENRICHMENT

Staying Sharp
9781119187790
USA $26.00
CAN $31.99
UK £19.99

Facebook
9781119179030
USA $21.99
CAN $25.99
UK £16.99

Guitar
9781119293354
USA $24.99
CAN $29.99
UK £17.99

Investing
9781119293347
USA $22.99
CAN $27.99
UK £16.99

Beekeeping
9781119310068
USA $22.99
CAN $27.99
UK £16.99

Digital Photography
9781119235606
USA $24.99
CAN $29.99
UK £17.99

Meditation
9781119251163
USA $24.99
CAN $29.99
UK £17.99

Pregnancy
9781119235491
USA $26.99
CAN $31.99
UK £19.99

Samsung Galaxy S7
9781119279952
USA $24.99
CAN $29.99
UK £17.99

iPhone
9781119283133
USA $24.99
CAN $29.99
UK £17.99

Crocheting
9781119287117
USA $24.99
CAN $29.99
UK £16.99

Nutrition
9781119130246
USA $22.99
CAN $27.99
UK £16.99

PROFESSIONAL DEVELOPMENT

Windows 10
9781119311041
USA $24.99
CAN $29.99
UK £17.99

AutoCAD
9781119255796
USA $39.99
CAN $47.99
UK £27.99

Excel 2016
9781119293439
USA $26.99
CAN $31.99
UK £19.99

QuickBooks 2017
9781119281467
USA $26.99
CAN $31.99
UK £19.99

macOS Sierra
9781119280651
USA $29.99
CAN $35.99
UK £21.99

LinkedIn
9781119251132
USA $24.99
CAN $29.99
UK £17.99

Windows 10
9781119310563
USA $34.00
CAN $41.99
UK £24.99

SharePoint 2016
9781119181705
USA $29.99
CAN $35.99
UK £21.99

Fundamental Analysis
9781119263593
USA $26.99
CAN $31.99
UK £19.99

Networking
9781119257769
USA $29.99
CAN $35.99
UK £21.99

Office 2016
9781119293477
USA $26.99
CAN $31.99
UK £19.99

Office 365
9781119265313
USA $24.99
CAN $29.99
UK £17.99

Salesforce.com
9781119239314
USA $29.99
CAN $35.99
UK £21.99

Coding
9781119293323
USA $29.99
CAN $35.99
UK £21.99

dummies.com

dummies®
A Wiley Brand

Learning Made Easy

ACADEMIC

9781119293576
USA $19.99
CAN $23.99
UK £15.99

9781119293637
USA $19.99
CAN $23.99
UK £15.99

9781119293491
USA $19.99
CAN $23.99
UK £15.99

9781119293460
USA $19.99
CAN $23.99
UK £15.99

9781119293590
USA $19.99
CAN $23.99
UK £15.99

9781119215844
USA $26.99
CAN $31.99
UK £19.99

9781119293378
USA $22.99
CAN $27.99
UK £16.99

9781119293521
USA $19.99
CAN $23.99
UK £15.99

9781119239178
USA $18.99
CAN $22.99
UK £14.99

9781119263883
USA $26.99
CAN $31.99
UK £19.99

Available Everywhere Books Are Sold

dummies.com

Small books for big imaginations

9781119177173
USA $9.99
CAN $9.99
UK £8.99

9781119177272
USA $9.99
CAN $9.99
UK £8.99

9781119177241
USA $9.99
CAN $9.99
UK £8.99

9781119177210
USA $9.99
CAN $9.99
UK £8.99

9781119262657
USA $9.99
CAN $9.99
UK £6.99

9781119291336
USA $9.99
CAN $9.99
UK £6.99

9781119233527
USA $9.99
CAN $9.99
UK £6.99

9781119291220
USA $9.99
CAN $9.99
UK £6.99

9781119177302
USA $9.99
CAN $9.99
UK £8.99

Unleash Their Creativity

dummies.com

dummies
A Wiley Brand

Printed and bound by CPI Group (UK) Ltd, Croydon, CR0 4YY

09/06/2025

14685922-0001